Editor: Donna Wood
Designer: Tracey Butler
Image retouching and colour repro: Jacqueline Street
Production: Rachel Davis
Indexer: Hilary Bird

Produced by AA Publishing
© AA Media Limited 2012

Published by AA Publishing (a trading name of AA Media Limited, whose registered office is Fanum House, Basing View, Basingstoke RG21 4EA; registered number 06112600).

A04734

ISBN: 978-0-7495-7359-1

A CIP catalogue record for this book is available from the British Library.

The contents of this book are believed correct at the time of printing. Nevertheless, the publishers cannot be held responsible for any errors or omissions or for changes in the details given in this book or for the consequences of any reliance on the information provided by the same. This does not affect your statutory rights.

The paper used for this book has been independently certified as coming from well-managed forests and other controlled sources according to the rules of the Forestry Stewardship Council.

FSC
www.fsc.org
MIX
Paper from
responsible sources
FSC® C015829

Printed and bound in Italy by Printer Trento SRL, an FSC-certified company for printing books on FSC mixed paper in compliance with the chain of custody and on-products labelling standards.

theAA.com/shop
www.2020v.org

2020 VISION

BIG IDEAS
TO REBUILD OUR
NATURAL
HOME

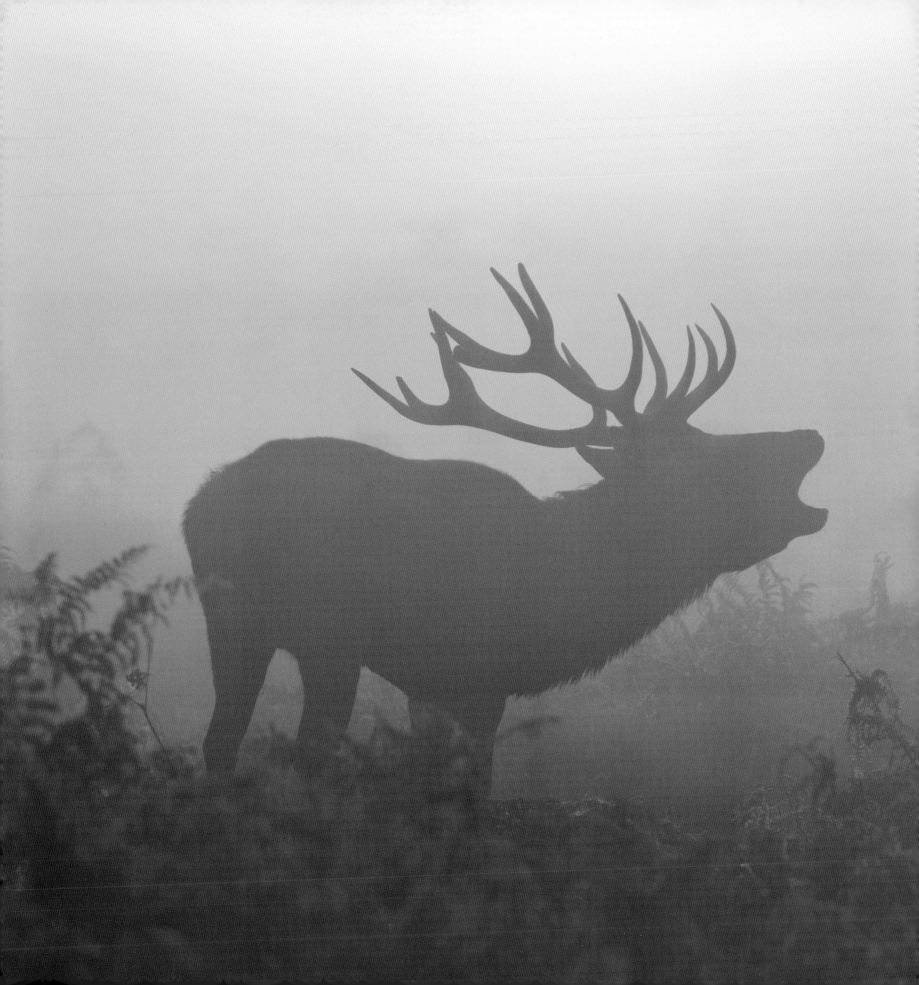

CONTENTS

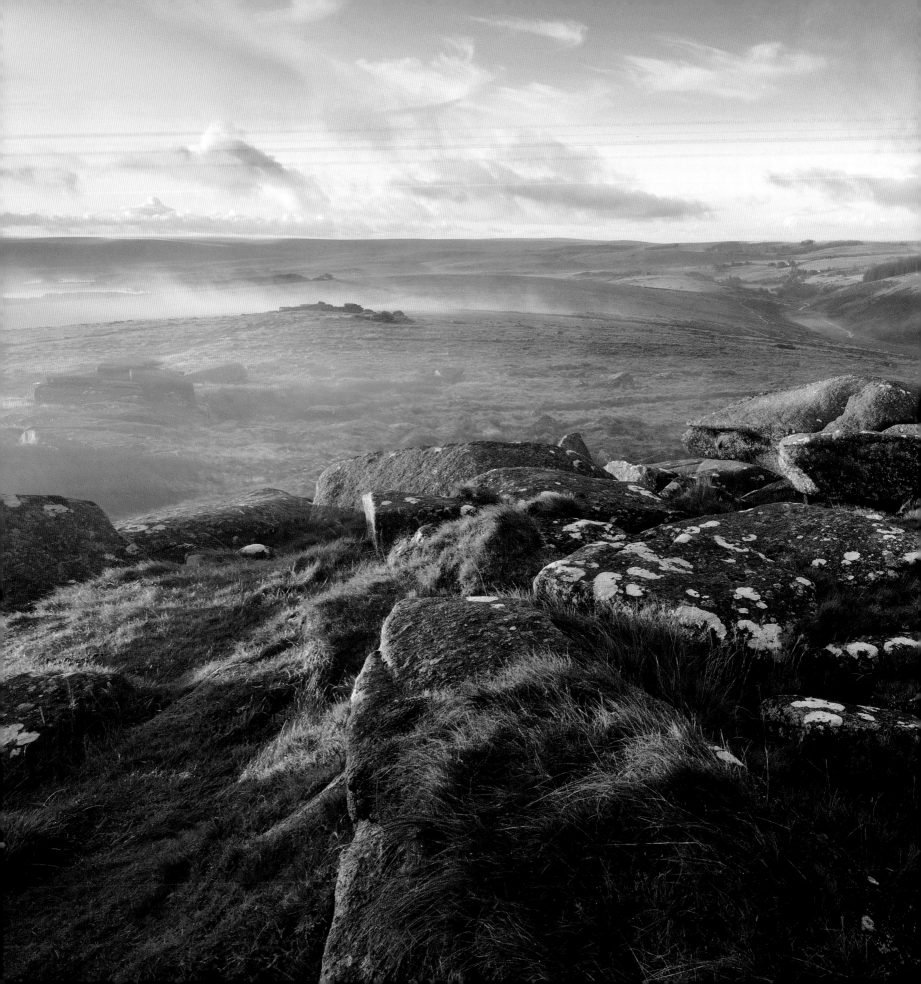

FOREWORD – **SEEING THE BIGGER PICTURE**

CHRIS PACKHAM, NATURALIST, PHOTOGRAPHER AND TV PRESENTER

Behind a successful image lies an intensity of concentration and observation that can be difficult to explain to those whose existence doesn't depend on a stab at visual perfection in a fraction of a second.

At this pivotal moment the picture-making process becomes a vortex, sucking existence away to leave only the photographer and their instance with the subject. It's a cruel, hard and lonely place to be and the pressure can be so intense that it distorts reason and perspectives of reality. We photographers naturally gravitate towards the detail of that moment. Its importance is grossly exaggerated relative to the rest of the world. We are locked into a minute fraction of existence for a minute fraction of time, and while we often get our picture, we occasionally lose sight of the bigger one. Our pictures may be beautiful, a success, a triumph even, but what are they actually worth to wildlife photography, to our overall awareness of life, to the animals and plants themselves?

It's perhaps not a coincidence that a real parallel exists between this practice and contemporary conservation, which in my opinion has historically lost sight of the bigger picture, with potentially disastrous consequences. As with our collective 'best pictures', we have produced, and continue to produce, superb results with specific conservation initiatives. We've learned how to protect, rebuild, reintroduce and restore a smattering of species and habitats. But, overall, these initiatives are not preventing a continuous decline in the wider environment; so, like our individual photographs, we have to question their efficacy. Harsh but true.

Addressing this would seem to be a necessary priority but change takes courage, pragmatism, conviction and real energy. It also needs imagination and honesty – all ingredients in this brilliant 2020VISION project, which very definitely seeks to present the bigger picture through the clever choreography of many individual images. Thus, this is not just a collection of the prettiest photos from around the UK; it has a defined purpose to portray a visual narrative that clearly defines the state of our nation's wildlife and, crucially – finally – the bigger thinking that could make a difference if we are to see nature, and people, flourish.

2020VISION not only allows us to celebrate the UK's natural riches but also gives us an insight into emerging perspectives, fresh ambitions and real hope for the future.

So look at, revel in and be astonished by what you see and read in this book; be in awe of the beautiful photographs, but do not forget the unique and innovative purpose of 2020VISION's objectives – to make us all realise it's the bigger picture that really matters.

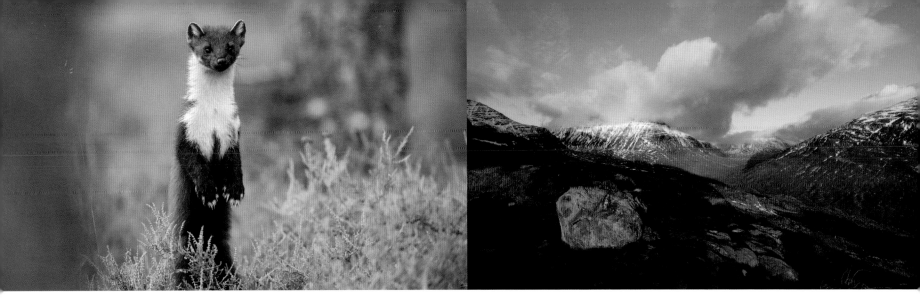

INTRODUCTION

It had been a long day, it was a dark rainy night and, to be honest, I wasn't in the mood. When the phone rang I nearly didn't answer it, but eventually I did, and within 20 minutes the voice on the other end had convinced me that gathering together a group of the UK's top nature photographers and getting them to collaborate on an exciting nationwide project was a sound idea. The voice belonged to my friend and colleague Mark Hamblin, and although I trust his judgement, I knew that this was a major undertaking he was suggesting. Game on! (But I didn't sleep much that night.)

Several hundred phone calls and a few months later, I found myself in Edinburgh as part of the newly formed 'Team 2020', standing in front of the great and the good from the world of conservation, launching 2020VISION, a project that was to take over not only my life, but that of many of my colleagues.

It's long been recognised that photography can have a powerful and immediate voice: it touches people on an emotional level; it connects with them like no other medium. But here's the rub: 2020VISION is not really about photography. Yes of course visual imagery is the currency we trade in, but really it's just another form of language. 2020VISION is about communication. It's about articulating an idea, nurturing an ethos and introducing a vision.

For decades, conservation has been about protecting individual species or specific habitats – a rare bird here, some grassland there. Nothing wrong with that, but the focus has been on preserving what fragments of nature we have left and putting a fence around them. As a consequence, nature has become separate from our 'normal' lives, a commodity almost. If you want to 'do' some nature, you drive to a nature reserve before returning to 'civilisation'. We've got

it all a bit skewed. 2020VISION promotes a fresh, more ambitious approach to conservation, an approach that seeks to repair, rebuild and reconnect those fragmented islands of nature – to reinvigorate whole ecosystems which stretch way beyond nature reserves. Let's be straight, this is not our idea – scientists, conservation groups and governments are now promoting the idea of 'rewilding', where whole landscapes are able to function more effectively, not only for the benefit of wildlife, but for us too.

So 2020VISION is essentially an advertisement for rebuilding ecosystems. What's an ecosystem, I hear you ask? Well, we could debate that all day, but really, when it comes down to it, an ecosystem is a home. Our home. My colleague Niall Benvie draws this analogy: 'We can all live in a rundown shack with a leaking roof and broken windows, but surely we'd prefer a secure, warm home that's looked after and keeps us safe?' Niall's absolutely right, of course. An investment in nature is therefore nothing more than an investment in our home.

2020VISION won't change the world overnight; there is no magic wand, no silver bullet. It's part of a process, a cultural process if you like, to motivate and inspire a wide range of people about the true value of a healthy, robust environment, an environment that supplies us with so many things that we don't even think about. Clean air, fresh water, flood prevention, crop pollination, even somewhere nice to walk the dog; these are all free 'services' that nature provides, and hundreds more besides. Our job as photographers, then, is to make the most compelling case possible for the rebuilding of our natural home – to make the United Kingdom a better place in which to live.

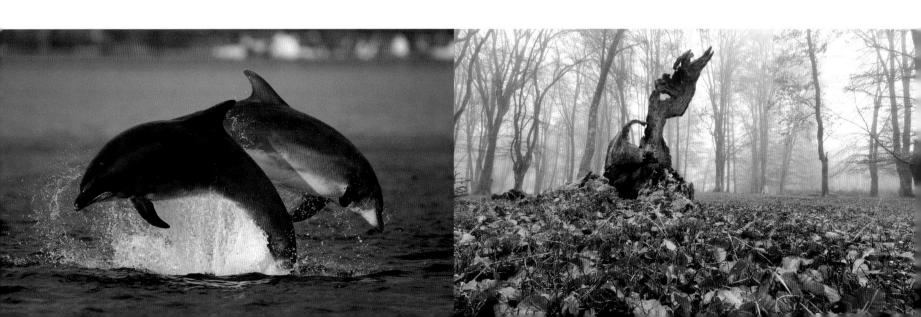

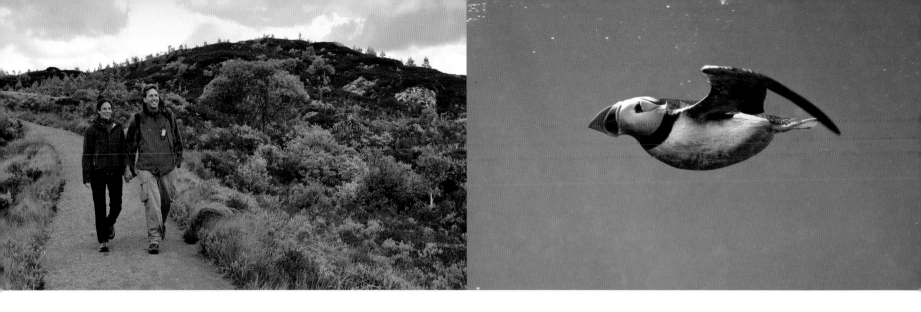

So why 2020VISION? Well that's easy. We enlisted 20 top nature photographers (they didn't need much persuasion, to be fair) to cover 20 flagship projects up and down the country, with 20 months to get the job done. But more significant is the year 2020, now the next target for halting biodiversity loss and a year that will signal a new generation of decision makers who will inherit the legacy of what we do, or don't do, today. The cost of the banking collapse will pale alongside that of our ecosystems unravelling if we don't repair and reconnect nature's broken bits.

And there's some great news on that front! There are people out there already doing this stuff. Spectacular rebuilding stuff. Heroic stuff. The big nature repair jobs that our photography team has worked on are nothing short of inspirational. Many of them stretch over hundreds of square kilometres of wild country, others are focused on the heart of our busiest cities; some will take decades to complete, a few will even take centuries. But the important thing is that the process has started, the vision is inspiring and the will to act is palpable.

In this book you'll get to meet the photographers, videographers, sound recordists, writers and designers who made 2020VISION happen. They've sat in cramped hides, waded in stinking bogs, waited hours for the light, got seasick, airsick and in some cases just sick of each other! It's been a long haul and they are all heroes. In reality, however, the real heroes are those who are out there – researchers, scientists, wardens, farmers, gamekeepers, volunteers. They are the ones doing the digging, planting, blocking, seeding, monitoring – making this stuff happen on the ground. And behind the scenes there are unlikely, unseen heroes – fundraisers, policy makers, community champions and government officials – working hard to make our country a better place. 2020VISION is merely a witness to all of their gargantuan efforts and it's the fruits of those efforts – many not yet realised – that this book celebrates.

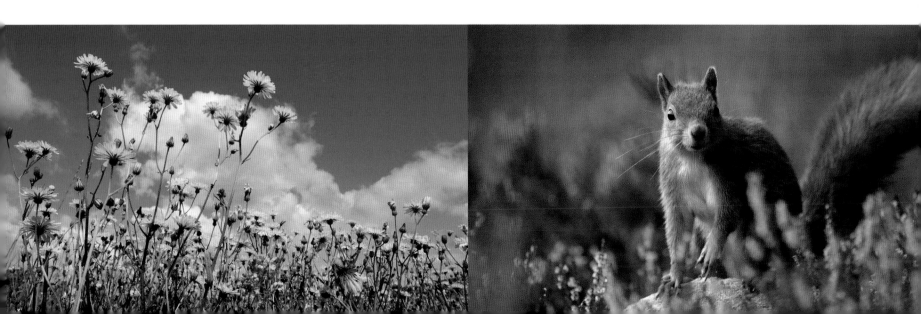

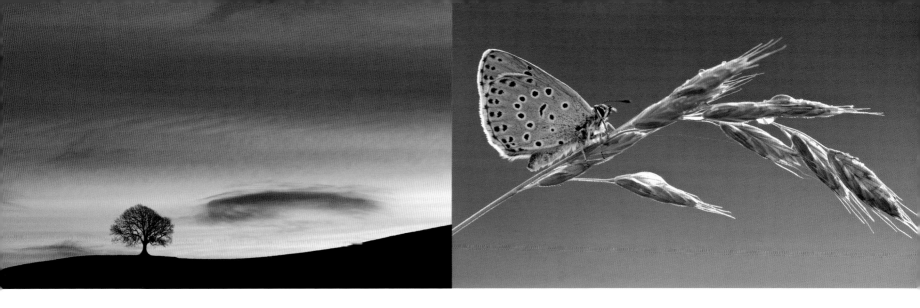

We all know that things aren't perfect, but do you know what? Bludgeoning people with bad news all the time saps their energy, their resolve. We think that if people feel good, they're more likely to do good. It's not that we're being all fluffy and romantic about it; it's just common sense. So yes, we need to be mindful that there is a long way to go in putting our home back in order, but in many places the plans have been drawn up, the materials ordered and the foundations laid. The rewilding process has begun.

So what does it take to be a rewilding hero? As it happens, not that much. We can all be heroes and I hope that by the time you reach the end of this book, you'll want to do your own bit to be a hero. It can start in your garden or local park. It can be something seemingly insignificant, something small, because lots of small things add up. We're going to give you some big ideas about how to rebuild our natural home but it's down to you, us, all of us to get out there and make it happen, to become heroes of Britain's ecosystems.

Peter Cairns
Project co-ordinator

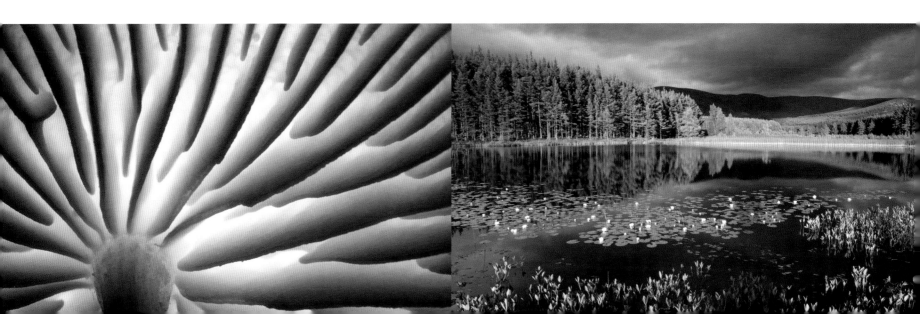

MEET THE TEAM!

2020VISION is very much a team effort and without a huge amount of input from a whole range of people – all with different skills – this book and its accompanying exhibition and multimedia shows would not have been possible. Here we introduce the people behind the scenes, all of whom share a commitment to helping to restore wild nature to these wonderful islands.

2020VISION PHOTOGRAPHERS

The principal team of photographers represents some of the best professionals at work today in the UK. They were enlisted not only for their photographic skills, but, equally importantly, for their commitment to conservation communication.

1 John Beatty
www.wild-vision.com

2 Niall Benvie
www.niallbenvie.photoshelter.com

3 Peter Cairns
www.northshots.com

4 Joe Cornish
www.joecornishgallery.co.uk

5 Guy Edwardes
www.guyedwardes.com

6 Lorne Gill
www.scottishnaturephotography.com

7 Fergus Gill
www.scottishnaturephotography.com

8 Chris Gomersall
www.chrisgomersall.com

9 Danny Green
www.dannygreenphotography.com

10 Ben Hall
www.benhallphoto.com

PROJECT MANAGEMENT

Peter Cairns: Project co-ordinator
Mark Hamblin: Image library and assignments co-ordinator
Emma Blyth: Web and PR
Niall Benvie: Writing and design
John MacPherson: AV and multimedia
Damian Waters: Young Champions co-ordinator
Chris Hatch: Legal and financial

ADVISORS

Chris Gomersall
Maggie Gowan
Pete Johnstone

To learn more about the **2020VISION** team and

11 Mark Hamblin
www.markhamblin.com

12 Paul Harris
www.paulharrisphotography.com

13 Ross Hoddinott
www.rosshoddinott.co.uk

14 Rob Jordan
www.robjordan.co.uk

15 Alex Mustard
www.amustard.com

16 Andy Parkinson
www.andrewparkinson.com

17 Linda Pitkin
www.lindapitkin.net

18 Andy Rouse
www.andyrouse.co.uk

19 David Tipling
www.davidtipling.co.uk

20 Terry Whittaker
www.terrywhittaker.com

GUEST PHOTOGRAPHERS

Our core team was supported by the following photographers who were recruited for their particular fields of expertise and have made an invaluable contribution to the 2020VISION image collection.

Charlie Hamilton-James
John MacPherson
Toby Roxburgh
Richard Steel
Dale Sutton
Nick Upton

VIDEOGRAPHERS
Raymond Besant
Will Bolton
Ben Burville
Andy Jackson

MUSIC AND SOUND
Martyn Ford
Chris Watson

MAIN WRITERS
Kenny Taylor
Niall Benvie
Claire Stares
Peter Cairns

GUEST WRITERS
Paul Kingsnorth
David Lindo
Sir John Lister-Kaye
Robert MacFarlane
Lucy McRobert
Bethan Roberts

the multimedia roadshow visit www.2020v.org

THE 2020VISION PROJECT LOCATIONS

1 MORE THAN JUST A FOREST
Caledonian pine forest
Project locations: Abernethy, Glen Affric and Beinn Eighe NNRs

2 MORE THAN JUST A FOREST
The National Forest
Project locations: Leicestershire and Staffordshire

3 MORE THAN JUST A PEAT BOG
The Flow Country and Northern Ireland
Project locations: Caithness and Sutherland, Ballynahone Bog, N.Ireland

4 MORE THAN JUST A PEAT BOG
Kinder Scout restoration project
Project location: Peak District National Park

5 MORE THAN JUST THE SEA
The value of marine ecotourism
Project locations: Inner Hebrides, Bass Rock and Farne Islands

6 MORE THAN JUST THE SEA
A new approach to sustainable fisheries
Project location: Shetland Isles

7 MORE THAN JUST SOME HILLS
Rewilding Scotland's uplands
Project locations: Coigach & Assynt, Glenfeshie, Creag Meagaidh NNR

8 MORE THAN JUST SOME HILLS
Wild Ennerdale
Project location: Lake District National Park

9 MORE THAN JUST A RIVER
A new approach to river catchment management
Project location: River Tweed

10 MORE THAN JUST A RIVER
Rivers on the Edge project
Project locations: Hampshire and Wiltshire

11 MORE THAN JUST A CITY
Black Country Living Landscape
Project location: Birmingham and the Black Country

12 MORE THAN JUST A CITY
The Greater Thames Futurescape
Project location: London and the Thames Estuary

13 MORE THAN JUST A SALTMARSH
Coastal rewilding
Project locations: Solway Firth and Morecambe Bay

14 MORE THAN JUST A FARM
Restoring intensive farmland to a conservation centre
Project location: Denmark Farm, Ceredigion

15 MORE THAN JUST A FARM
Hope Farm: helping farmers to help wildlife
Project location: Cambridgeshire

16 MORE THAN JUST A WETLAND
The Brue Valley Living Landscape
Project location: Somerset Levels

17 MORE THAN JUST A WETLAND
Rutland Water Habitats project
Project location: Oakham, Rutland

18 MORE THAN JUST A WETLAND
The restoration of the Cambridgeshire and East Anglian Fens
Project location: East Anglia

19 MORE THAN JUST A HEATH
The Suffolk Coast and Heaths project
Project location: Suffolk

20 MORE THAN JUST A HEATH
Grazing for Wildlife project
Project location: Hampshire

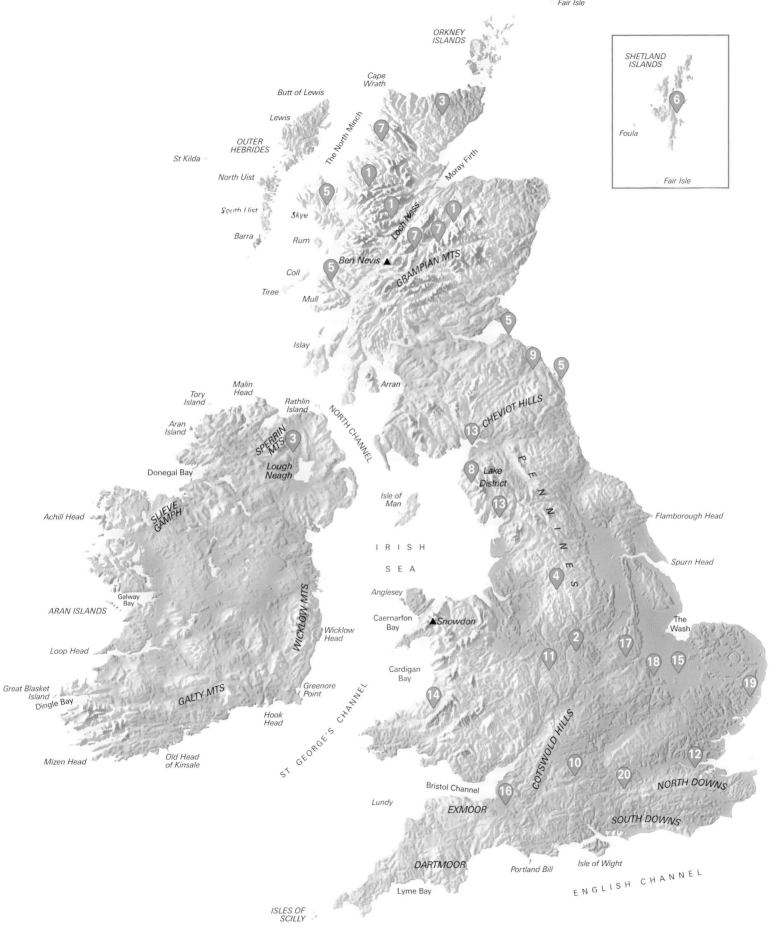

ORKNEY
ISLANDS

Fair Isle

SHETLAND
ISLANDS

Foula

Fair Isle

Cape
Wrath

Butt of Lewis

Lewis

OUTER
HEBRIDES

St Kilda

North Uist

South Uist

Barra

The North Minch

Skye

Rum

Coll

Tiree

Mull

Islay

Arran

Moray Firth

Loch Ness

Ben Nevis ▲

GRAMPIAN MTS

NORTH CHANNEL

Malin
Head

Tory
Island

Aran
Island

Rathlin
Island

Donegal Bay

SPERRIN
MTS

Lough
Neagh

Achill Head

SLIEVE
GAMPH

CHEVIOT HILLS

Lake
District

Isle of
Man

P
E
N
N
I
N
E
S

Flamborough Head

Spurn Head

I R I S H

S E A

ARAN ISLANDS

Galway
Bay

WICKLOW
MTS

Wicklow
Head

Loop Head

Greenore
Point

Anglesey

Caernarfon
Bay

▲ Snowdon

Cardigan
Bay

The Wash

Great Blasket
Island

Dingle Bay

GALTY MTS

Hook
Head

St GEORGE'S CHANNEL

NORTH DOWNS

Mizen Head

Old Head
of Kinsale

COTSWOLD HILLS

Bristol Channel

Lundy

EXMOOR

SOUTH DOWNS

DARTMOOR

Portland Bill

Isle of Wight

ENGLISH CHANNEL

Lyme Bay

ISLES OF
SCILLY

15

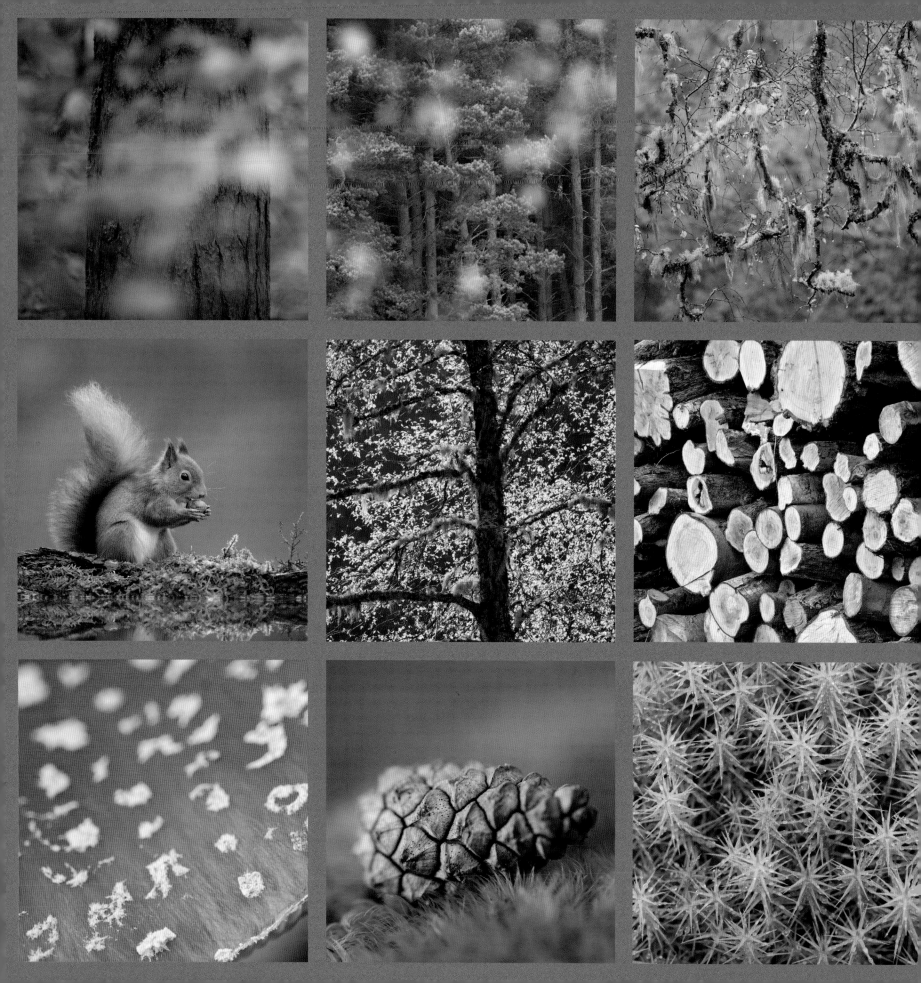

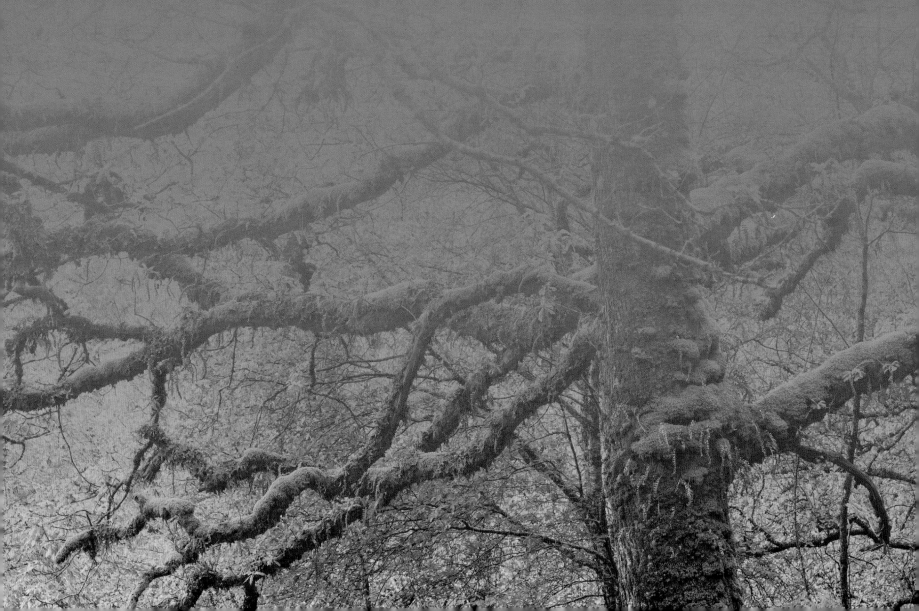

More than just a…

FOREST

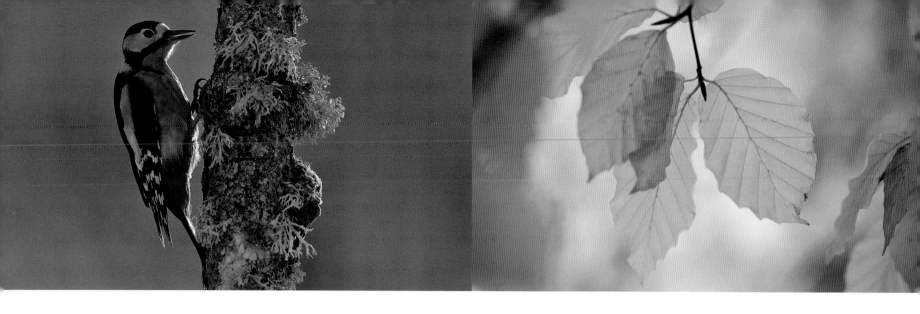

INTRODUCTION

'Forest'. Whether or not you know much about trees or wildlife, that word can stir many ideas and emotions. In a way, it tells us something about ourselves. Forest is a huge, wooded place beyond the boundaries of the known, the tamed and the cultivated. In our minds, it can be wild – fairytale wild – and so both an inspiration and a challenge.

That's how it has been across hundreds of generations, since people first occupied these lands. The first to go to the north of the country would have done so as the land began to green with recolonising trees. They would have known birches and junipers, and then the pines that followed. They would have seen the deer that lived in the forests, heard the grunting of wild boar and, at night, the howls of wolves. As the forests grew and changed, other generations would have used them as hunting and foraging grounds, sources of

fuel and building materials and (at the fringes or in clearings) places to make homes. But through much of prehistory and history, people would also have seen a shrinking of the forests; a pushing back of the boundaries of the deep, wide woods to make way, especially, for farmland. 'Deforestation' is often used these days to describe loss of tropical forests. In Britain, major reductions in forests happened a very long time ago.

In the natural course of things, much of Britain would be cloaked in trees, from valleys to moors, coasts to mountainsides. Much of the original tree cover had already gone by the time the Romans came here, around 2,000 years ago. By the early 20th century, only about one-twentieth of the land was wooded. Then, as now, Britain's woodland cover was among the lowest of any European country. But things have changed, and are continuing to change.

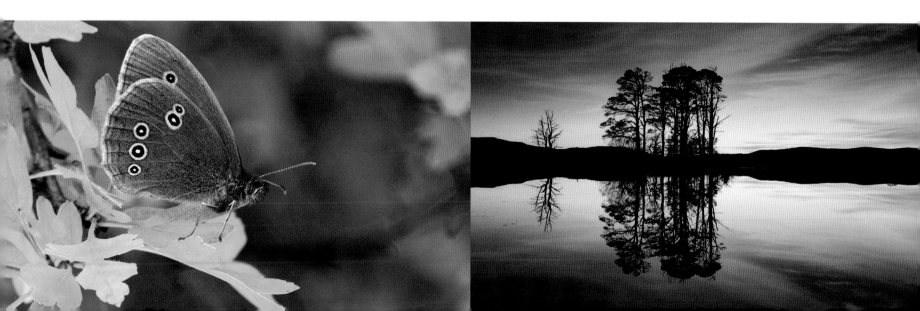

In the early years of the 21st century, something is stirring in forests ancient and new. Boosted by the help of many different people, the UK's forests are on the move. And as they expand, so the opportunities for fresh and exciting ways of seeing, using and enjoying forests are also growing.

In the last hundred years or so, woodland cover has more than doubled. Scotland has seen the biggest increase, due largely to massive planting of conifers. England, Wales and Ireland have also seen big increases in the number and size of both broadleaved and cone-bearing woods.

As many older plantations mature, new possibilities begin to unfold concerning how best to shape them for the future. These include moving away from clear-felling large areas of so-called 'blanket' forestry to encouraging a more nature- and people-friendly continuous woodland cover, with trees of many different ages.

The march of the trees couldn't be happening at a better time. Trees trap carbon dioxide – a key greenhouse gas – so they can play an important part in helping us to cope with climate change. Woodland creation is a fairly inexpensive way of helping with part of this fight.

But never mind the money: think wild; think nature; think fun and challenge. What price the red squirrel, peeking at you from high in the branches of an ancient pine tree? What value the family of badgers, rooting for worms in an oakwood, close to where children can make a den among the elder bushes? Or the roe deer, seen in a blur of orange through the deep green of summer leaves as

you walk or cycle along a woodland greenway, the animal there and then gone, like a waking dream?

Woodlands are some of the very best places for number and variety of different kinds of wildlife. Where they are big (who can say where the precise shift between 'wood' and 'forest' happens?), all the better for creatures, such as woodpeckers, that need lots of tree-covered ground and plenty of insect-rich dead wood to thrive.

Britain is blessed with many kinds of woodland. The shapes and colours of these are part of what makes different areas of the country distinctive. Oak, ash, birch, pine, spruce, hazel, alder – those are just some of the trees that predominate in different places, each type a life support system for its own community of plants and creatures.

In the ancient Caledonian pinewoods in the heart of the Scottish Highlands lives a particularly choice blend of wildlife. Capercaillie (turkey-sized, and the largest grouse in the world), pine marten, Scottish wildcat, red squirrels, crossbills, crested tits and wood ants are part of this community. Some of these are elusive. But that's part of the fun. You're unlikely to see a wildcat as you walk in the forest, yet simply knowing that one might be there – that this is a place where such a fine and feisty creature still survives – adds an extra pleasure to forests like these. It sparks the imagination. And thanks to some great work by local people, those pinewoods are being conserved and expanded, those chances for new encounters with wildlife increased.

In places such as Glen Affric, Beinn Eighe and Abernethy, enthusiasts have been helping the old pine forests to thrive. Teams of volunteers and staff from government agencies and conservation bodies have all been part of that work. The same is true in projects to boost forests across the country, from the smallest, community-owned woods, to the largest, landscape-scale schemes.

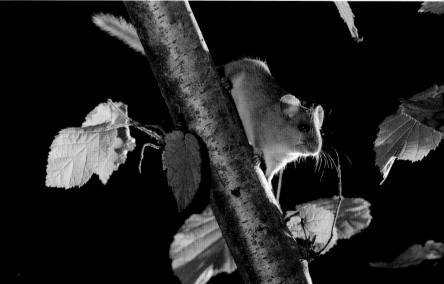

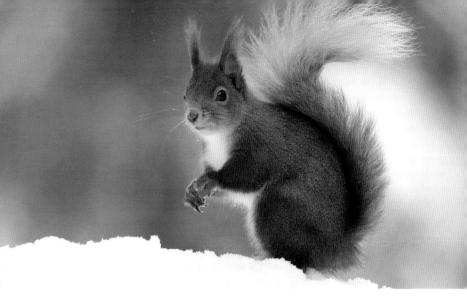

In the centre of England – in the territory where tales of Robin Hood and his Merry Men were born – The National Forest has taken root. It is transforming a vast area. Millions of trees have already been planted, in a project that is blending new and maturing woodlands with a wide variety of different landscapes. In this way, one of the country's least wooded regions could eventually have trees across a third of all the land within it.

On the border of Somerset and Devon, a huge mosaic of woodland, interwoven with pastures, is being created in the Neroche Scheme. Here, as in so many recent tree-linked projects, nature, economy, the arts and local communities will all benefit.

Hundreds of local groups are now involved in work with woods and forests in different parts of Britain and Ireland. The extent is mind-boggling, stretching from restoration projects on the Northern Isles (bare of much woodland since Viking times) to the far south of England, plus projects to the west – in Wales and Northern Ireland. And that's the buzz about the big woods today. For generations, most people in these islands have been kept apart from the forests, unable to influence the look and the life of them. Now that has changed. The forests are on the move again. People are central to their future success and the forests can once more be central to our own wellbeing.

No one can say quite what the next few decades will bring in terms of changes in our forests. But change they will. And as they do so, the word 'forest' can come back into our everyday speech as something exciting, something inspirational.

Right now, it could mean pleasure, health, wildlife, coolness in green shade, timber supply, carbon store and source of art and ideas. In the future? What unfolds will be as big as our imaginations can stretch. Large as a forest. A forest of possibilities.

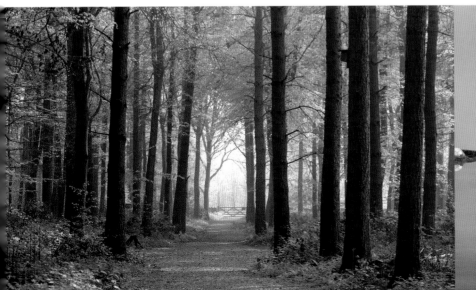
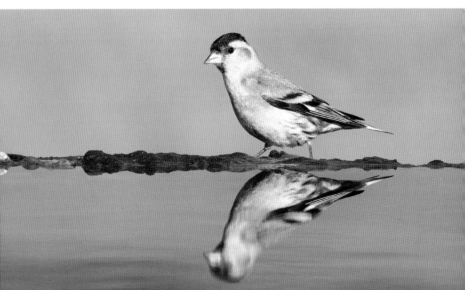

I'm privileged to work in this place. Each year, each month, each day throws up new views and perspectives that I'm lucky enough to witness.

Ross Watson, Operations Team Leader, RSPB Abernethy National Nature Reserve

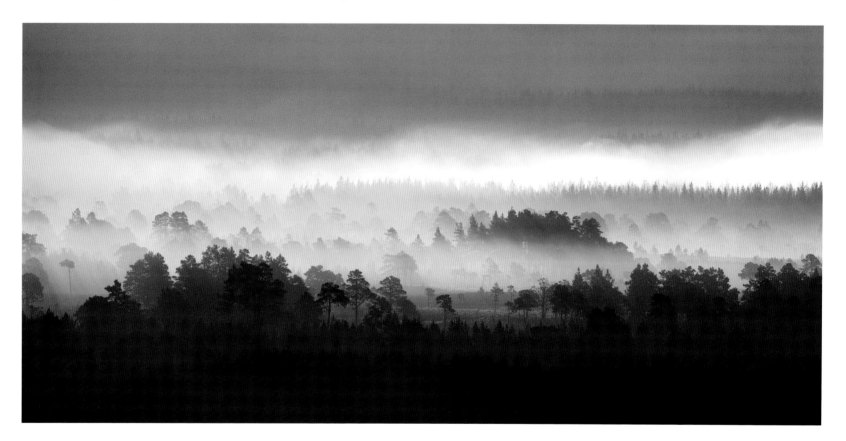

↑ **ROTHIEMURCHUS PINE FOREST**

Cairngorms, Scotland

The Great Wood of Caledon once covered much of the Scottish Highlands. Now reduced to just 1% of its former range, remnants like this one in the Cairngorms are not only being preserved, but are providing a springboard for the resurrection of this unique forest, with isolated fragments expanding and joining with others.

RED SQUIRREL IN AUTUMN →

Cairngorms, Scotland

These charismatic rodents have become symbolic of changing attitudes towards the value of wild forests. The pine woodlands of the north represent the squirrel's main UK stronghold and, as the pressures on them mount, a diverse, robust and interconnected forest becomes all the more essential.

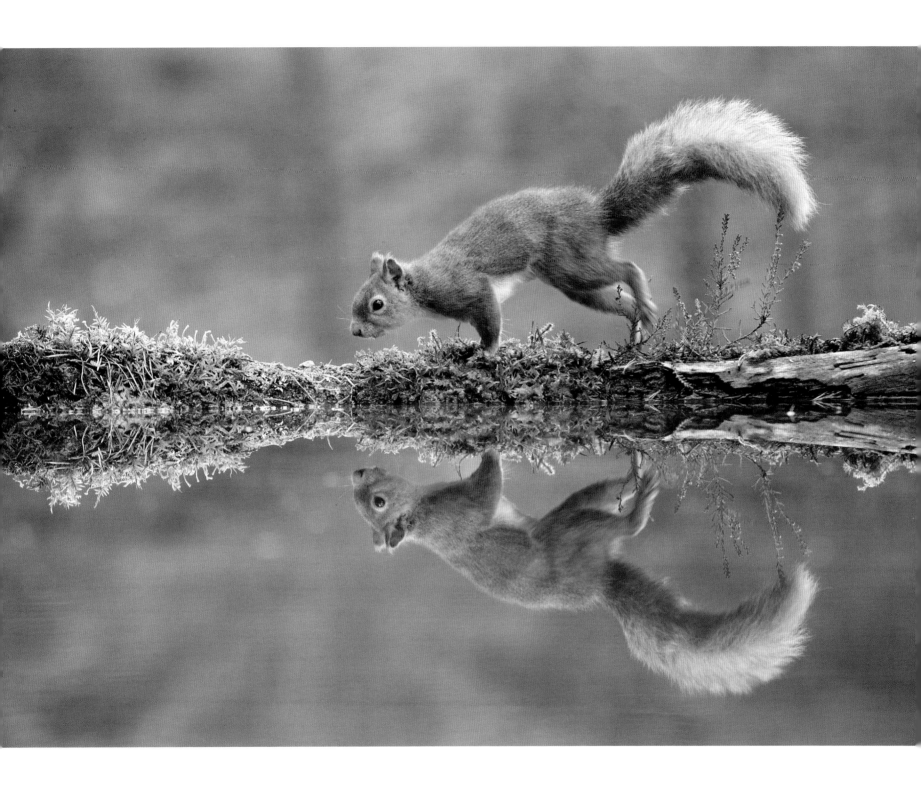

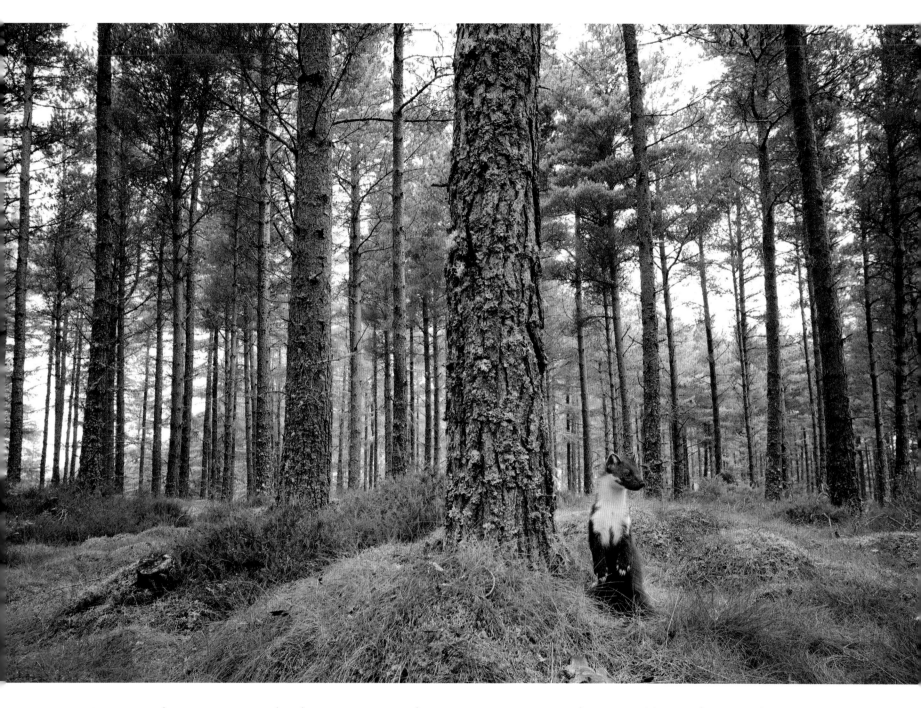

Pinewoods are special places. Go and camp in one — the smell in the early morning is amazing! David Frew, Manager, Mar Lodge Estate, Braemar

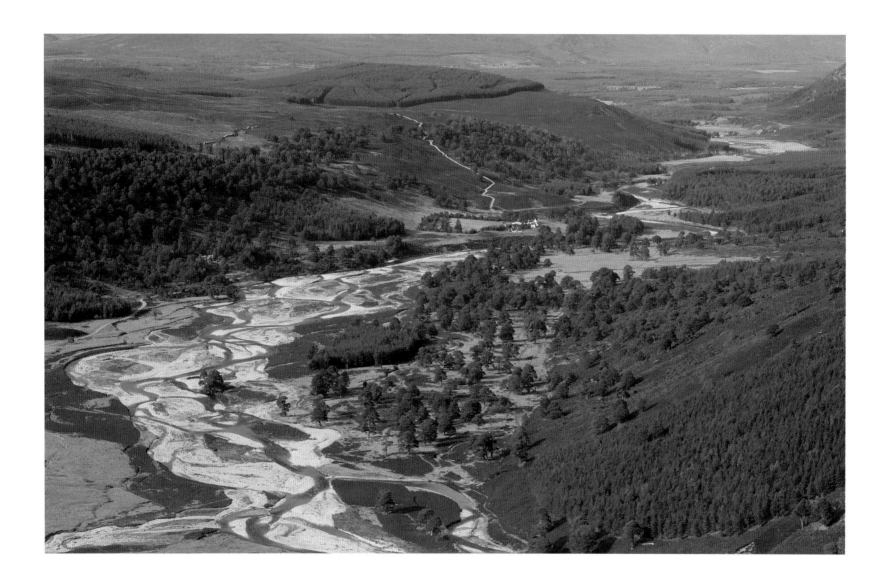

PINE MARTEN SURVEYING ITS HABITAT

Black Isle, Scotland

As more of the ancient wildwood is restored and post-war conifer plantations mature, pine martens are one of the beneficiaries, clawing their way back after centuries of persecution and habitat loss. These super-sized stoats were once common across the whole of the UK.

THE RETURNING FOREST

Glenfeshie Estate, Cairngorms, Scotland

Conservation bodies are not alone in their quest to rejuvenate Scotland's Great Wood. Glenfeshie Estate in the southern Cairngorms has ambitious plans to restore ecological integrity to a previously overgrazed landscape. After just a few short years, the results are manifest.

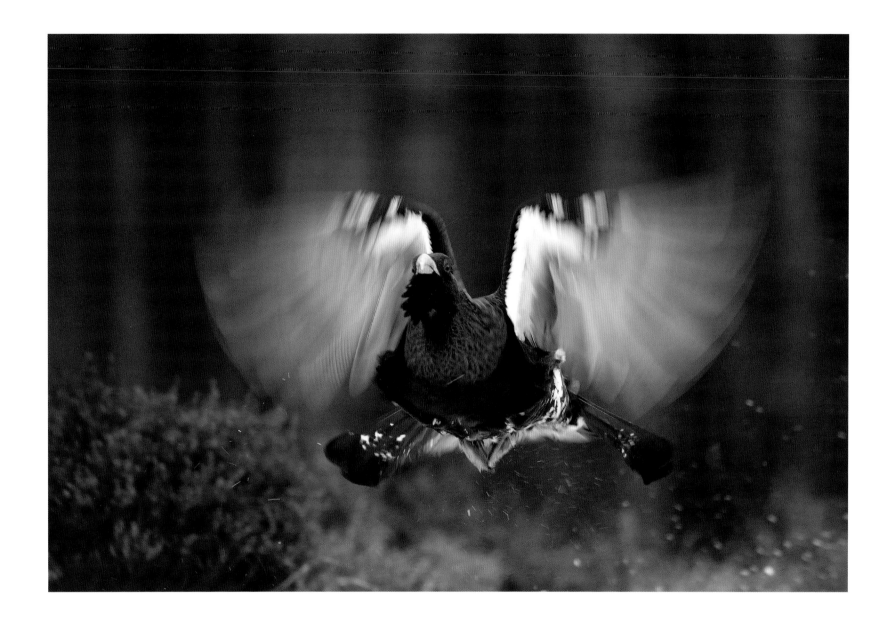

MALE CAPERCAILLIE IN DISPLAY FLIGHT

Cairngorms, Scotland

Capercaillies, the world's largest grouse, have the unenviable title of Britain's fastest declining bird. As with other pinewood specialists, their long-term survival could depend on the creation of expanded forest networks to allow free movement of birds between different populations. For now, the future for this Scottish icon remains precariously linked to the future of the forest in which it lives.

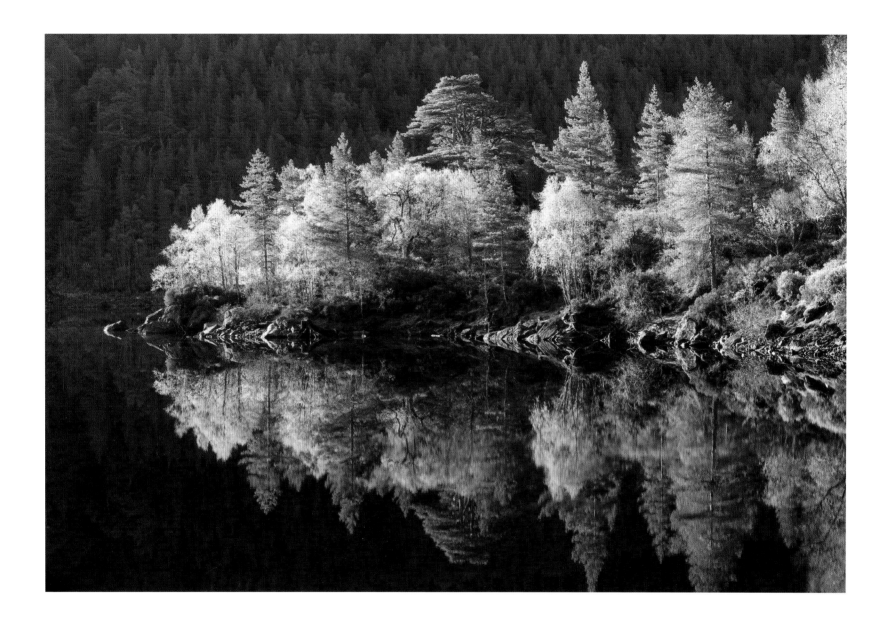

DAWN REFLECTIONS IN LOCH BEINN A'MHEADHOIN

Glen Affric, Scotland

Most forest restoration initiatives are justified – understandably so – by how they will be of benefit to people. Here in Glen Affric, one of the most extensive tracts of ancient pinewood, a long-established project is underway to restore a wild forest, which is there for its own sake and is able to function as it needs to without concessions to economic viability.

When you look at a forest from afar, you can be captivated by its scale, its diversity and its beauty. When you enter a forest, you simply become part of it.

James McDougall, Forestry Commission Scotland, Edinburgh

ATLANTIC OAKWOOD, LOCH SUNART

Ardnamurchan, Scotland

This rich, temperate rainforest, festooned in lichens, mosses and liverworts, is found on the most westerly edge of the British mainland and is one of the rarest forest types in Europe. The Sunart Oakwoods Initiative is a community-based partnership working to protect and expand this rare woodland for both wildlife and local people.

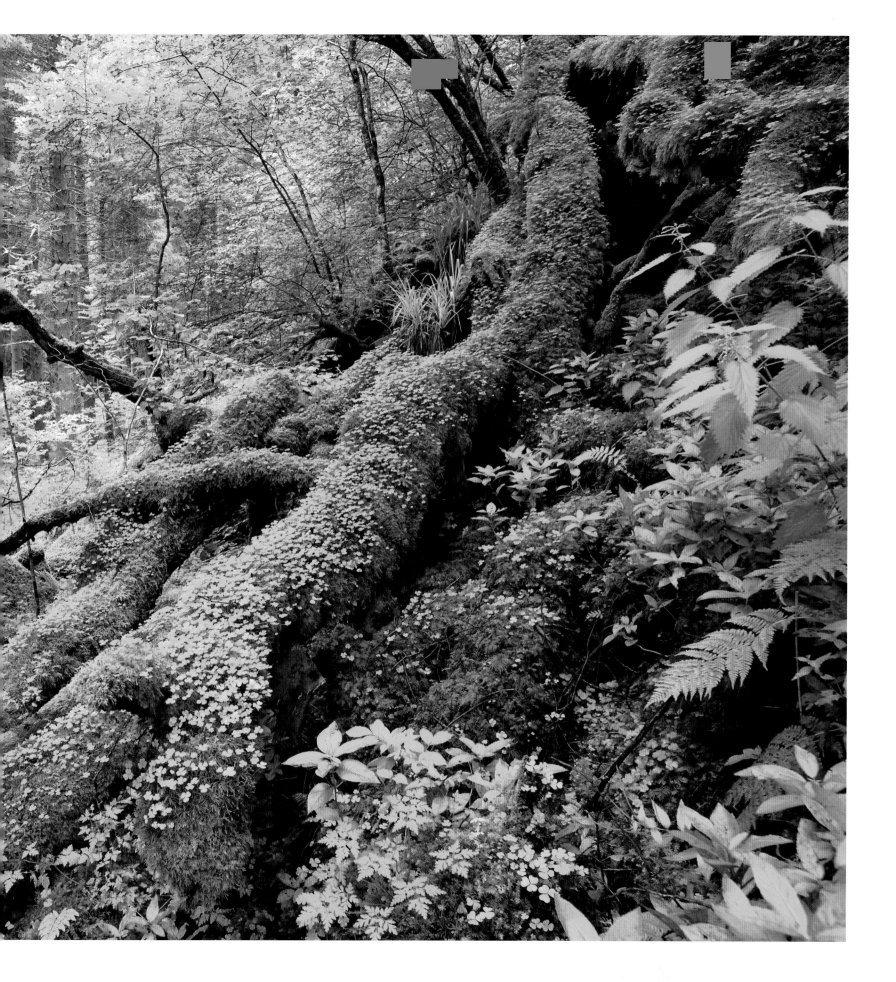

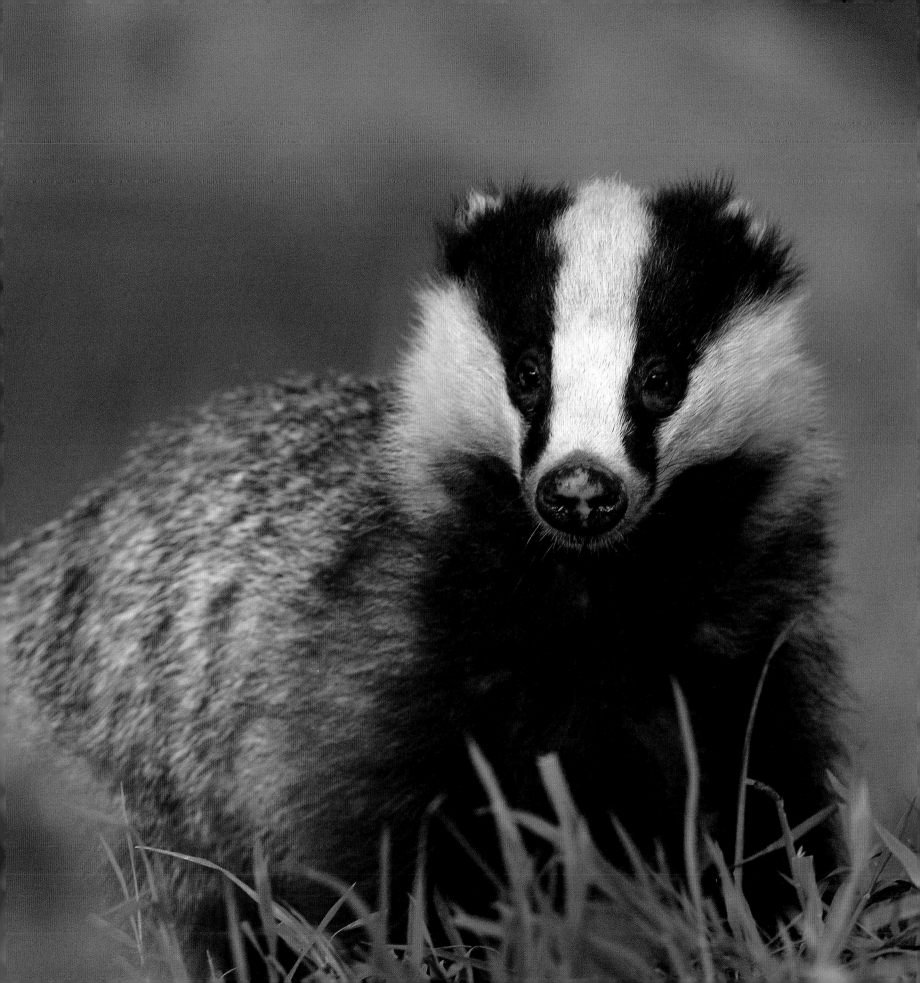

NATURAL REBIRTH ON A SOUR OLD HILL

SIR JOHN LISTER-KAYE, OBE, WRITER AND OWNER OF AIGAS ESTATE

Thirty years ago I bought a patch of sour old moorland on a Highland hill. For all its raw geological beauty it was a couple of hundred acres of wet, desolate land that had been burned and grazed, grazed and burned until there was nothing left but acid-loving un-nutritious grasses and rushes and a few clumps of stunted heather and sphagnum moss.

Once, a very long time ago, those acres had been climax forest, a tiny corner of the Great Wood of Caledon. It was forest cover of dominant Scots pine and downy birch; there would have been rowans and wild cherries, holly and sessile oak too, as well as an understorey of juniper, bilberry and heathers and a whole mosaic of wildflowers. It had soil. And with the dynamic, locked-in fertility of that forest humus came insects, bugs and worms, the essential invertebrate life-giving food for so many other forest organisms, ultimately all the way up the food chain to the birds and mammals of the forest: the pine marten and the red squirrel, the crested tit and the crossbill, the black grouse, the wild boar and lynx, the wolf, the brown bear, the fox, the badger, the golden eagle and the sheltering red deer stag.

But man had moved in and done away with most of that. It had all gone – every last bug and worm – drained away because the natural restoration processes had been cut off with the clear-felling of the trees and the relentless, merciless pressure of overgrazing. So I decided to act. I put on some Highland cattle to break things up a bit for a summer and a winter. Then I took them away and stood back. I left it to nature to do the rest.

Now, 30 years later, by the process of natural regeneration, I have a fine maturing birchwood with a rapidly expanding mix of pine, hazel, juniper, rowan, gean and bird cherry, goat willow and even a few aspen sprinkled in. I have a proper wood, some would say a forest. Every spring it bursts apart with birdsong. Roe deer drop their spotted fawns in its shady clearings among the broom; buzzards nest in the birches; and pine martens and badgers have moved in and made it their home. The black grouse are back. It is alive again, a rebirth brought about without a management plan or a budget, no drainage or grants or fences, no risk assessments or health and safety regulations, no scientific monitoring – in fact nothing at all except patience and a will to let nature do its thing.

I often show the old photographs to interested folk and I ask them 'How many options for people and wildlife were there in the sour old hill?' They look blank and answer 'None!' 'And now?' I ask again.

There is a living ecosystem – not yet complete, but coming along just fine. There is firewood and useful timber growing night and day, there are fruits and game, there is brilliant birdsong, there is an uplifting educational and recreational resource – something to set the human spirit soaring once again – and there is now plenty there for science to research and monitor.

But even more important than all those essentially human-focused benefits, there is soil again delivering invertebrate food, rebuilding the food chain. Earthworms trail their inches through the damp hollows, speckled wood and Scotch argus butterflies abound, gnats dance in the quiet air. There are nesting sites for dozens of bird species; there is shelter for deer and habitat for mice and voles in the rich field layer burgeoning with wildflowers. There is foraging ground for foxes and badgers and pine martens. Red squirrels again romp through the canopy and the sparrowhawks can always snatch a chaffinch among the birches; the tawny owl can always find a wood mouse or a vole. My wood is alive, it is singing and it is constantly building for its own future – and for ours. And it hasn't cost a penny.

The process is called restoration ecology – rebuilding and putting back ecosystems where we can. It's perfectly possible and is a win-win situation for everyone, if only we can connect properly with nature and find the will to achieve it.

BLUEBELL WOOD IN SPRING

Hampshire, England

Just as ancient woodland would once have carpeted much of the Scottish uplands, the same is true of lowland Britain, where the uplifting sight of a flowering bluebell wood would once have been much more common. As pressure on land use has intensified, the UK's lowland forest has become dangerously fragmented, just as we have begun to recognise that connectivity is key.

The forest isn't only important for its role in biodiversity and climate change, it is a place of childhood wonder, fiction and fantasy.

Jayne Boulton, zoo biologist

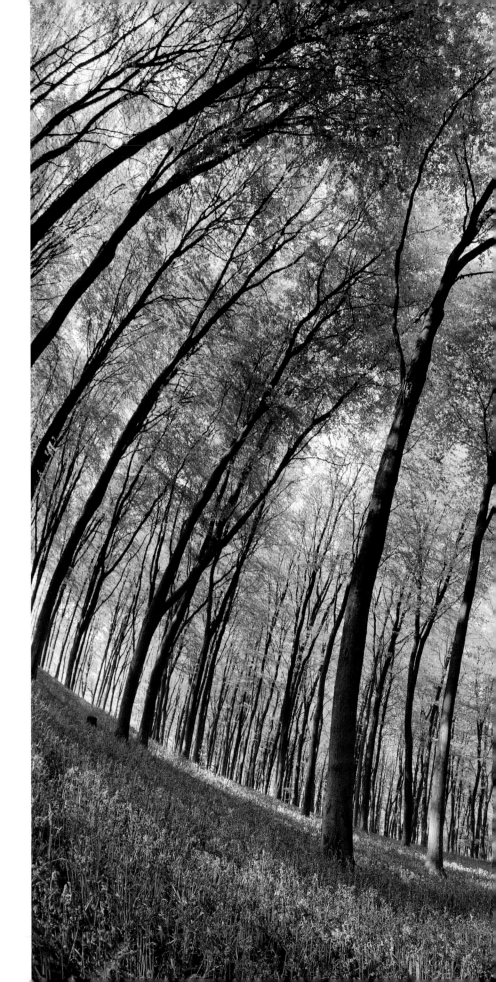

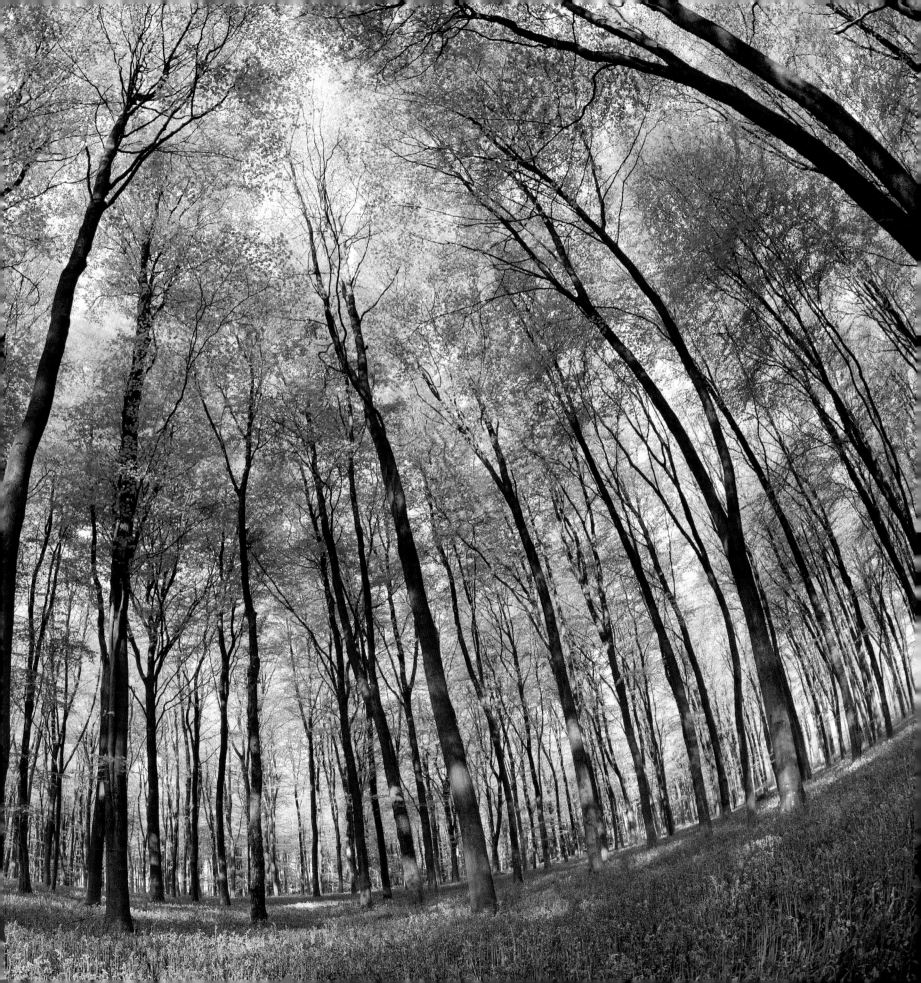

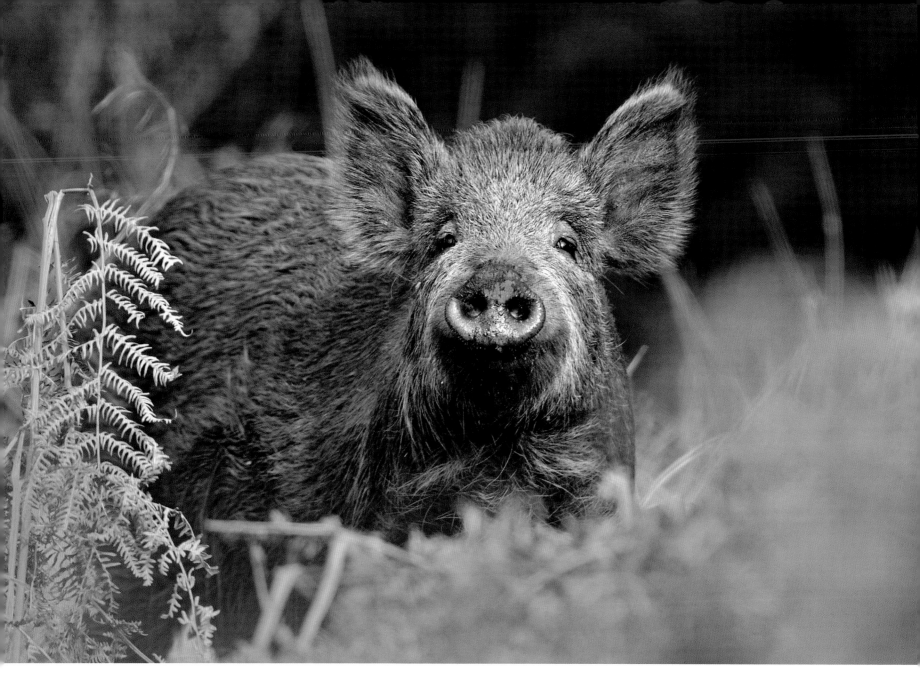

WILD BOAR SOW

Forest of Dean, Gloucestershire, England

The return of wild boar across many parts of southern England is challenging our tolerance to live alongside animals that we've grown used to not having around. Their rooting and digging can look destructive to our eyes, so accustomed to an orderly countryside, but they are forest engineers, exposing the ground to fresh seed and new growth. Managed imaginatively, these native woodland architects could become a valuable – and cheap – forest toolbox.

AUTUMN IN THE NATIONAL FOREST

Leicestershire, England

One of the country's boldest restoration projects, The National Forest covers 200 square miles of a previously predominantly industrial landscape in central England. This is a forest in the making, blending new and maturing woodland to effect change on a landscape scale. After just 20 years, the figures are already impressive: 8 million trees planted and woodland cover increased from 6% to 19%.

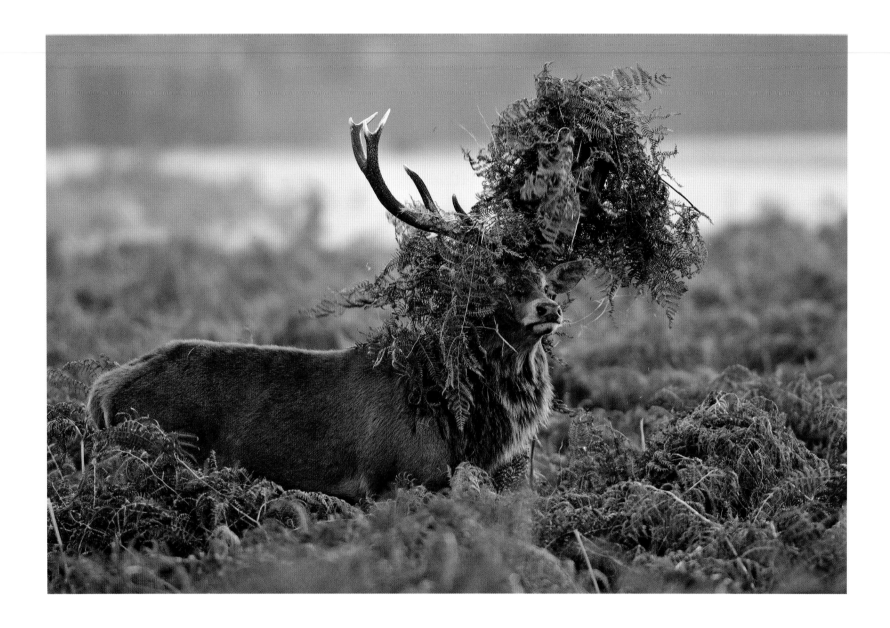

RED DEER STAG

Leicestershire, England

The National Forest is an inspiring example of big thinking. A richer, more diverse landscape is of obvious benefit to wildlife such as red deer, but this multipurpose forest will also provide fresh economic opportunities in sustainable forestry, agriculture, tourism and woodcrafts, not to mention the contribution to climate change and community health.

The change in the air, the smell, the feel underfoot: all this tells you that there are some places where the scales are always going to tip on the side of 'good'.

Sophie Churchill, Chief Executive, The National Forest Company, Derbyshire

Building a forest more or less from scratch, as with The National Forest, or repairing one that has suffered centuries of abuse like Scotland's Great Wood takes time, imagination and, of course, money. But more than anything, it takes the will to succeed. Throughout the UK that will is increasingly visible. Not only are there physical signs of a regenerating forest, there is a palpable energy, a spirit of collaboration within families, schools, businesses and local communities as well as conservation charities; there is pride in seeing the forest return. People are at the heart of piecing our forest's back together; they are investors in the big plan to rebuild our natural home.

Teacher on a school visit to The National Forest

The children experienced planting trees for themselves — they absolutely LOVED IT!

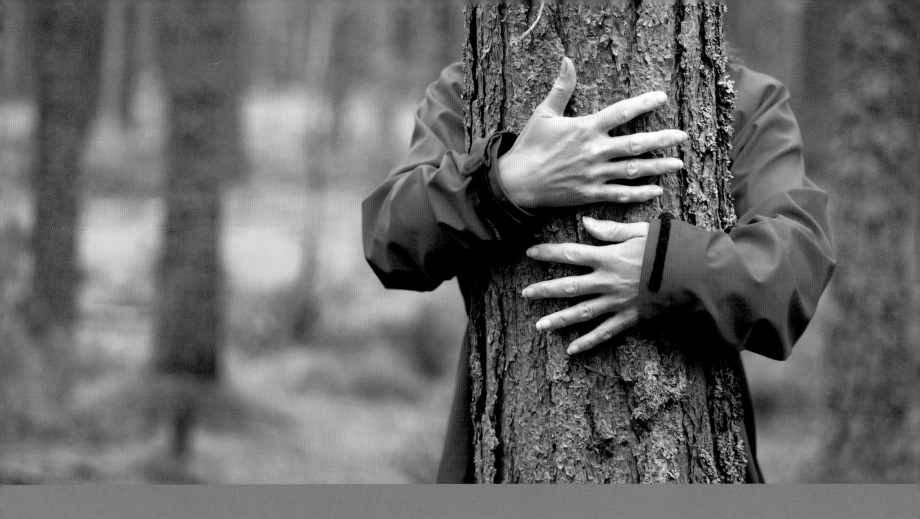

Forest in numbers

£1 billion: The value of social and economic benefits provided by UK forests each year.

250,000: The number of UK homes that could be heated by wood we already produce, reducing carbon emissions by 400,000 tonnes.

10 million: The number of tonnes of CO_2 that our forests consume each year.

13%: The area of the UK which is forested, compared with a European average of 44%.

167,000: The number of UK jobs provided by forests and woodland.

8,000: The number of hectares of new woodland created in the UK between 2010 and 2011.

350 million: The number of annual trips the British public makes to a forest or woodland.

200: The number of products harvested from our forests in addition to timber.

16%: The amount of wood we currently use which is grown in the UK.

£7.2 billion: The annual contribution to the UK economy from the forestry and wood-processing sector.

375,000: The number of children who have enjoyed environmental education sessions since the inception of The National Forest.

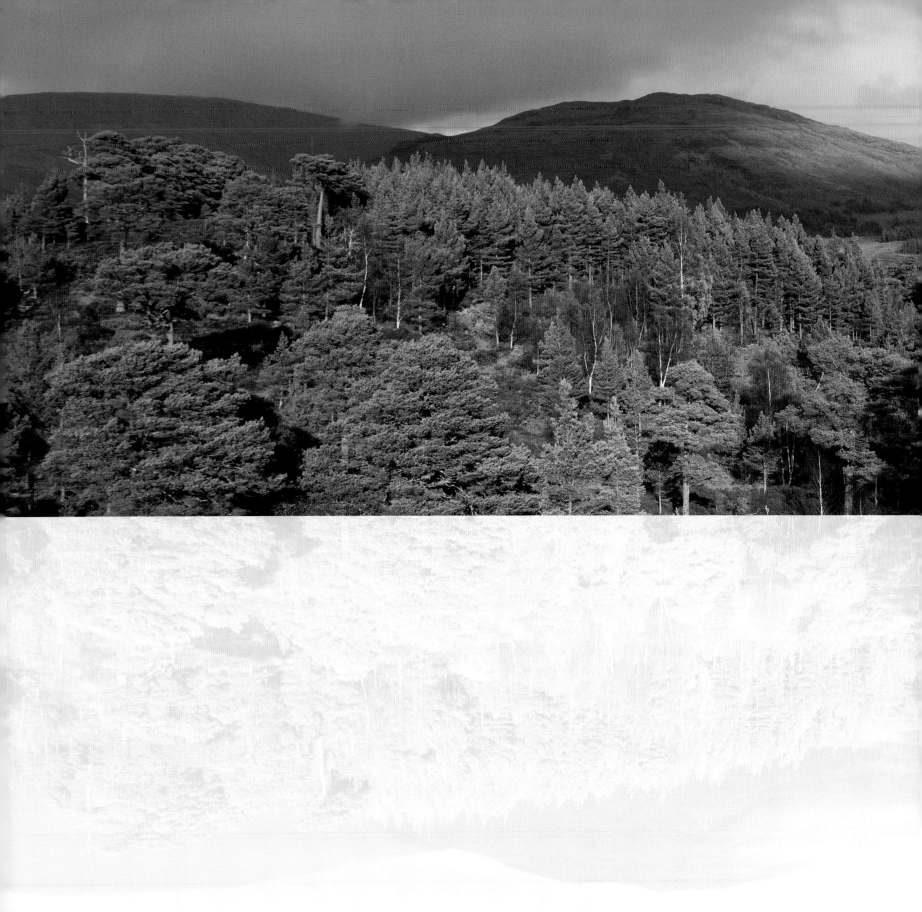

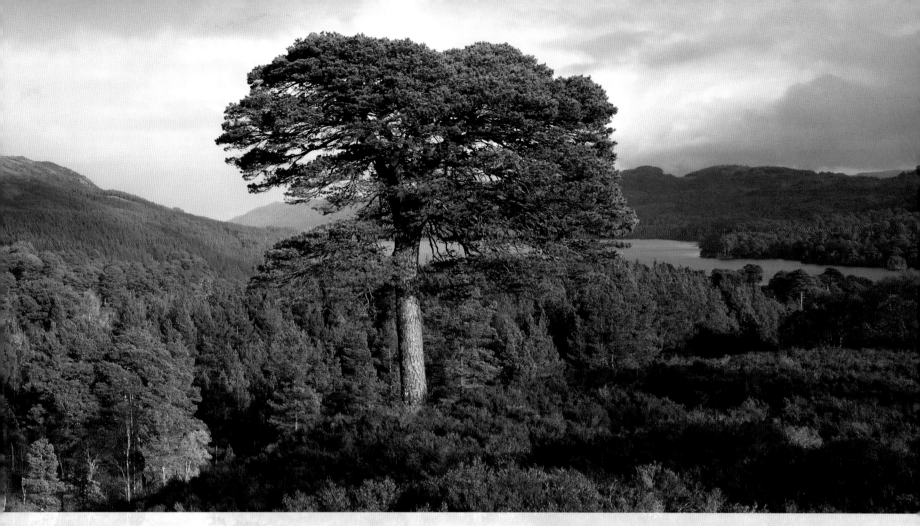

Carbon store. Air conditioner. Playground.

More than just a *forest*

More than just a…
PEAT BOG

INTRODUCTION

Sometimes it can be good to feel very, very small. The way you might do looking out over a sweep of desert or ocean, where what you see seems so vast you are tiny in comparison. And in that smallness, amazingly, you can get a sense of closer connection to land, sea and sky.

Big bogs can be like that. Britain's largest are huge, sodden flatlands that stretch for many miles in every direction. If trees grow there at all, they are few. So it's mainly the margins of such places that give a sense of distance: hills on a far horizon; the way you can see – just and no more – the curve of the earth.

That's part of why these sweeps of water-filled bogland are important. They're cool, in more ways than one, and can surprise us and give a fresh perspective on British and Irish wild landscape and life forms.

And wild they most certainly can be, those bogs that have survived in these islands until now.

The largest and wettest of them can be difficult to explore, with surfaces that quake perilously under your boots, pockmarked with water-filled holes that constitute a considerable hazard for the unwary. But precisely because they can be so challenging for humans to walk across, bogs can also be a haven for many kinds of wildlife. Choose the heart of a bog as a breeding or feeding place, and a bird, mammal or insect can survive without much risk of disturbance from casual passers-by.

Golden plover piping lovely, haunting whistles in the distance; a whirr and blur of dragonfly wings; the sound of a deer splashing along the side of a pool; a short-eared owl flying low over moss and heather:

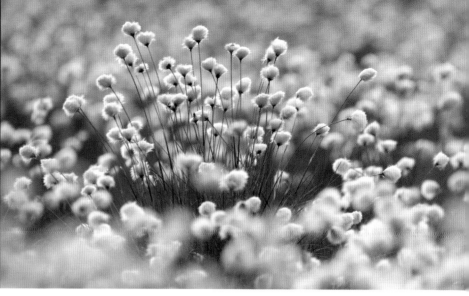

those are some of the sounds and images you could put in store from a visit to a healthy bogland. On the bog surface, insect-eating plants such as sundews can thrive, their leaves shining with sticky droplets (lovely to look at in the sunshine, but deadly traps to capture unsuspecting flies).

A bog in the so-called 'Flows' of Caithness and Sutherland in Scotland, or on Lewis in the Western Isles, has a core very far indeed from tracks and roads. These places are where the largest blanket bogs in Europe still cloak whole, low-lying landscapes. Blanket bog is one of several different kinds of peatland. It develops where a cool, wet climate favours the growth of many kinds of sphagnum bog moss. In a blanket bog, all the food for the growth of these simple plants comes from rainfall. And bog moss can hold an astonishing amount of water, with less solid material in it than is found in an equivalent measure of milk. Bog mosses also provide the key to how some other kinds of peatlands form, including raised bogs. These derive part of their water from the land surface and part from rain. Their surface can be a gently rising dome, studded with small pools. The patterns formed by open water in any kind of bog can look interesting, seen from above and at a distance. Close up, bogs are simply brilliant.

At some places, such as Flanders Moss in Stirlingshire, Scotland, which is now Britain's largest surviving raised bog, you can walk along sections of boardwalk to explore parts of the bog, or look at it from a viewing tower. That way, you can home in on the many colours of the mosses and other small plants. Cherry, wine, toffee, lime and buttercup are some of the tones you could see at close range. It's a carpet of living plants.

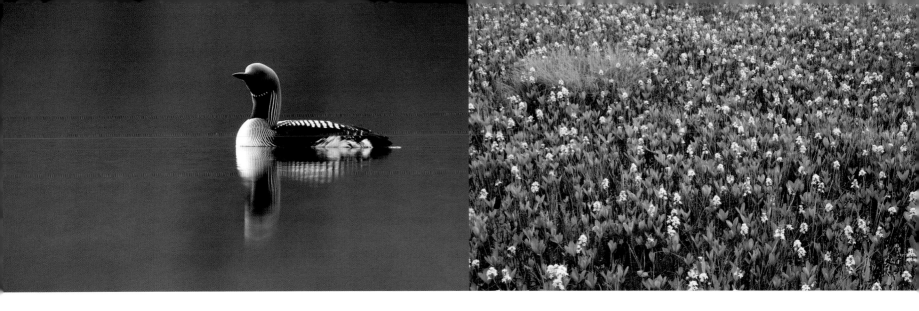

Beneath the carpet is layer upon layer of peat – the dark brown, gooey material formed from the gradual build-up of bog mosses and marshland vegetation. This includes trees, grasses, fungi and other types of organic matter such as insect and animal remains, which have been pressed down by the growth of living mosses above. In some places, this peat has grown over thousands of years. It is thought that most modern peat bogs formed after the retreat of the glaciers at the end of the last Ice Age, some 10,000 years ago.

In the past, peat has been used both to power small-scale domestic heating (as in many of the croftlands of the western Highlands and Islands of Scotland) and – through much larger-scale extraction – for both fuel and horticulture. Together with drainage and removal of peat to create farmland and housing areas, industrial-scale peat cutting has greatly shrunk the extent and expanse of UK peatlands. For a short while, planting of conifers in the Caithness Flows also damaged parts of the bogs there.

Many people have begun to realise that healthy bogs, in all their wild, wet oddity and beauty, are much more useful and productive than damaged ones. One reason for this is their value as a habitat for wildlife. But a major part is now based on knowledge of how much carbon they store.

In the oxygen-starved conditions beneath the surface of a bog, the plant material in peat (which absorbed carbon dioxide – a potent greenhouse gas – while alive) doesn't decay. It holds the carbon, for as long as it is wet. Peat can be nine-tenths water. But dry it out, and the carbon will be released, adding to the planet's greenhouse gas burdens.

Metre for metre, peatlands store more carbon than any other kind of habitat on earth. Globally, although they cover only about three-hundredths of the land surface, they hold twice as much carbon as all the trees in all the world's forests.

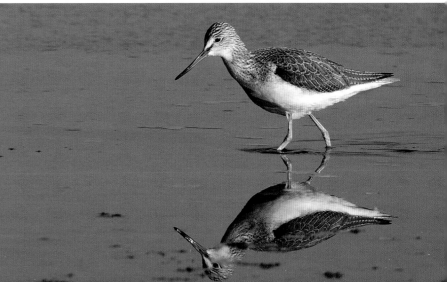

In the UK, peatlands are by far the biggest natural carbon store we have. They cover just under one-tenth of the land surface, which (amazingly for the size of these countries) represents more than one-tenth of all the peatland in Europe. But the best available evidence suggests that less than one-fifth of the UK's peatlands are undamaged by drainage, regular burning or cultivation. That's why there's now an extra urgency – and energy – in efforts being made by different groups to restore, conserve or even to expand peat bogs in Britain and in the Irish Republic.

While scientific studies of peatlands advance, practical action is being taken in many different places. Drains have been blocked, water levels raised, trees removed, peat extraction halted and bog mosses reintroduced as part of this process. Projects as far apart as the heart of the Irish Republic, Northern Ireland, Snowdonia, the Peak District and both central and northern Scotland have all been playing a part.

The cost of this restoration work is much lower than the long-term costs of leaving the peatlands damaged and depleted. And the earlier people get involved in helping to restore the bogs, the more cost-effective and far-reaching the work can be.

As well as doing a great deal to help maintain the peatlands in good health as vital carbon stores, this practical action can also reduce the costs of treating drinking water, since boglands can be very efficient at filtering out impurities. In some places, bogland can even provide new opportunities for tourism and nature studies, including through the possibilities for people to see some unusual wildlife.

Golden plover, dunlin, dragonflies, eagles and bog rosemary, plus sphagnum plants by the billion, have already benefited. The soggy, splendid bog moss carpets may have been allowed to wear thin. But, with help, they can still be magic.

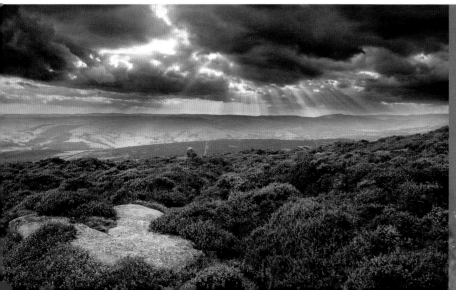

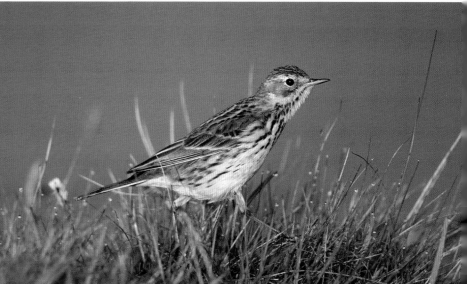

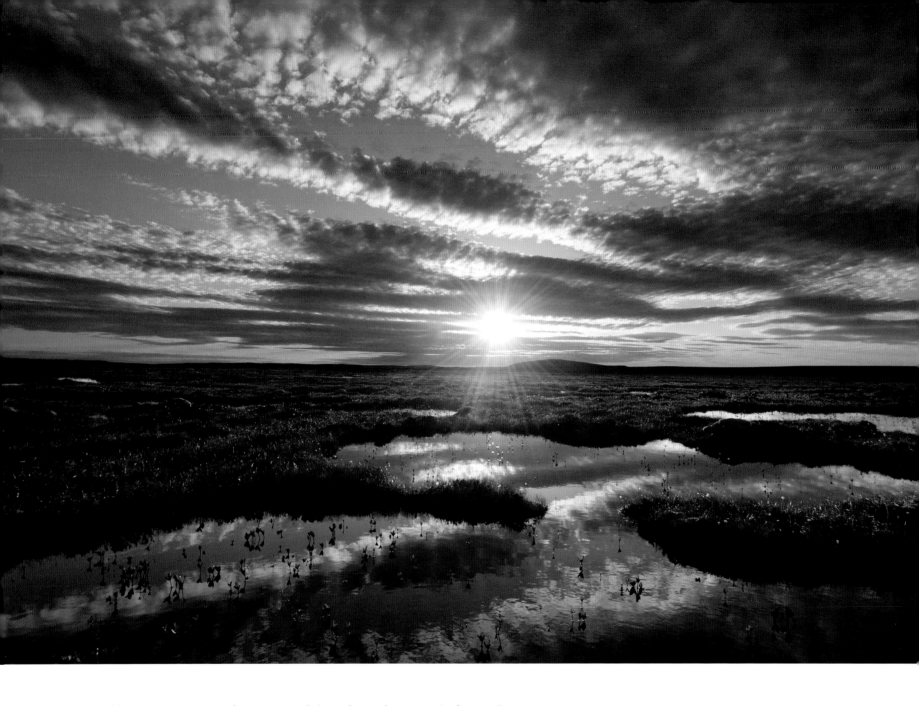

Walking across the vast blanket bogs of the Flow
Country with 8,000 years of history beneath your feet
makes you feel suitably insignificant.

Norrie Russell, Site Manager, RSPB Forsinard Flows, Sutherland

Sutherland, Scotland

Caithness, Scotland

The Forsinard Flows is the most extensive blanket bog in the world. Covering 4,000 square km, the Flow Country is one of the RSPB's Futurescapes, a portfolio of UK-wide restoration projects which will provide rich habitats for a wide range of specialised wildlife.

Of all the unique species associated with the Flows – and there are many – few are as symbolic as the red-throated diver, its haunting call a soundtrack to the wild north and a reminder of the need for ongoing repair work to degraded blanket bogs throughout the UK.

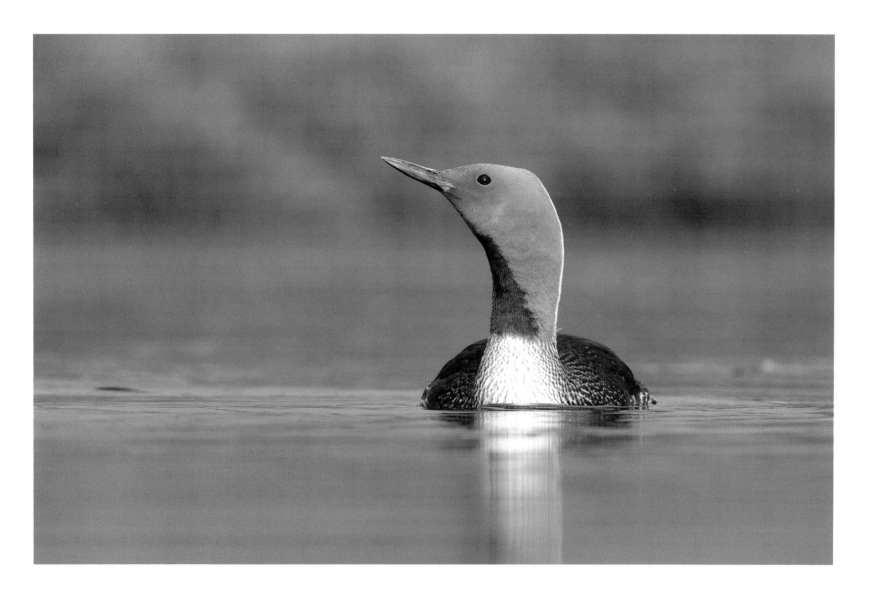

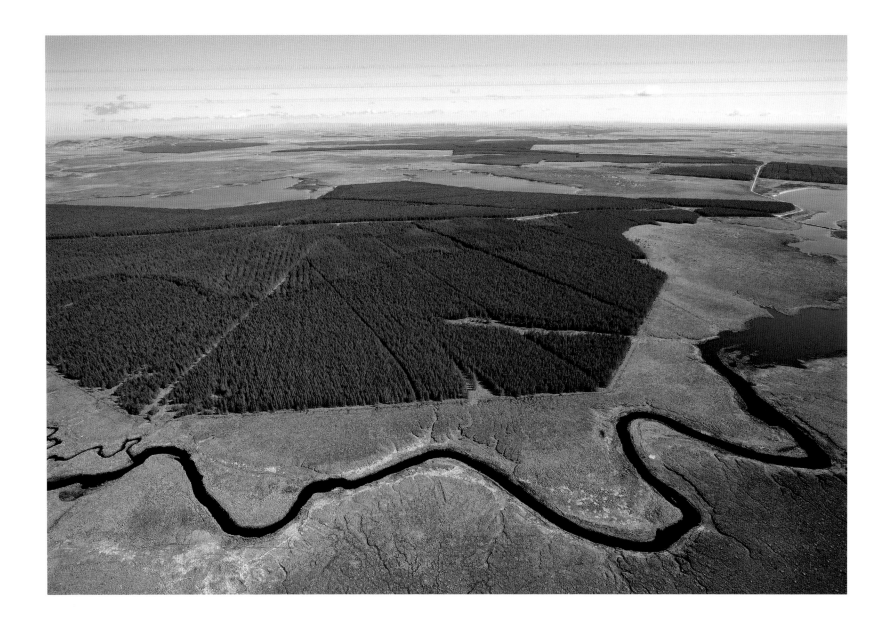

FORSINARD FLOWS FROM THE AIR

Sutherland, Scotland

Only from above can we truly appreciate the complexity and extent of Scotland's Flow Country and the scale of restoration required. The inappropriate planting of huge conifer blocks along with the creation of drainage ditches have dissected and drained the bog; although 2,000 hectares of blanket bog have already been restored through felling and drain blocking, the re-wetting of the peat and the locking of its precious carbon will take many years yet.

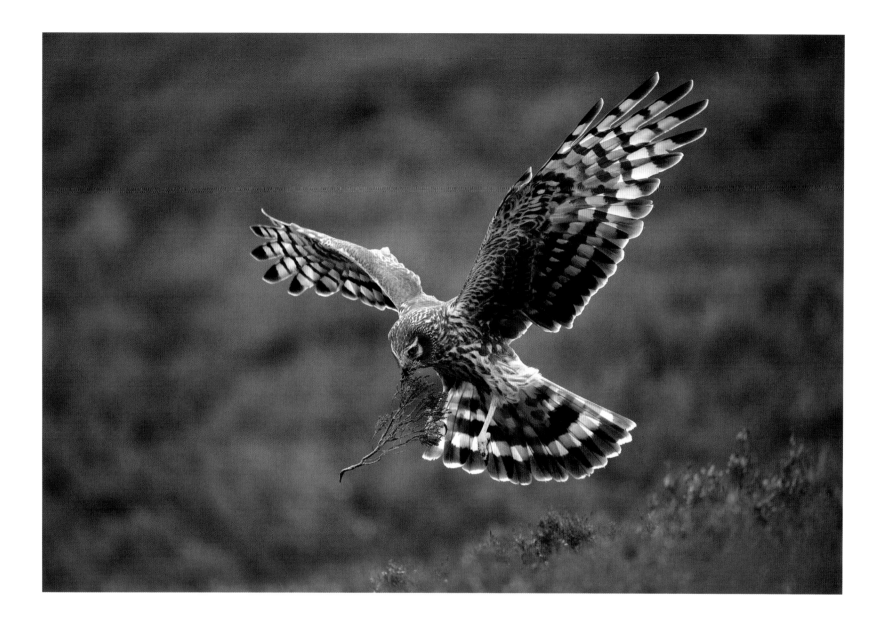

HEN HARRIER BRINGING IN NEST MATERIAL

Sutherland, Scotland

Hen harriers breed in relative peace in the Flow Country. Elsewhere their predation on red grouse can impact on shooting revenues. Although legally protected, their expansion relies not only on habitat restoration, but also on a willingness to accommodate their presence on grouse shooting estates.

Walking the Flows, with rod or camera or sometimes both, is as close to heaven as I'll probably get.

Steve Taylor, fisherman and photographer, Sutherland

BALLYNAHONE BOG AT SUNSET

County Antrim, Northern Ireland

This Ulster Wildlife Trust Reserve is the country's second-largest raised bog and was partially drained for peat extraction in the early 1990s. Following protests from Friends of Ballynahone Bog, the peat company was forced to block the drains it had dug and, in 1995, Ballynahone became an Area of Special Scientific Interest.

If you're looking for a true wilderness experience, get yourself to the middle of an undisturbed peat bog.

Niall Benvie, 2020VISION photographer

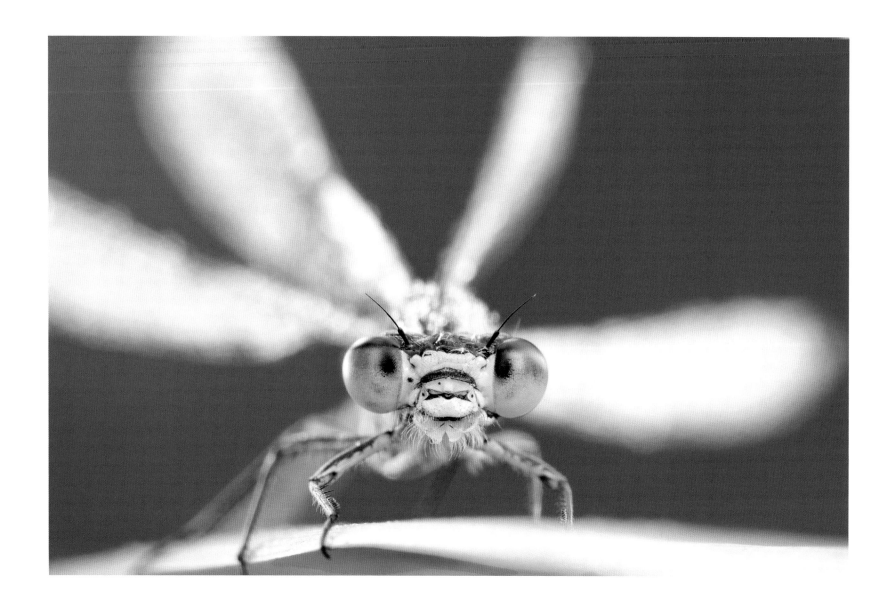

COMMON BLUE DAMSELFLY

England

A healthy peat bog is alive with insects in the summer. Large numbers of dragonflies and damselflies breed on upland moors and bogs, providing essential food for waders and grouse. But the drying out of the UK's peat bogs, primarily through drainage, is not only damaging to wildlife, it ultimately weakens one of our most powerful tools in combating climate change.

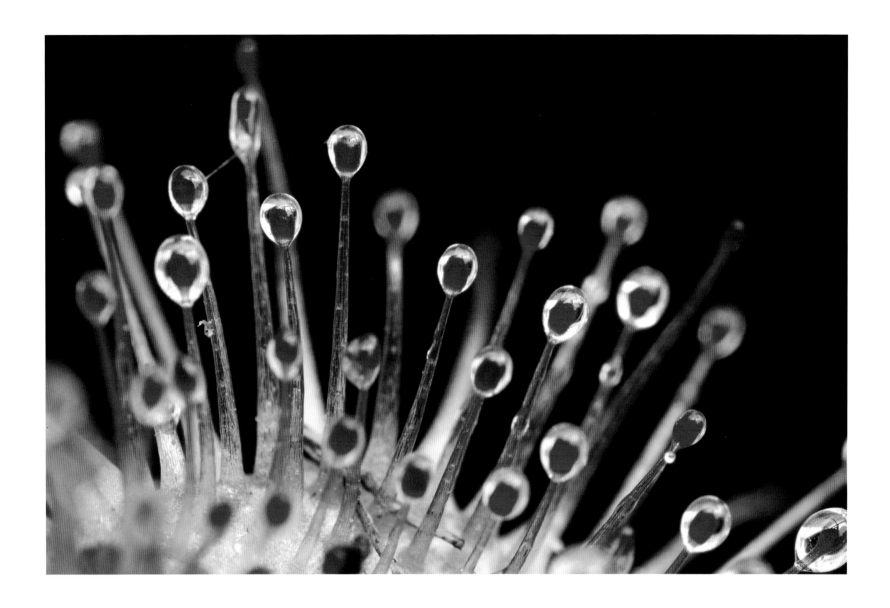

SUNDEW IN SUMMER

Peak District, England

It is estimated that the loss of only 5% of the carbon stored in our peat would equate to the UK's total annual greenhouse gas emissions. Against such a startling backdrop, the significance of insects and specialised peatland plants can seem irrelevant, but it is that very community of living organisms that creates carbon-locking peat.

*These environments are of incredible value to us as a nation and globally –
there is wildlife that lives here that lives nowhere else in the world.*

Mark Reed, Sustainable Uplands project, Aberdeen

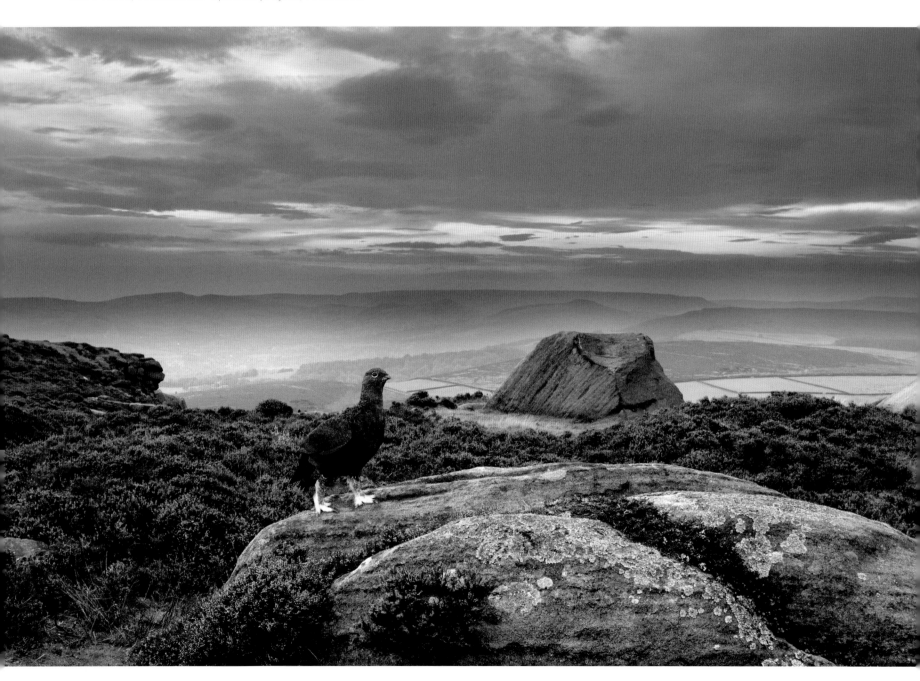

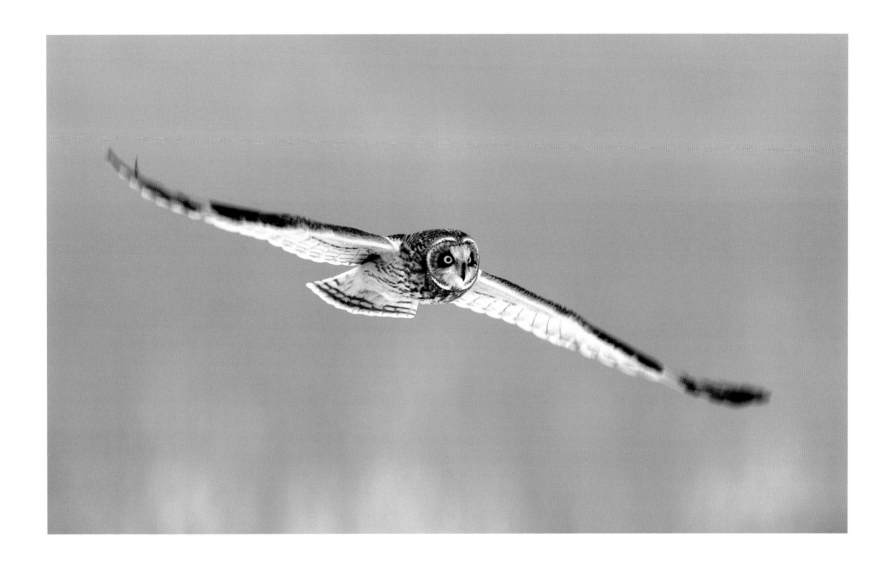

RED GROUSE

Peak District, England

Restoring peatland and blanket bog in the Peak District is a big job needing a big commitment. The Moors for the Future project is a partnership of organisations working to restore this fragile upland habitat for the benefit of myriad species, red grouse being one...

SHORT-EARED OWL IN FLIGHT

Peak District, England

... and short-eared owl another. The presence of predators on peatland, though contentious in some areas, is a barometer of the health of the ecosystem; these are species that indicate a plentiful food supply and are part of an intricate jigsaw of life.

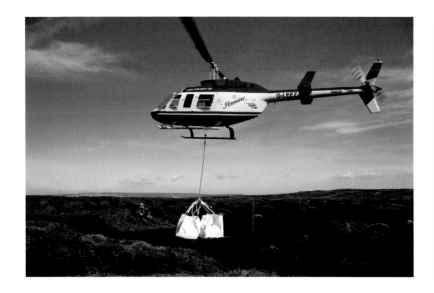
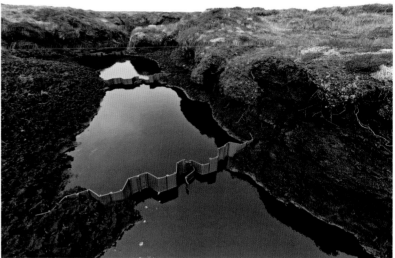
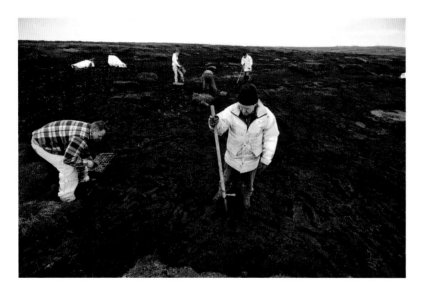
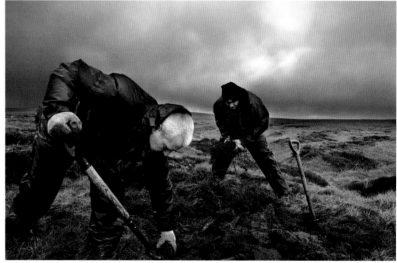

RESTORATION IN ACTION

Kinder Scout, Peak District, England

The National Trust's Peatlands for the Future project on Kinder Scout is another example of ambitious repairs to nature in action. In heavily eroded areas, artificial drains are being blocked to raise the water table, helicopters are flying in heather brash to provide a seed source, and cotton grass is being planted manually – 100,000 individual plants to date.

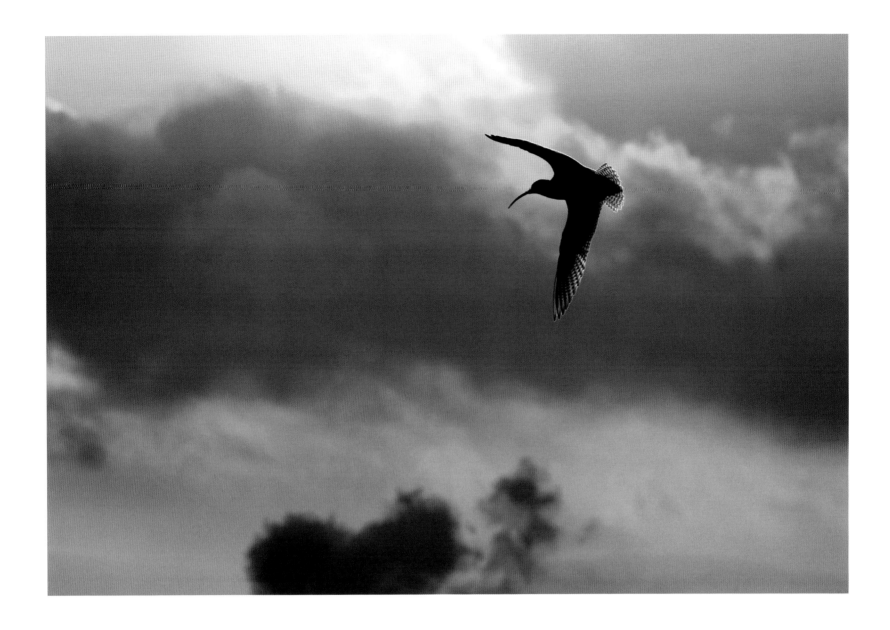

CURLEW AT DUSK

Peak District, England

Re-assembling the complex biological communities that make up diverse peatlands is a major investment but one that makes complete sense. It's not just wildlife that prospers as a result; healthy peatlands lock up carbon, help reduce flood risk and improve water quality.

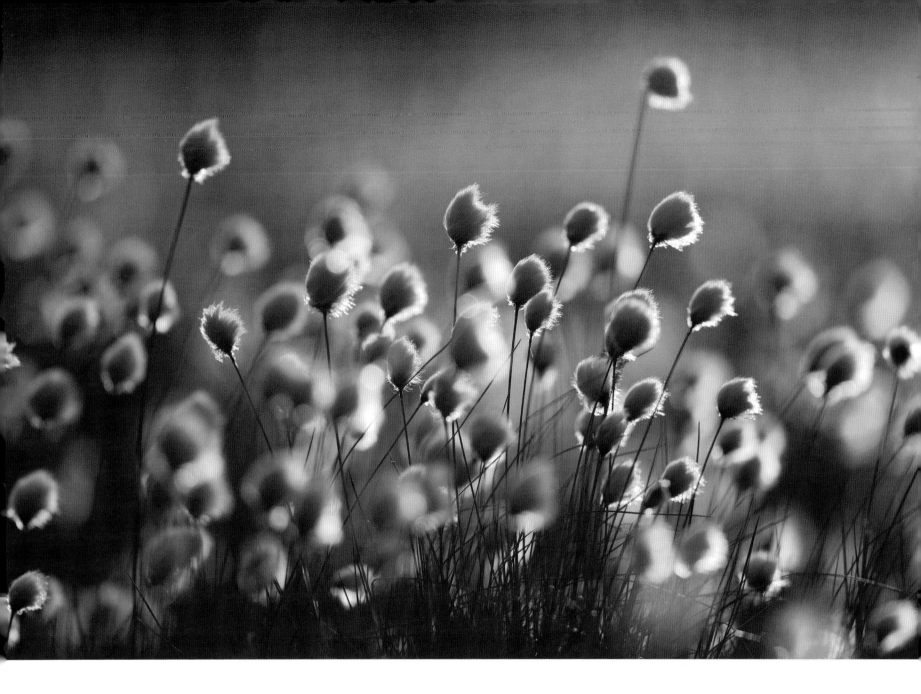

HARESTAIL COTTON GRASS IN EVENING LIGHT

Flanders Moss NNR, Scotland

The complex plant communities that form healthy peatlands and bogs are sensitive to a wide range of factors including atmospheric pollution. Understanding the needs of peat-forming plants such as Sphagnum moss, the glue that holds bogs together, as well as other peatland specialists like cotton grass, is vital in establishing how effective large-scale restoration can be.

Bogs are cool and clean, sanctuaries of simplicity yet incredibly important for storing CO$_2$. Gareth Browning, Wild Ennerdale project, Cumbria

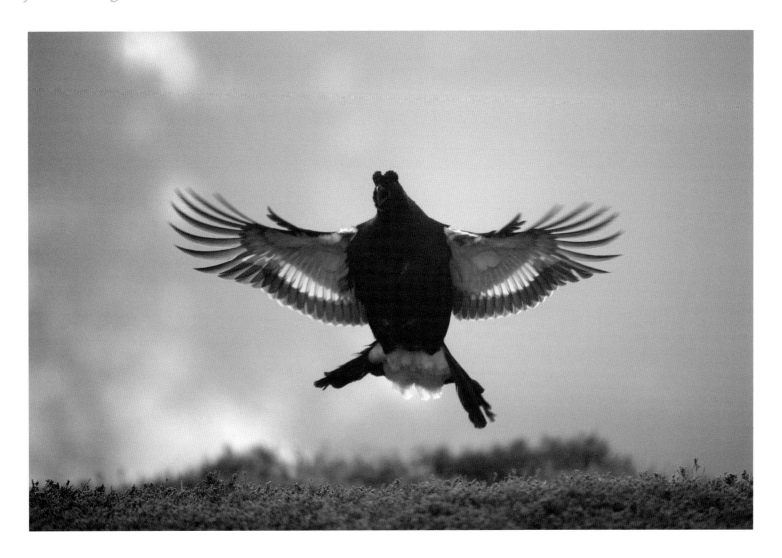

DISPLAYING MALE BLACK GROUSE

Grampian Mountains, Scotland

One of the dangers of over-categorising different habitats is that we lose sight of the 'edge effect'. Species such as black grouse thrive in a mosaic of habitats, often including the edge between forest and bog, where insect life is rich. The Living Landscape approach now widely adopted by Wildlife Trusts across the country is encouraging fresh thinking about weaving different habitats together, merging the physical lines between different land uses and breaking down the cultural barriers between people and nature.

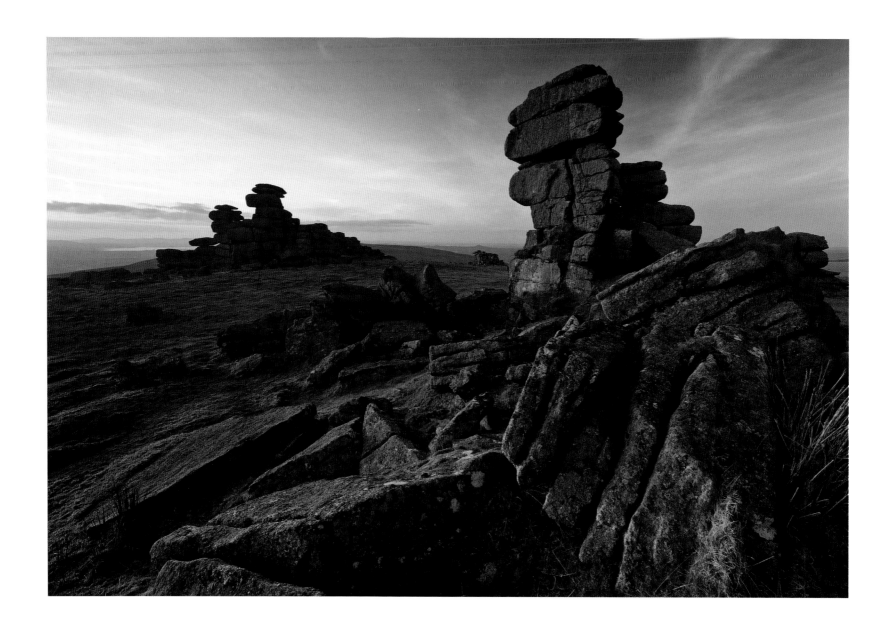

GREAT STAPLE TOR AT DAWN

Dartmoor, England

In the south-west, degraded peatlands are being re-wetted on both Exmoor and Dartmoor through the Mires on the Moors project, part of the wider International Union for Conservation of Nature UK Peatland Programme. Repairing whole landscapes doesn't come cheap, and this project is partly funded through water customers' bills, but the longer-term payback is a cleaner, more plentiful water supply.

Peat bog in numbers

50%: The amount of the UK's soil carbon in peatlands.

50,000: The number of Sphagnum moss plants found in 1 square metre of bog.

94%: The amount of the UK's lowland peat bog that has been lost.

1mm: The depth by which peat 'grows' each year.

95%: The water content of a peat bog.

2,200 hectares: The area of drained bog being restored at RSPB Forsinard Flows through blocking drains.

50: The number of years that a carnivorous sundew plant can live.

1.5 million: The number of tonnes of carbon a year that eroding British peat bogs may be emitting – equalling the emissions from 400,000 family cars.

4,000 square km: The area covered by the Flow Country in Caithness and Sutherland, Europe's largest blanket bog.

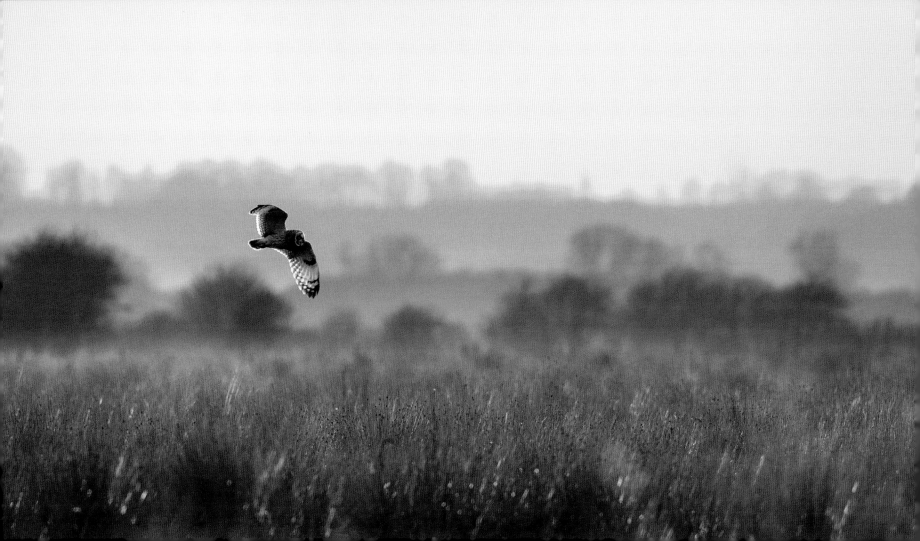

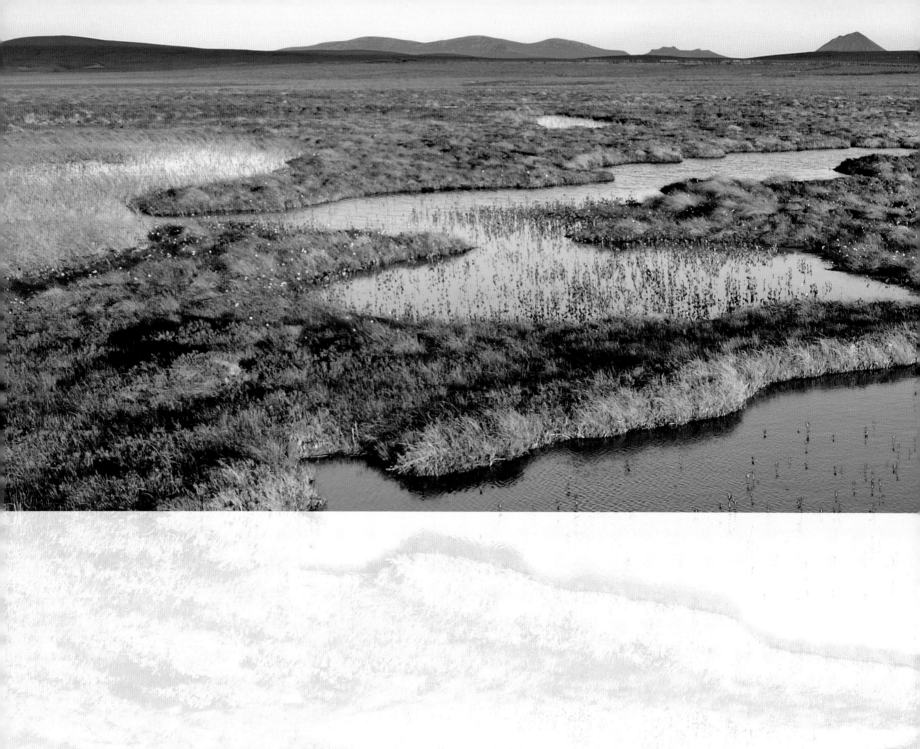

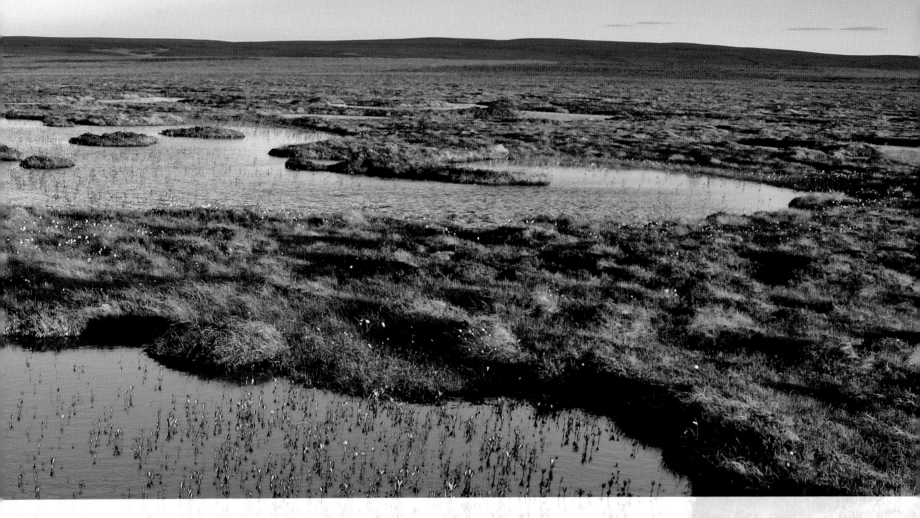

Carbon trap. Cistern. History classroom.

More than just a *peat bog*

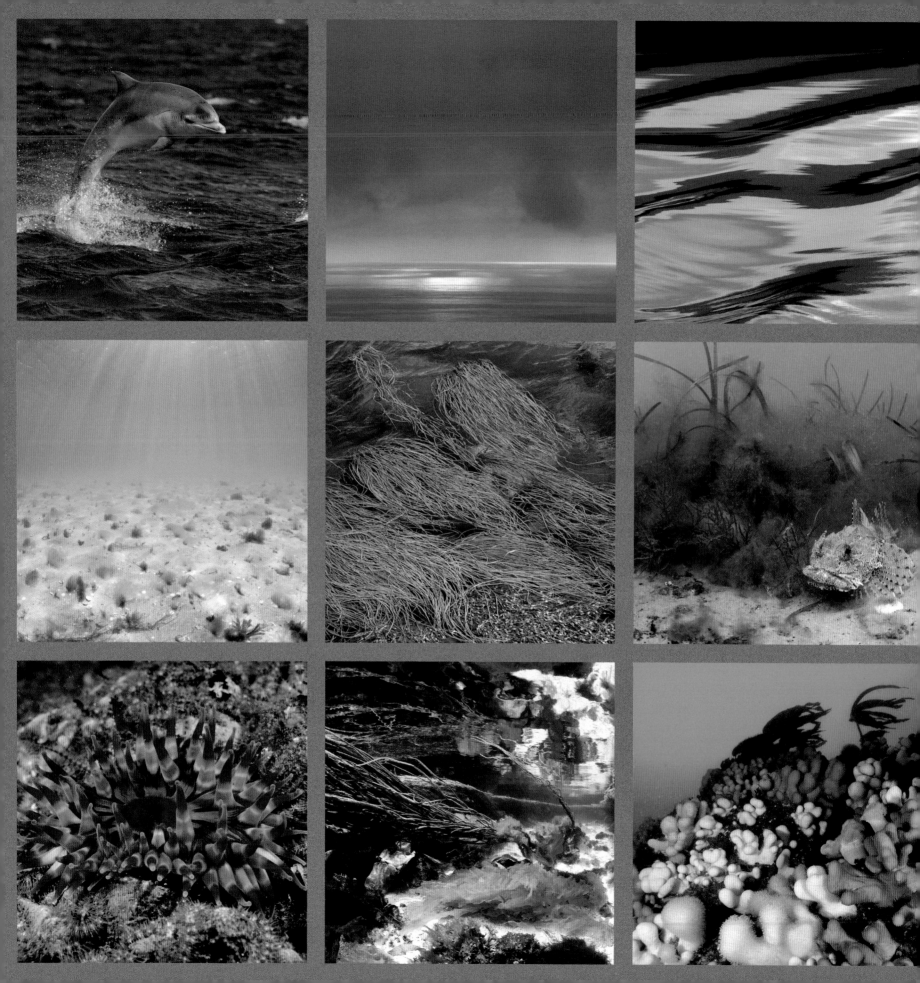

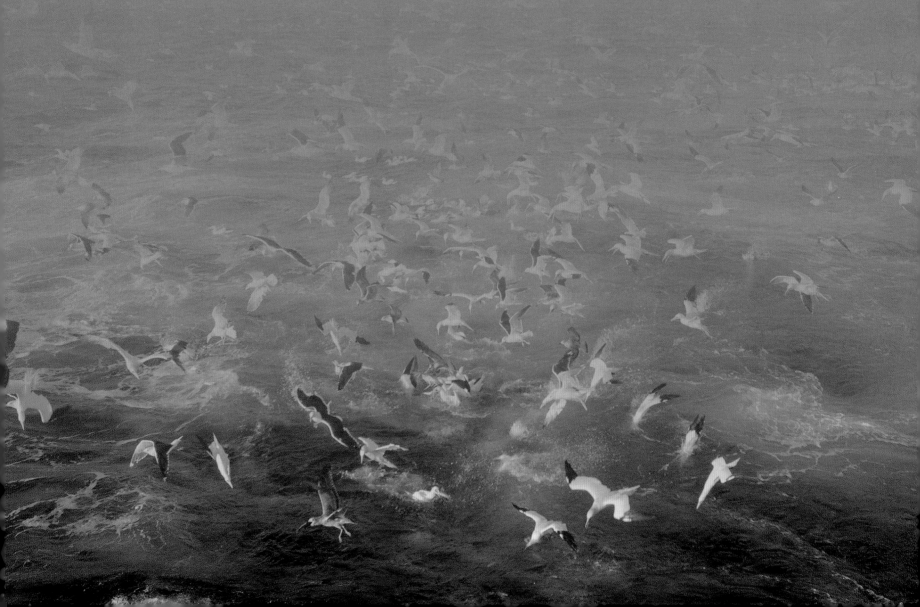

More than just the…

SEA

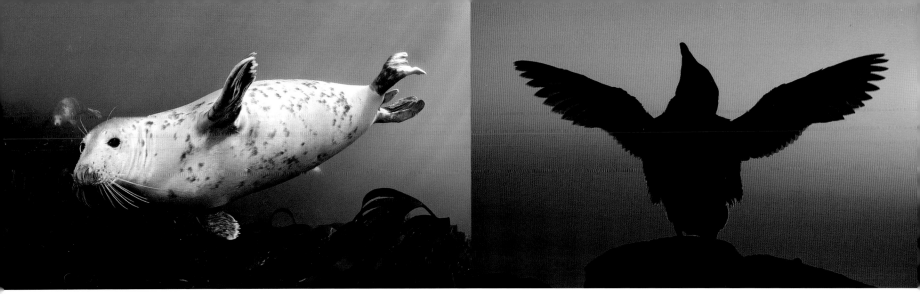

INTRODUCTION

Sea defines the UK, not only in terms of geography, but in how whole groups of people think of themselves. On a large scale, that could be any one of the countries of Britain and Ireland. At a local level, it could be an island community, close to other islands, but proud of its distinctiveness.

Sea channels great and small have both separated us from others and formed seaways for crossing, trade and other contact. Melting of the last ice sheets saw the final flooding of the divides that separate England from France; Wales and Scotland from Ireland. And a huge, underwater landslide off Norway, over 8,000 years ago, pushed the last land link between Britain and the continent underwater, as the North Sea took its present form. These marine divisions set Britain and Ireland apart, including their varieties of wildlife and plants. Since then, the nearness of sea and ocean has continued to have a major influence on climate, vegetation and cultures here. That includes the way in which Viking raiders and settlers made a lasting mark, over many centuries, on language, land use and traditions in the west and north of Scotland, the north-east of England and parts of Ireland.

People have always benefited from the bounty of both the sea and the coasts here, whether they were hunter-gatherer-fisher folk in the Middle Stone Age or the crew of a multimillion-pound trawler in the present day, kitted out with satellite and computer-linked fish-finding hardware.

The harvest could be as simple as edible molluscs taken from the shore, crabs and shellfish caught inshore with more effort, or fish of many kinds taken from deeper offshore in voyages that could be so risky that many a fisherman has drowned in plying his trade.

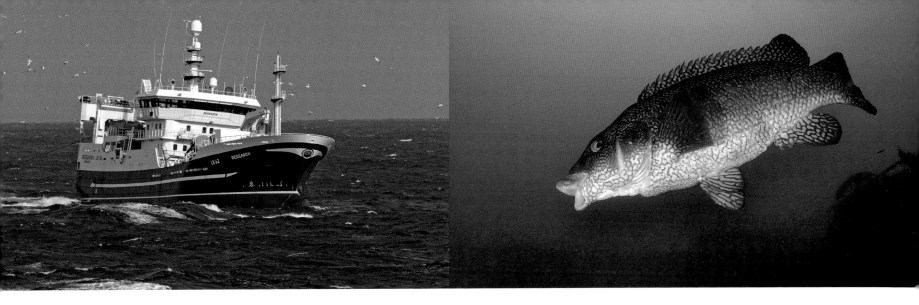

More than 330 kinds of fish live in the seas around Britain and Ireland. In the past, the abundance and size of some of these were almost beyond belief, compared with stocks in the present day. Herring by the billions, the wealth from their capture supporting coastal economies from Shetland to East Anglia, were part of that picture. So too were cod that could be as big as an adult man, taken from fishing grounds in the North Sea and Atlantic where it once must have seemed that the waters would pay out without end, like salt-sprayed slot machines on a jackpot roll.

But times have changed, with many fish stocks both in the UK and across the world drastically reduced and under continuing pressure. In the recent past, the scale and sheer efficiency of some of the modern catching methods have been part of the problem. Efforts to control the size of catches, through internationally agreed quotas, have been difficult for different interest groups to agree on, but are now in place for commercially important fish species in British and Irish waters.

Huge efforts have been devoted to making our remaining fisheries more sustainable. Regulations have been part of that, but so too have been high-profile, TV-linked campaigns to reduce the crazy amount of fish discarded in the North Sea as 'by-catch' because of EU regulations.

A challenge that will be even trickier to face is the gradual warming of seawater, which can make economically valuable cold-water fish, such as cod, move north. The same is true for cold-water fish such as sand eels, which are staple food for many seabirds, whales and other kinds of marine wildlife.

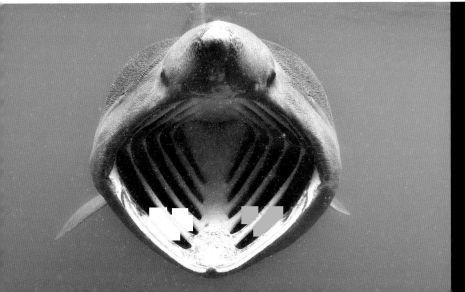

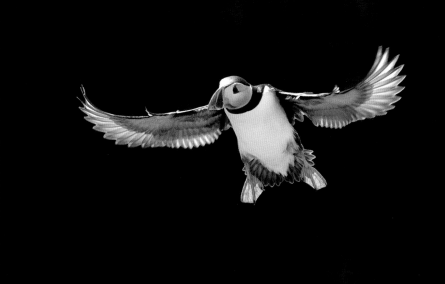

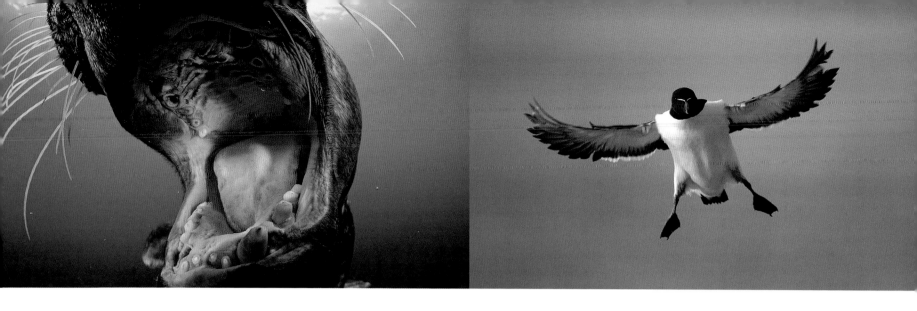

As fish stocks change, so coastal communities have changed and the harvest of marine life altered. Many places that were once thriving fishing ports now hold far fewer vessels, while along North Sea coasts, the west of Scotland and the Irish Sea, effort has shifted from offshore hauls of fish towards the inshore catching of shellfish such as Dublin Bay prawn. In part, this is because of long-term declines in many stocks and because of efforts to restrict catches of 'fin' fish, such as cod, to help the shoals recover some of their former strength.

The most valuable offshore fin fishery in the UK is now for mackerel, mostly caught by boats operating from Scotland. At the moment, stocks of mackerel are abundant. And the good news (in an industry that often has little cause for celebration) is that the fishery for them seems to be well managed, with very little by-catch. Fisheries and fish stocks may always be hard to manage, but the sea is now providing a new bounty for some coastal communities. For them, the challenge and the economic opportunities are coming not from catching but from watching what lives on and under our coastal waters.

Coastal recreation has changed in ways that would have seemed incredible only a few decades ago. We're not talking sandcastles on the beach or grit in the sandwiches, but nature-based tourism. Worldwide, for example, whale watching, an activity focused on observing and enjoying these animals, not hunting them, began less than 60 years ago. Now it is worth billions of pounds internationally every year.

In the last 30 years, Scotland has been an important part of that global picture, with both the Isle of Mull, off the west coast, and the Moray Firth, near Inverness, becoming major centres for watching whales and dolphins (cetaceans), both at sea and from the land. The waters off the west of Scotland are among the most important in

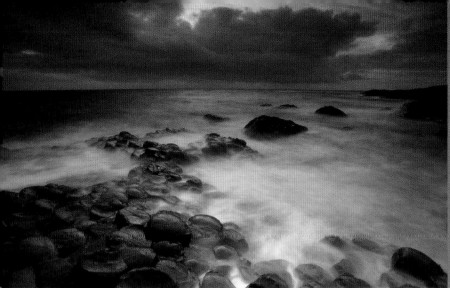

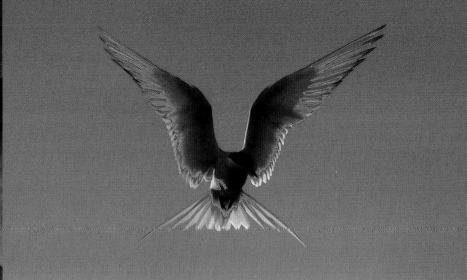

Europe for cetaceans. A couple of dozen different kinds use them, from the harbour porpoise (the smallest) to the blue whale, the largest creature ever to have lived.

Near Mull, minke whales are among the big cetaceans that use waters fairly close to the shores of this and neighbouring islands and headlands in summer. Add the several million pounds that other stars of the Mull wildlife scene – the breeding population of reintroduced sea eagles, for example – are worth to the local economy each year, and it's easy to see how a healthy environment, including healthy seas, can support the wellbeing of some coastal human communities.

Making links to a different kind of wellbeing – the sheer physical feel-good factor for body and mind that can come from closeness to the sea and coastal exploration – is part of the plan elsewhere. In recent years coastal paths have been made good and mapped,

opened and publicised in many places around Britain. These are helping visitors to enjoy scenery and explore wild areas they might not otherwise have considered in the past, and so also contribute to fragile coastal economies.

The longest and boldest route of all has got to be the All Wales Coast Path. Opened in the summer of 2012, it was developed after a huge amount of co-operative effort, involving (among others) the Welsh Government, 16 local authorities and two National Parks. The result is a wonderful 1,400km continuous route that will allow people to walk the entire Welsh coastline in all its wave-splashed, bird-loud, breezy beauty.

There's no other country in the world where you can do that with such help, information and backing from everyone from local landowners to a national government. It's inspirational: a breath of fresh air and sea spray. Just as a sea coast should be.

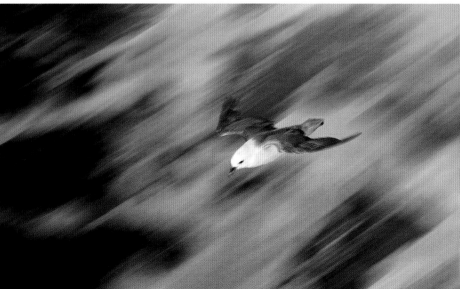

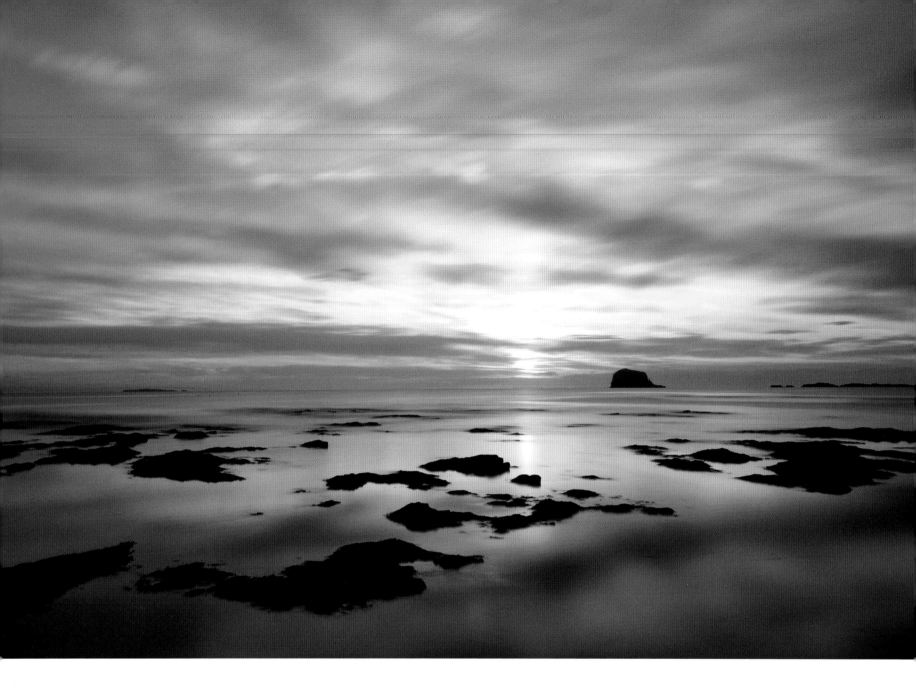

The sea is the heart of the community and is full of nature's secrets.

Rachael Melvin, boat tour guide, Firth of Forth

BASS ROCK AT DAWN

Firth of Forth, Scotland

A small, dome-shaped volcanic plug is silhouetted against the dawn sky. From January onwards the Bass Rock, just offshore from North Berwick, turns gradually white. At the height of the breeding season, 150,000 gannets carpet the rock, turning it into what Sir David Attenborough called 'one of the wildlife wonders of the world'.

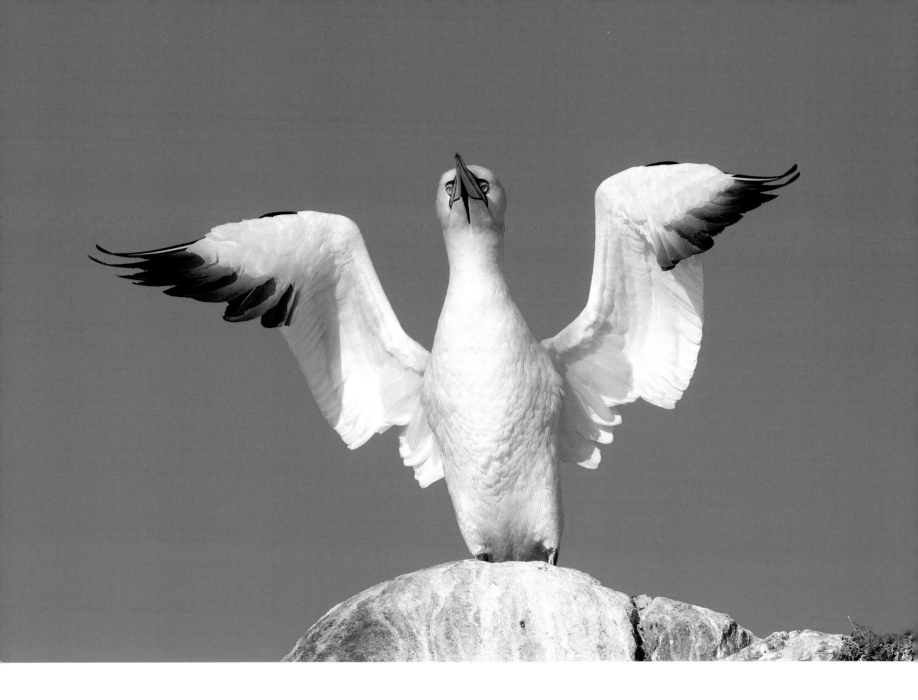

GANNET

Bass Rock, Firth of Forth, Scotland

As our perceptions and attitudes change, so too does the way in which we look upon and use our precious marine resources. In recent years, public appetite to get up close and personal with wild animals has ignited exponential growth in wildlife tourism. In the Firth of Forth, this has become something of an industry, with the gannets of the Bass taking centre stage.

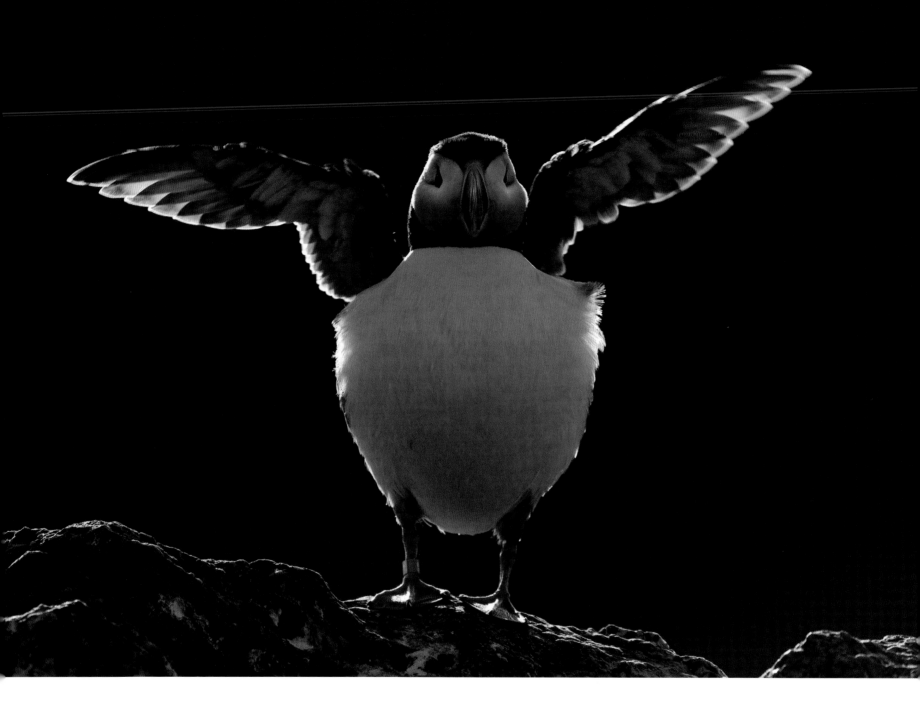

PUFFIN STRETCHING

Farne Islands, Northumberland, England

Puffins are front-cover birds, the media superstars of the wildlife world. Cute, clown-like and approachable, they have all the necessary credentials for their role as seabird ambassadors. But behind their appeal as tourism icons, puffins, as well as other seabirds, are indicators of the health of our seas – just like us, they are part of the marine food chain.

Seabird tourism has become big business. The Scottish Seabird Centre in the coastal town of North Berwick provides visitors – all 270,000 of them – with an annual gannet fix, a unique view into the lives of these ocean wanderers. Further down the coast in Seahouses, hotels, restaurants, pubs and boat operators all benefit from the nearby Farne Islands and their bountiful wildlife.

The Seabird Centre brings in around £2 millon to the local economy.

Tom Brock, Chief Executive,
Scottish Seabird Centre, North Berwick

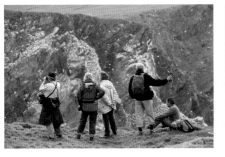
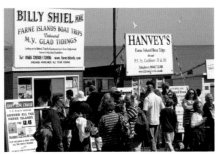
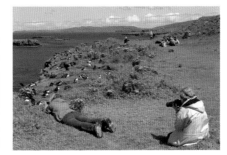
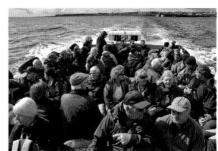

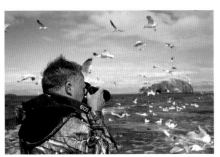
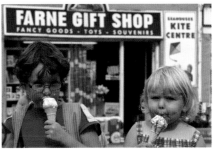

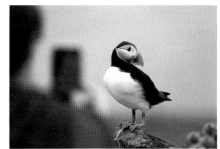

Puffins rely on their charisma and enormous numbers, but on Scotland's west coast, the reintroduced sea eagle, the third-largest eagle in the world, cashes in on its sheer magnificence. On the island of Mull, sea eagle tourism is reportedly worth over £5 million to the local economy, while in Portree on Skye the sea eagle has become not just an economic asset but also a cultural icon.

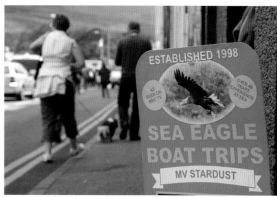

I remember the excitement of going on the boat with my father and I try to pass that on to the people we take out to visit each summer. William Shiel, boatman, Farne Islands

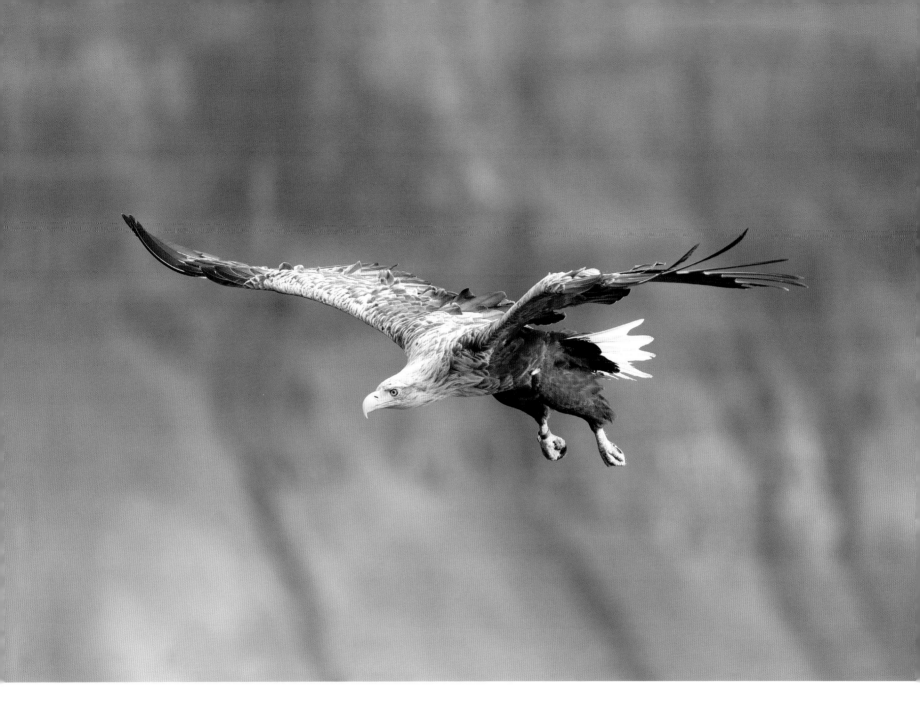

WHITE-TAILED SEA EAGLE IN FLIGHT

Portree, Skye, Scotland

Reintroduced from Norway around 35 years ago after a century-long absence, white-tailed sea eagles are now being restored to Scotland's east coast as well as to south-west Ireland. Apart from their obvious tourism appeal, these top-of-the-food-chain predators inject a dynamic into the coastal ecosystem that has long been missing. In recent years there have been more sea eagles in Scotland than for over a century.

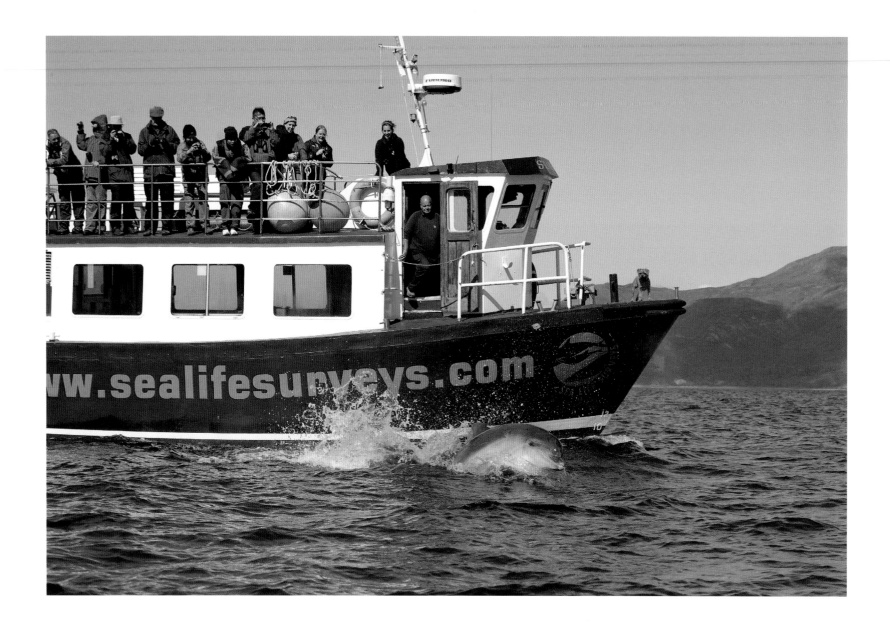

BOTTLENOSE DOLPHIN AND TOURIST BOAT

Sound of Mull, Scotland

It's hardly California, but Scotland's west coast is fast gaining a reputation for whale and dolphin watching: a day off the island of Mull might bag you all manner of sightings. Tourism providers are benefiting from unprecedented numbers of wildlife watchers.

BOTTLENOSE DOLPHIN BREACHING →

Moray Firth, Scotland

Further east, just north of Inverness, there's a persistent crowd on the beach awaiting the arrival of the local dolphins, which provide a spectacular free show. By generating an estimated £4.5 million each year in spin-off services, they're a spectacular asset too!

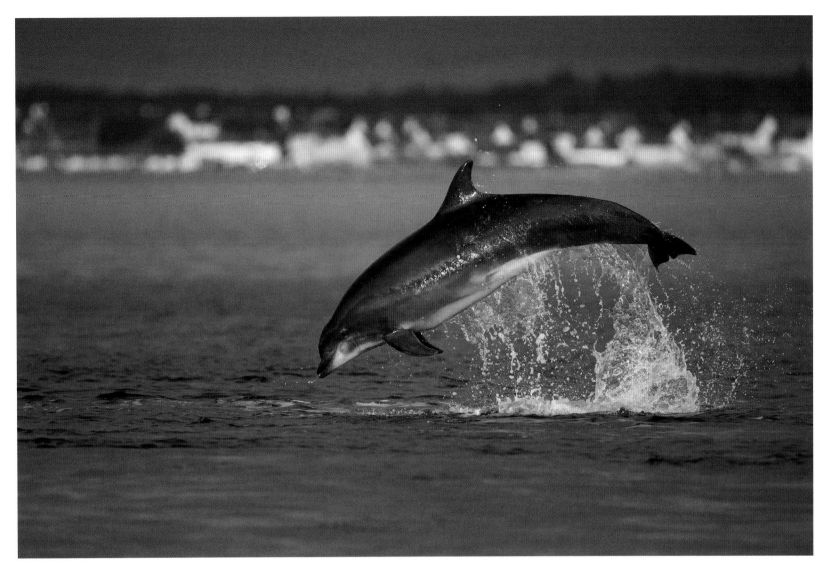

The UK coasts boast a huge variety of whales, dolphins and porpoises and we are extremely lucky to have these species right on our doorstep.

Morven Summers, Volunteer Co-ordinator, Hebridean Whale and Dolphin Trust, Isle of Mull

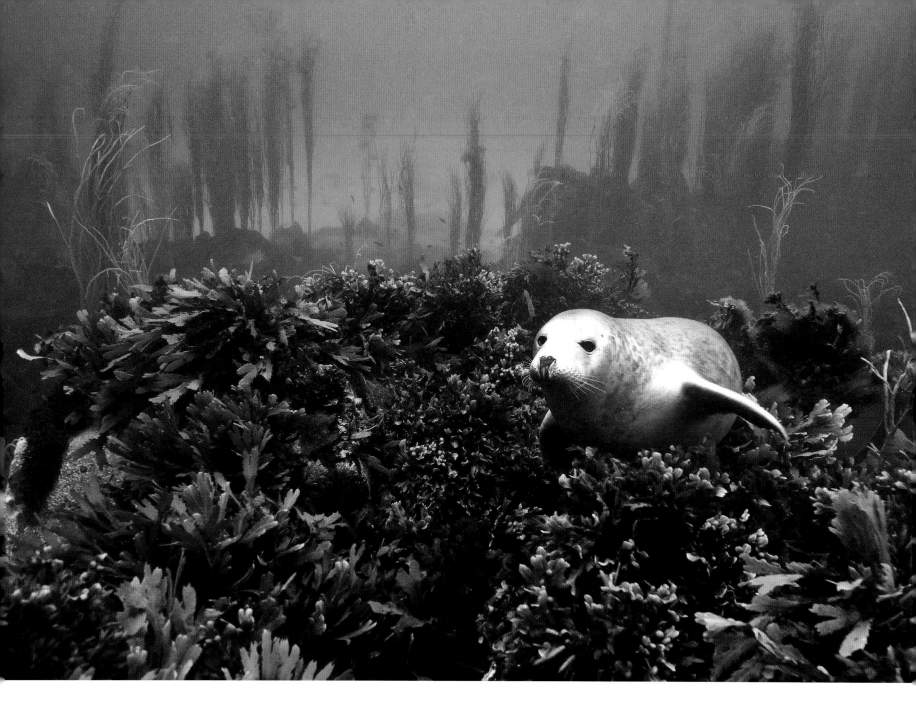

*For me, the sea is a place of space and freedom,
but it is also an environment used and abused.*

Mark Newell, Centre for Ecology and Hydrology, Edinburgh

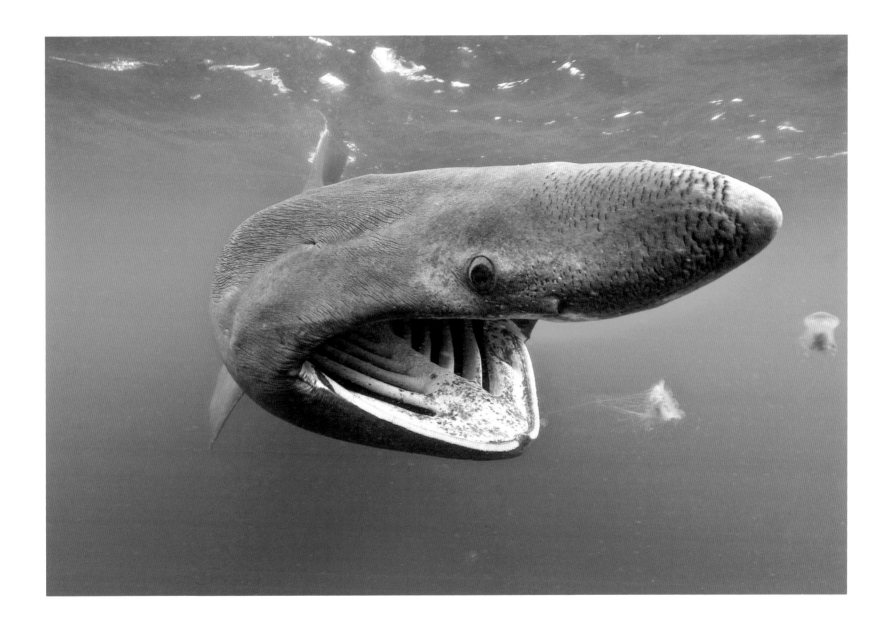

← GREY SEAL IN KELP FOREST

Farne Islands, Northumberland, England

The foundation upon which marine tourism is built is healthy and productive seas. If fish do well, the species that eat fish do well, and, ultimately, we do well too.

BASKING SHARK ↑

Inner Hebrides, Scotland

This is the second-largest fish in the world. It's a shark and it comes to the UK every summer. Before a state of national emergency is declared, these gentle giants are plankton feeders, filtering their food through the gill rakers within that very impressive mouth!

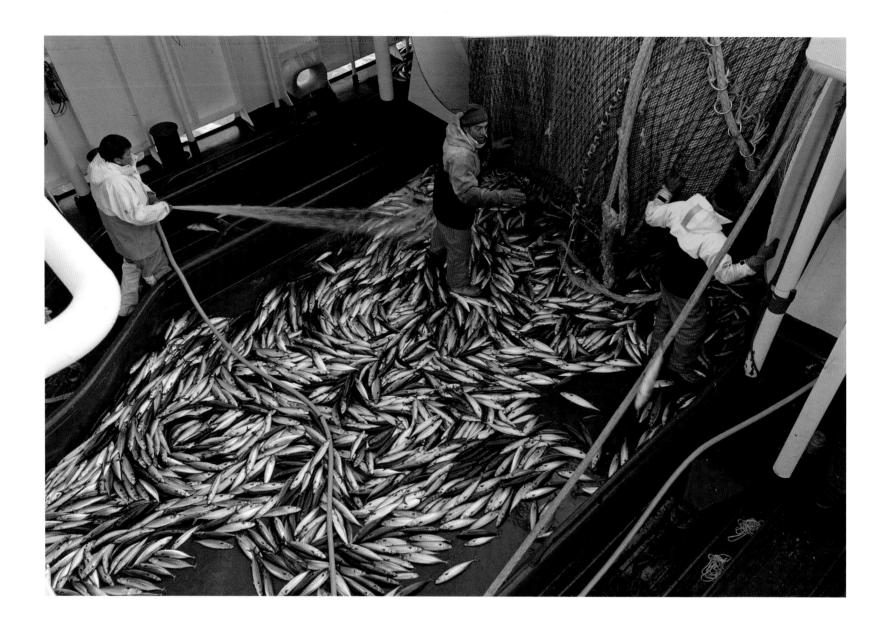

SUSTAINABLE MACKEREL TRAWLING

Shetland Isles, Scotland

Managed for the long term, our seas are capable of providing us with a healthy and long-lasting food supply. This fishery from Shetland is certified by the Marine Stewardship Council (MSC), which means that this catch comes from, and can be traced back to, a sustainable source. Buying MSC-labelled products rewards fisheries that support healthy marine environments.

It's easy to forget how the sea affects us – providing food, regulating our climate and acting as a perfect playground. In fact, it's even more simple than that: no plankton in the sea, no people on the planet. Doing more to protect our oceans really is a no-brainer. Alex Mustard, 2020VISION photographer

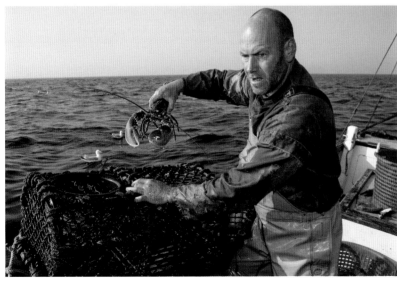

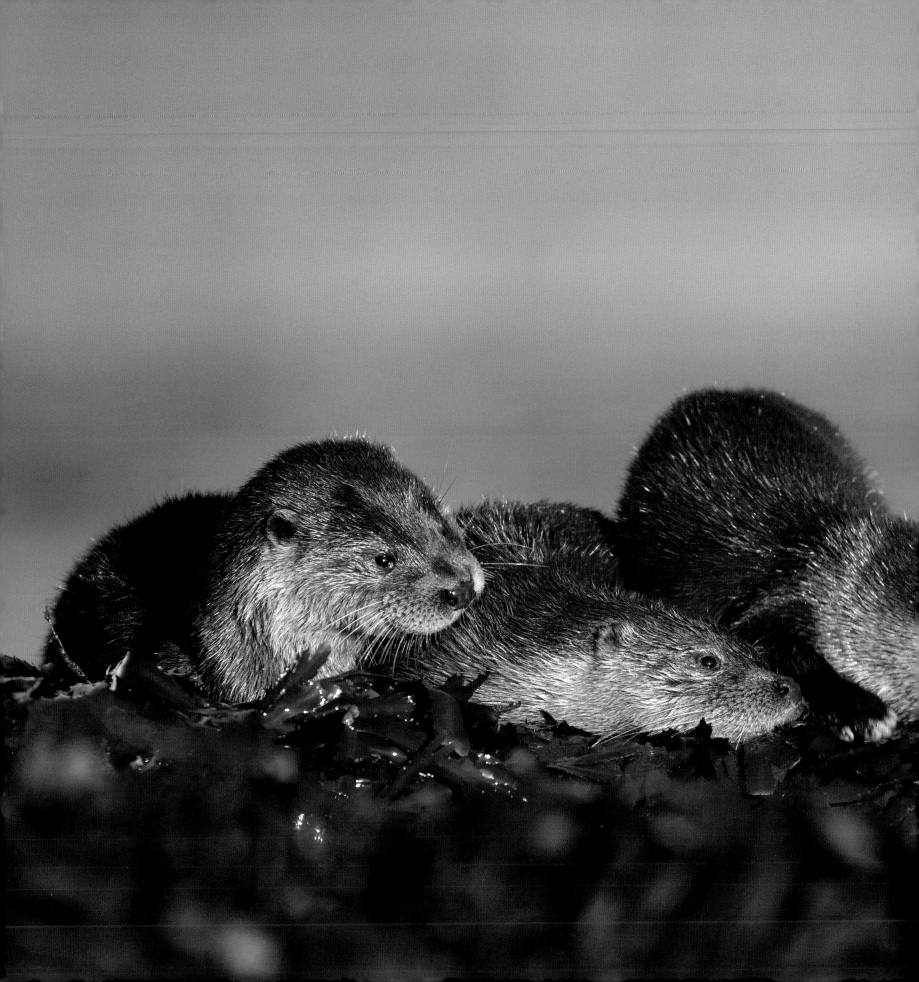

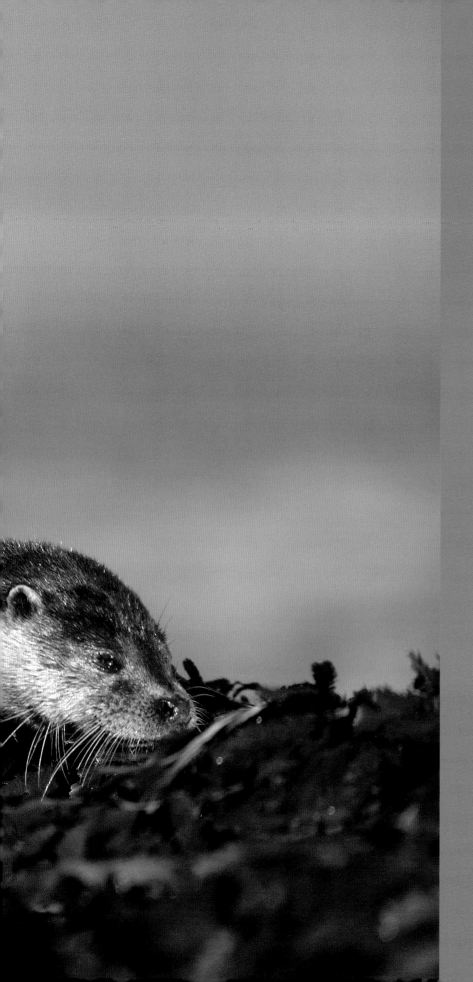

Sea in numbers

£17 billion: The value of seaside tourism to the annual UK economy.

126: The number of UK beaches awarded a Blue Flag eco-label.

6,477: The number of fishing vessels in the UK fleet.

£719 million: The value of the 606,000 tonnes of sea fish and shellfish landed by UK vessels in 2010.

28: The number of cetacean species recorded in UK waters.

127: The number of areas proposed as UK Marine Conservation Zones.

2%: The extent of UK seas currently designated as protected areas.

44,000: The number of species found in UK waters.

20,000km: The length of coastline in the UK.

£5 million: The annual value of white-tailed sea eagle tourism to the Isle of Mull's economy.

3%: The amount of the UK's energy that could be generated by wave power by 2020.

330,107: The number of items of beach litter collected over one weekend from the UK's beaches.

50: The percentage of the world's grey seal population resident in UK waters.

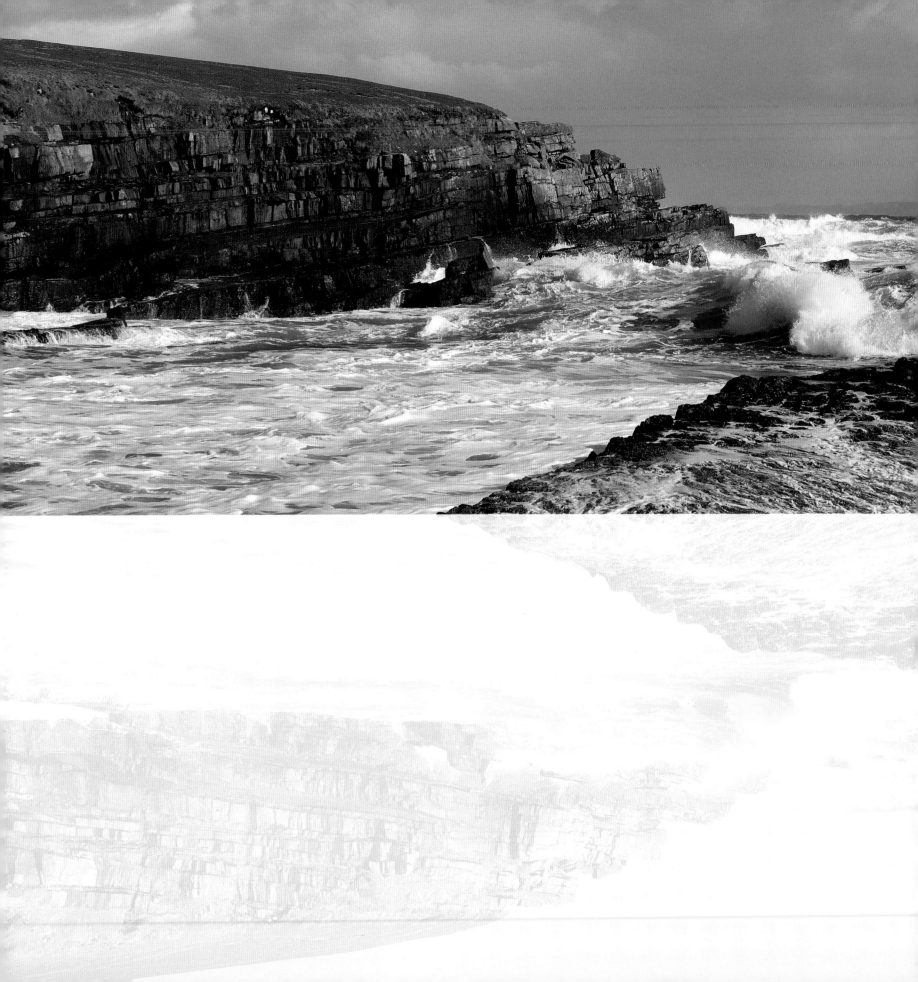

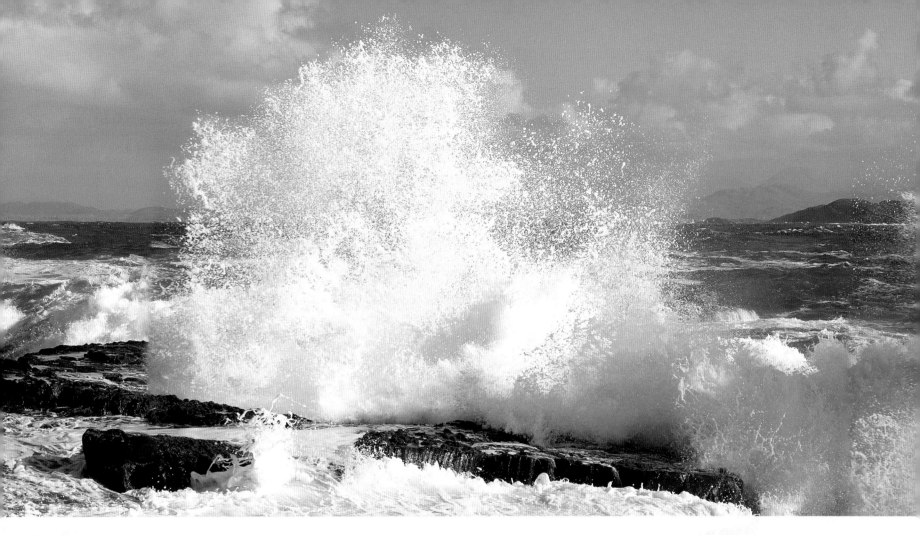

Climate regulator. Larder. Tourist attraction.

More than just the *sea*

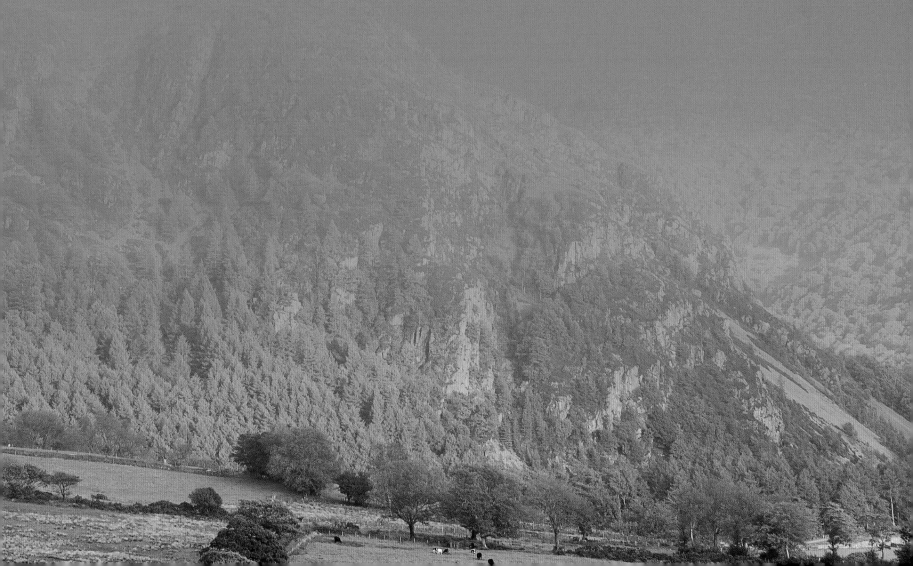

More than just some…
HILLS

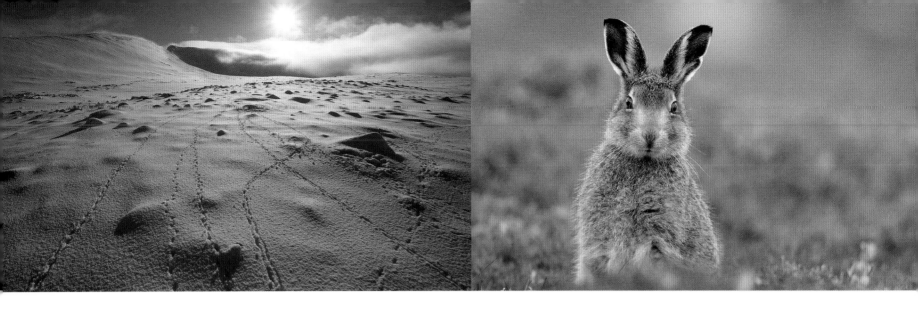

INTRODUCTION

Hills and mountains matter. Some people can't get enough of them, spending leisure time or lifetimes hiking into the hills or climbing crags. Others have less desire to explore them. But somehow, the idea of mountains can loom large in the minds of many people who think of them, in different ways, as holding the very essence of 'wild'.

That's still the case with the perception of mountains in Britain and Ireland, even though those mountains and the wider uplands have been used, influenced and altered by people over millennia. The Cairngorms, Snowdonia, the Pennines, the Mournes – all have their fan bases, and names that stimulate the imagination of anyone who loves them. Add the Black Cuillin, Torridon, the Cheviots, Brecon Beacons, the Cambrian Mountains and many more names of ranges and individual hills to the mix, and the blend becomes dizzying.

In Scotland, peaks over 3,000 feet (914m, but the old-school height has more of a ring to it) hold a particular fascination and challenge for some keen hill-goers. The country has 284 of these 'Munros', named after the Scottish climber who first listed them in the 19th century, plus a further 511 'tops' (peaks over 3,000 feet that are part of a range or ridge). Wales has a small cluster of summits topping the magic altitude in Snowdonia. Ireland has one, at Carrantuohill in the deliciously named Macgillycuddy's Reeks; England has none.

But the timeless allure of uplands can't be pinned down by a simple reckoning of height above sea level. Much lower hills in different parts of Britain and Ireland are important to many people. They might be a landmark near a town or city, or promise wide vistas if you walk them. And again and again, whether viewed from nearby

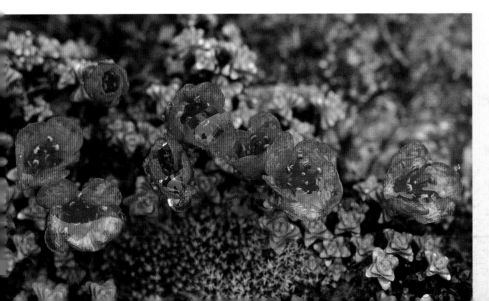

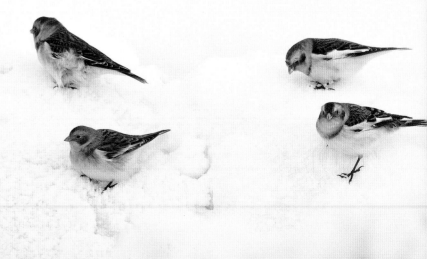

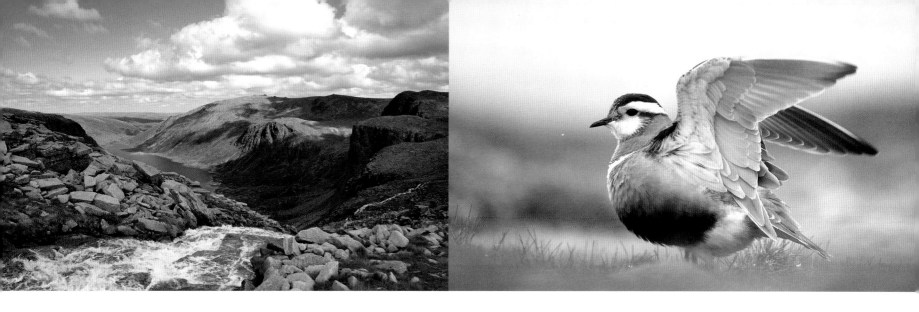

or at a far horizon, they promise contrast and a different perspective on the everyday, lowland scene.

Uplands, roughly speaking, are the areas with ground above the limit of farming, which is often at around 600m above sea level in Britain. They cover 40% of the UK's land surface. In Scotland, two-thirds of the whole country is upland.

For people with some knowledge of the uplands, the contrasts with the low ground can be compelling. Physical challenge is often part of that, since it needs effort to gain the breezy heights. You don't need to do it as a rock climber, but a walk up a steep hill demands commitment and effort. As you go up a mountain, every 100m higher is like taking a trip 100km north, in terms of the plants that grow there and the drop in temperature.

The rewards of a hike could include huge vistas (some hills of even modest size can look out over several counties) and a sense of wide spaces of land and sky. The chance to encounter some upland wildlife and plants can seem all the sweeter because of their scarcity. You could walk for an hour and not see a bird, then a golden eagle flies overhead. You could see only grasses for part of the day, then find a clump of delicately flowered saxifrage by a tumbling waterfall. The sense is one of discovery in a place that can seem pristine, even if it is not.

Human influence on the uplands is still far-reaching. Nowadays, the rain that falls on the highest tops can bring pollution from distant cities and factories. Sheep flocks and herds of red deer, both subject to huge human control by people who farm and own large parts of the uplands, influence both the look of the hills and some of the

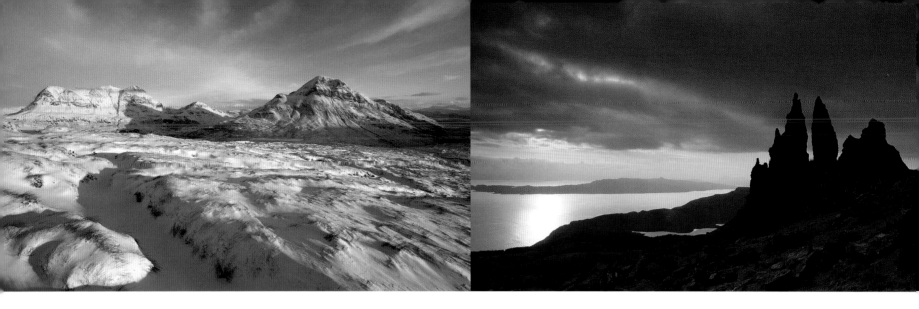

ways in which they affect the lowlands. Rising air temperatures and changing climate at a time of global warming work their own kinds of erosion on the upland scene, altering the communities of birds, plants and insects that live there in ways that are subtle, but persistent.

Whatever happens in the uplands can have an impact on the landscape far beyond and far below. Movement of water is part of that link and interaction between high- and lowland. Mountains and hills catch, hold, filter and release enormous amounts of water, including the water that we can use for drinking. Loosen the fragile mountain soils, for example by heavy grazing and removal of trees from the middle slopes, and erosion (a natural process on any mountain) accelerates. Run-off is faster and dirtier and the risk and severity of flooding on the low ground greater. At the same time, the store of water in the hills that could be released more gently is reduced.

Rising temperatures are already having an impact on the uplands. Earlier snowmelt, for example, can be a problem for birds whose breeding is linked to finding insect food at the snow edge at particular times. Tackling upland issues, including the effects of climate change, the long-term loss of native woodlands and erosion of peatlands, can be tricky. But far-sighted groups of people are trying.

At Ennerdale in the Lake District, people and organisations supporting the Wild Ennerdale project have been working to allow natural processes to play a greater part in shaping the future landscape and life of the valley and so increase the sense of wildness that people experience when they visit. This has involved leaving dead trees where they fall, allowing the River Liza to flood new areas, and using a herd of Galloway cattle to graze the area as they please, in a way that might mimic the ranging pattern of the ancient forest cattle that would once have roamed British

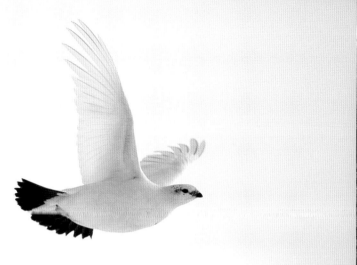

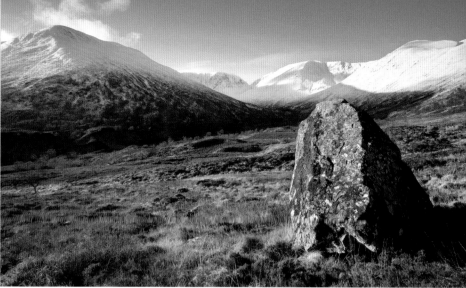

woods. Some conifer plantations have been felled, while ancient woods of oak and birch are being extended.

Large-scale woodland restoration is also underway in the Cairngorms – the largest mountain area by far in the whole of Britain and Ireland. At Abernethy, Glenmore and Inshriach on the skirts of the mountains, huge areas of commercial conifer plantation have been restored to more natural Caledonian-type forest, where Scots pine is the commonest tree, with further Caledonian forest restoration at neighbouring Glenfeshie. Boosting the fortunes of Scots pine and other native trees here will help a whole range of native pinewood wildlife, such as crossbills, wood ants and wildcats.

Coigach and Assynt, in the far north-west of the Scottish mainland, hold some of the most amazing-looking mountains in Britain – including Suilven, Canisp, Stac Pollaidh and Quinag. None of

these is a Munro, but all pack a huge landscape punch, rising over loch-studded low ground, not far inland from a beautiful coast of headlands, bays, islands and beaches.

Partners in the area's Living Landscape project are working together in the largest scheme of its kind in Scotland, aiming to bring both environmental and social benefits to the area. Here, native woodlands of oak, birch and hazel, red deer in the hills and fish in the rivers are part of the natural local resources. Reconnection and restoration of woodlands, wetlands, peatlands and heaths will be part of the work in Coigach and Assynt.

Success will support all kinds of wild nature, including golden eagles, and create jobs in an area that has long suffered from unemployment and population decline. Feet on the ground, but thinking big and aiming high: that sounds like a great combination for the uplands. Watch this lofty space.

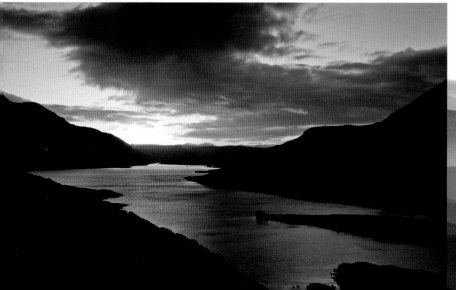

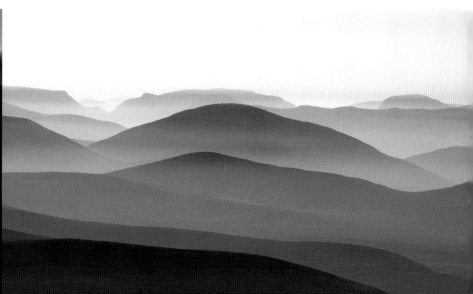

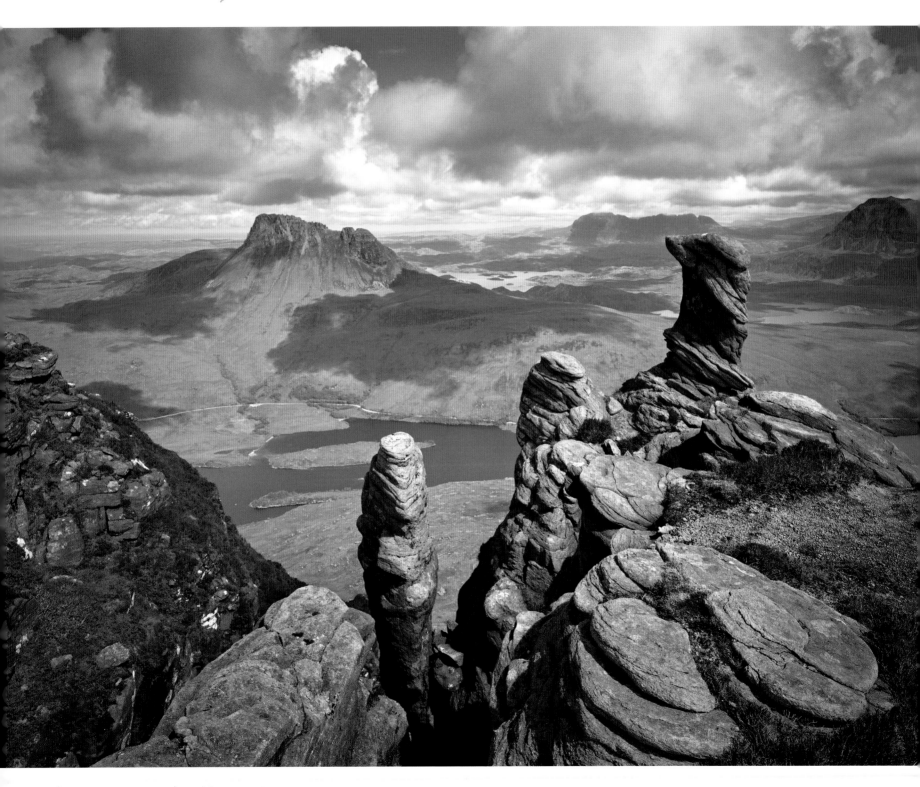

The hills are my refuge, their wildlife my inspiration, their solitude my balm. Derek McGinn, hillwalker, Inverness

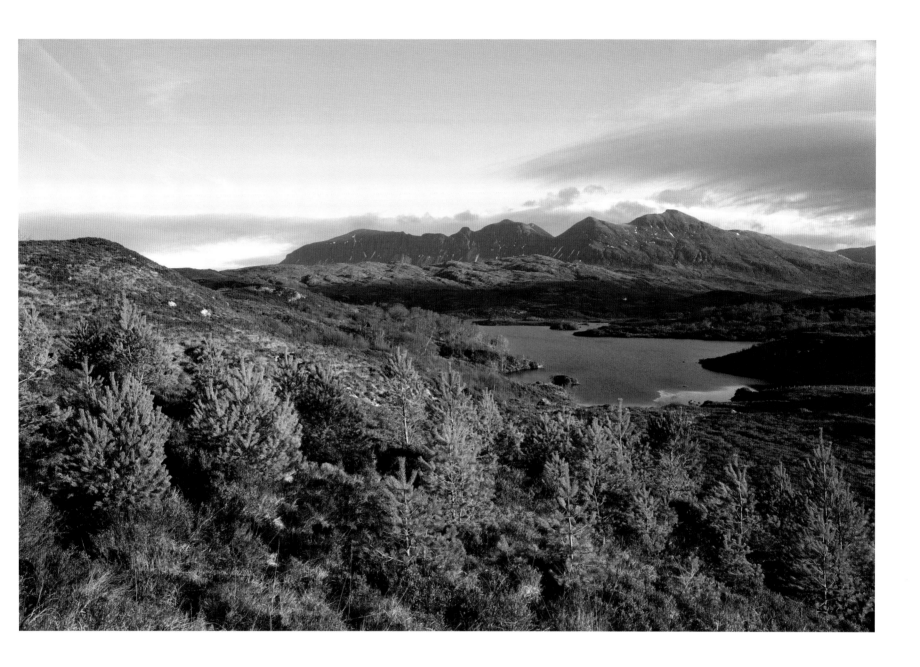

VIEW FROM SGORR TUATH

Wester Ross, Scotland

The Coigach and Assynt Living Landscape (CALL) project is an inspiring vision for over 1,800 square km of Scotland's wildest hill country. A partnership of conservation groups and private landowners, it will raise the bar for big nature repair jobs.

LITTLE ASSYNT ESTATE

Sutherland, Scotland

The regeneration of native woodland corridors that would once have skirted the higher hills is part of a suite of objectives that will help re-establish ecological integrity to Coigach and Assynt, but beyond this, the project aims to deliver a range of social benefits.

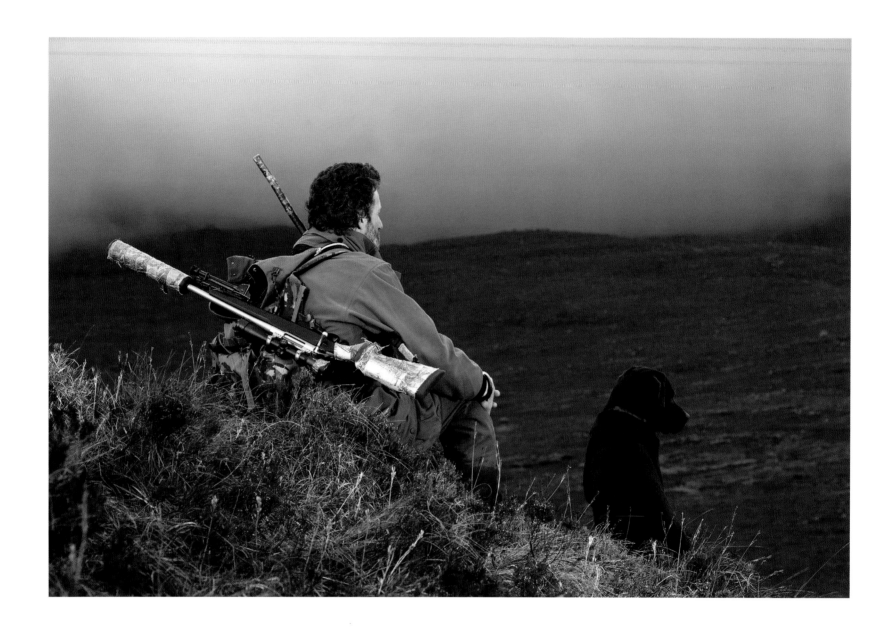

DEERSTALKER LOOKING OUT OVER UPLAND LANDSCAPE

Quinag, Sutherland, Scotland

Don O'Driscoll is a deerstalker with the John Muir Trust, one of the partners in the CALL project. Red deer are an integral part of the upland ecosystem but balancing the regeneration of fragile plant communities with the presence of hungry deer is a tricky job. Making more of local venison and seafood is one of the priorities of the CALL project and creating tangible economic spin-offs plays a big part in building local community engagement with the project.

My 'office' is 4,000 hectares
of one of Scotland's best
mountain landscapes.
Going to work in the morning
isn't a chore, it's an honour.

Rory Richardson, Reserve Manager,
Creag Meagaidh NNR, Lochaber

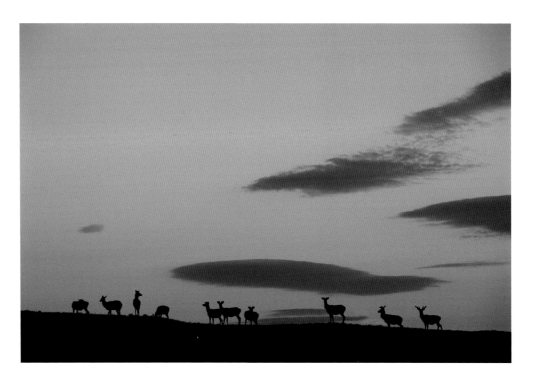

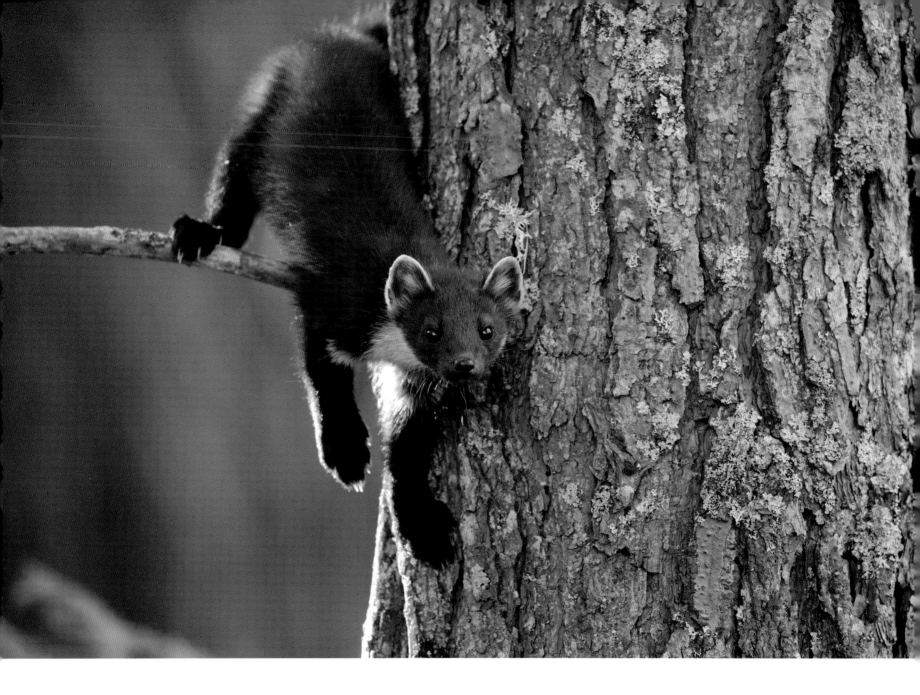

PINE MARTEN CLIMBING TREE

Beinn Eighe NNR, Scotland

As Scotland's hill country undergoes increasing change, species that have lived on the edge for decades will start to recolonise and prosper. In parts of northern Scotland, people are one such species. Projects like CALL are designed very much with local communities at their heart, driving their own change, led by their own aspirations.

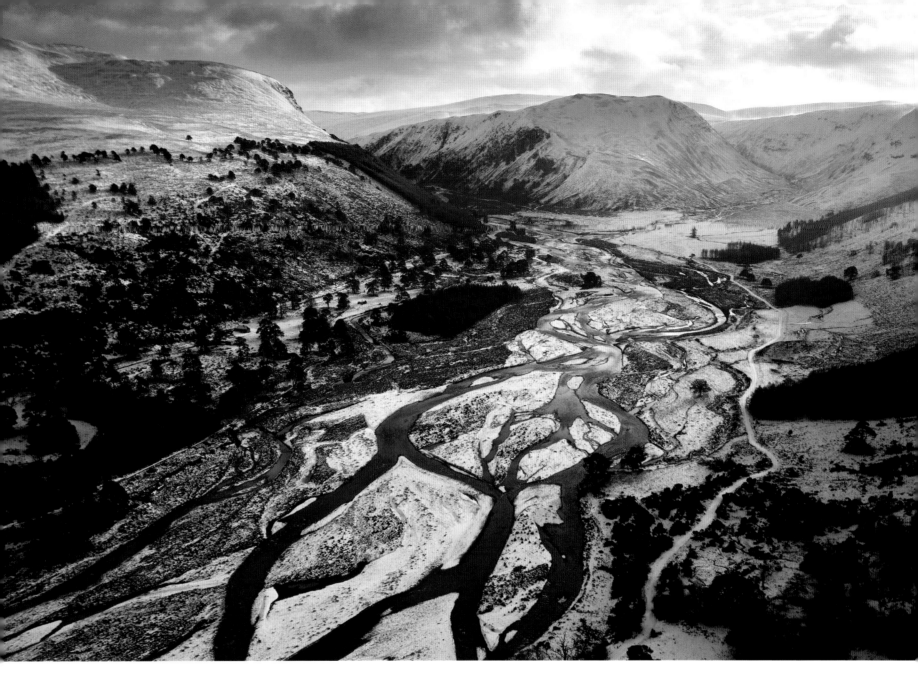

AERIAL VIEW OVER GLENFESHIE

Cairngorms, Scotland

There are few places in Scotland where the upper limit of trees is governed only by natural forces such as climate and soil quality. In Glenfeshie, attempts are underway to re-establish this sub-alpine habitat and its associated plant communities. The vision is long term but, crucially, embraces the whole landscape from river bottom to mountain top.

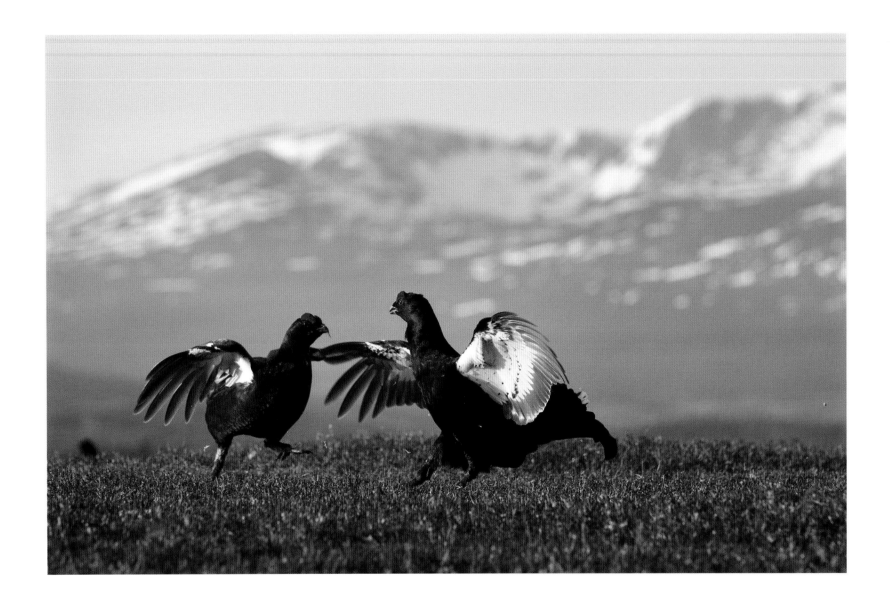

BLACK GROUSE LEKKING ↑

Grampian Mountains, Scotland

With the re-establishment of wet bog, forest edge and upland scrub communities, black grouse in Glenfeshie are recovering against a backdrop of decline in many other areas.

HILL WALKER IN WINTER →

Torridon, Scotland

Outdoor recreation is the best – and cheapest – way of improving the nation's health and fitness, so these mountains provide not only visual spectacle but also an outdoor gym; a fuel station for the soul.

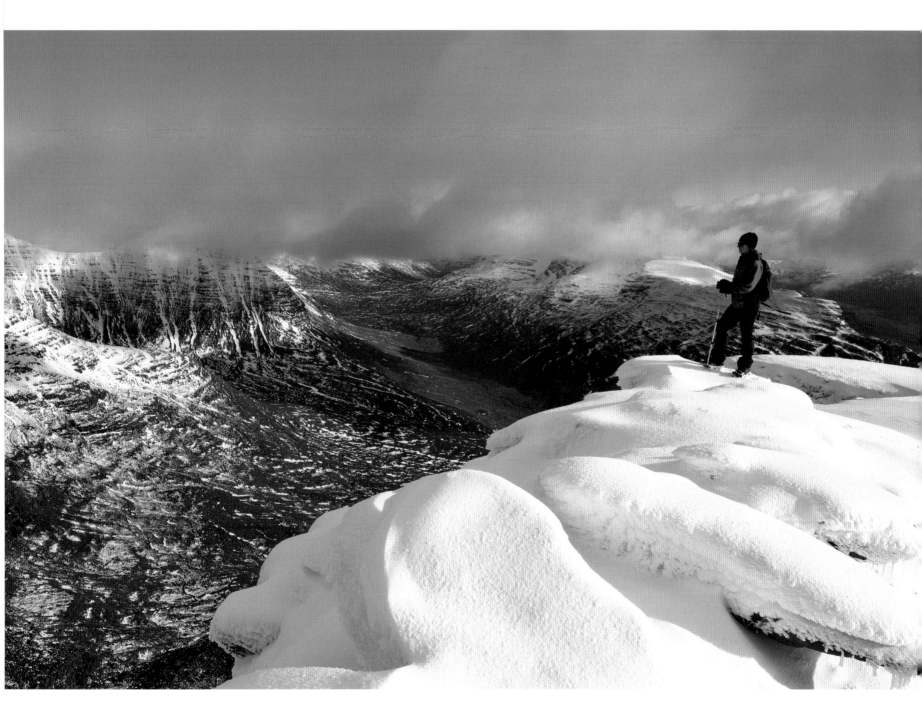

I go to the hills to reconnect and understand my place in this beautiful world.
I come back alive and glad to be so. Jim Manthorpe, writer, photographer and film-maker, Knoydart

Coigach and Assynt, Glenfeshie and Creag Meagaidh in Scotland, Pumlumon in Wales and Wild Ennerdale in northern England are all dots on the map just now, but they are symbolic dots. As these upland landscapes grow, mature and start to deliver both ecological and social benefits, they will become beacons, inspiring models for others to follow.

I remember standing near an upland valley lake and wondering how nature could be so silent and still, yet create and support life in so many forms.

Estelle Bailey, Montgomeryshire Wildlife Trust, Powys

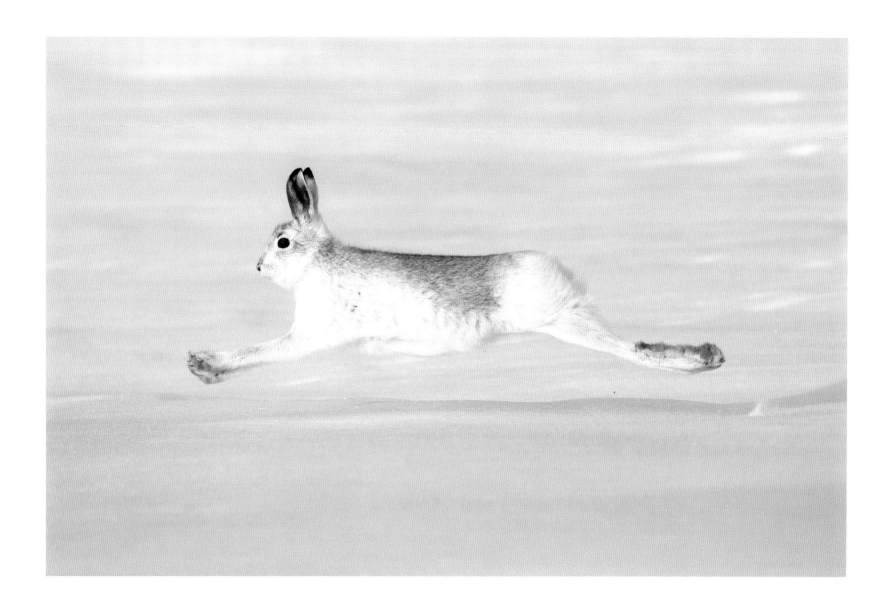

MOUNTAIN HARE IN ITS WINTER COAT

Inverness-shire, Scotland

Synonymous with the hill country of northern Scotland but with a small population in the northern Peak District, mountain hares are fleet of foot and if disturbed can hit 45mph in a matter of seconds – a useful skill when one of your primary predators is the mighty golden eagle.

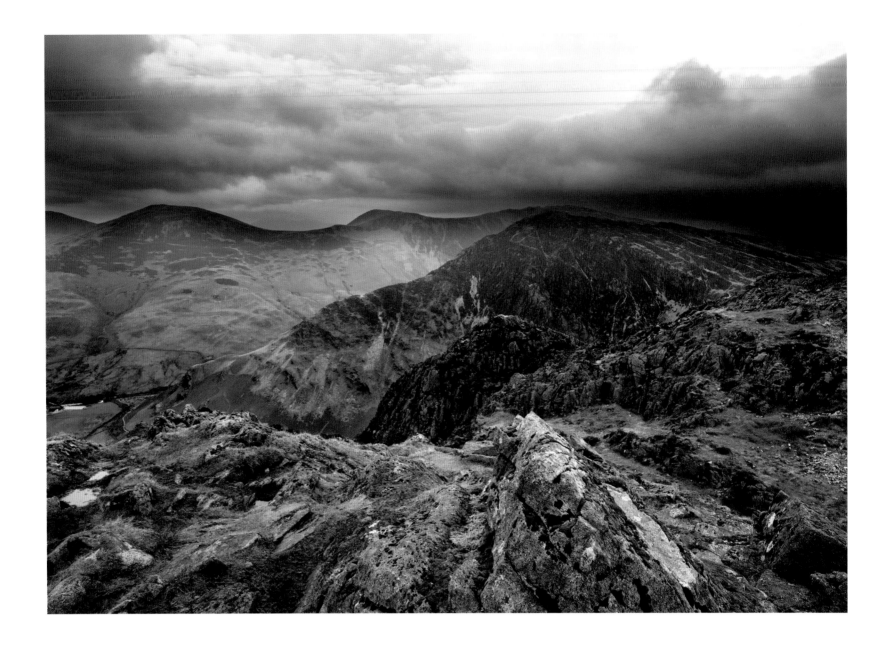

STORMY DAY OVER HAYSTACKS

Lake District, Cumbria, England

The Lakes have long been one of England's most popular rural retreats – a wild yet heavily managed landscape. In recent years a recognition that this land cannot keep giving without reinvestment has ignited ambitious projects like Wild Ennerdale, where the landscape and ecology of a remote mountain valley are evolving primarily through natural processes. Elsewhere, the Lakeland Living Landscape initiative is reconnecting fragments of habitat over the entire Lake District, creating a robust ecosystem that will be better equipped to provide services such as clean water and carbon storage.

TWO WAYS OF SEEING

PAUL KINGSNORTH, WRITER AND FOUNDER OF THE DARK MOUNTAIN PROJECT

I live in one of the most beautiful areas of England: the Lake District. The high fells begin just a few miles from my front door. The air is clean, the water in the streams is safe to drink. Every day I walk my dog down the footpath that begins outside my door and leads within minutes into drystone-edged fields, into old woods and up to the green domed hills. People travel from across the world to walk these peaks, wander in these valleys. When time and family permit I go out fell running, traipsing for miles around the cols in the mist, slaloming down the screes in my mudclaws, pounding across the becks and through the acid of the boglands. It's lonely, bleak, sometimes dangerous. I love it.

These are the landscapes that formed me, and when I was a child I looked at these mountains as wild places. Now I'm an adult, I know better. There is great beauty in the English Lake District – a great, deep, old beauty in those ancient drystone walls, in the hedged fields and the low farm buildings, in the Wordsworthian peaks and the tree-hung meres. But the beauty is human. This is a tamed landscape: tamed so long ago that none of us can remember and only few can imagine what it was like before it was civilised.

But archaeology and palaeobotany can tell us. They reveal that until Mesolithic humans arrived here around 7,500 years ago, what is now Cumbria was thickly forested: mixed oak woodland in the lowlands, pine and birch on the fell slopes. It was inaccessible, dangerous, wild. With the advent of the Neolithic period, which is marked by the beginnings of agriculture, by stone axe factories on what are now bare fells and the raising of the stone circles, the forests had begun their long falling away. Today, there is nothing of that original, wild landscape left but the occasional shadow smudging a valley in the evening sun.

When I look at Cumbria like this, the fields and farmhouses and sheep-gnawed fells seem less beautiful. In my idle moments I wonder if this is what the Amazon will look like in 300 years' time. Will people walk through that landscape too, marvelling at the clean air and the tidy farms, and never know what songs were silenced, what worlds were here before the great forests were stripped away? This tamed earth, shaped by man into a thing of appealing, safe beauty, like a dog breed or a begonia, the tragedy long buried beneath the pylon lines and the kissing gates.

Going back in time is never an option, but going forward with some knowledge of what we have lost – or, more accurately, destroyed – might help us realise the importance of wild landscapes to our civilisation and our psyche. It should not be beyond our wit or capabilities to put the existence – which, in Britain, means the restoration – of genuinely wild, beyond-human landscapes at the heart of our definition of the good society. I hope we might get there one day. Until we do, we will be poorer than we think.

Mountains have a special place in our hearts. Their beauty and challenge draw us back time after time.

Stuart Brooks, Chief Executive, John Muir Trust

Hills in numbers

60%: The amount of Scotland's land mass that can be termed hills or mountains.

500,000: The number of people who reach the summit of Snowdon each year.

373,000: The number of people who visited Scotland's top five ski resorts in 2011.

110,000: The number of people who tackle the summit of Ben Nevis each year.

£900 million: The value of hillwalking, mountaineering and climbing to the Scottish economy.

1,500m: The depth of bedrock that mineral water in the Peak District passes through before being bottled at source.

100%: The projected increase in native woodland on the Glenfeshie Estate in the Cairngorms as a result of deer management.

600m: The height above which ptarmigan live all year round.

12,000: The number of years mountain hares have been present in Britain.

3,699 hectares: The area of the John Muir Trust Quinag Estate in Assynt.

4 million: The number of people supplied with water originating from Pumlumon catchments in Wales.

500: The number of Arctic charr that spawned in the River Liza, Ennerdale, in 2010.

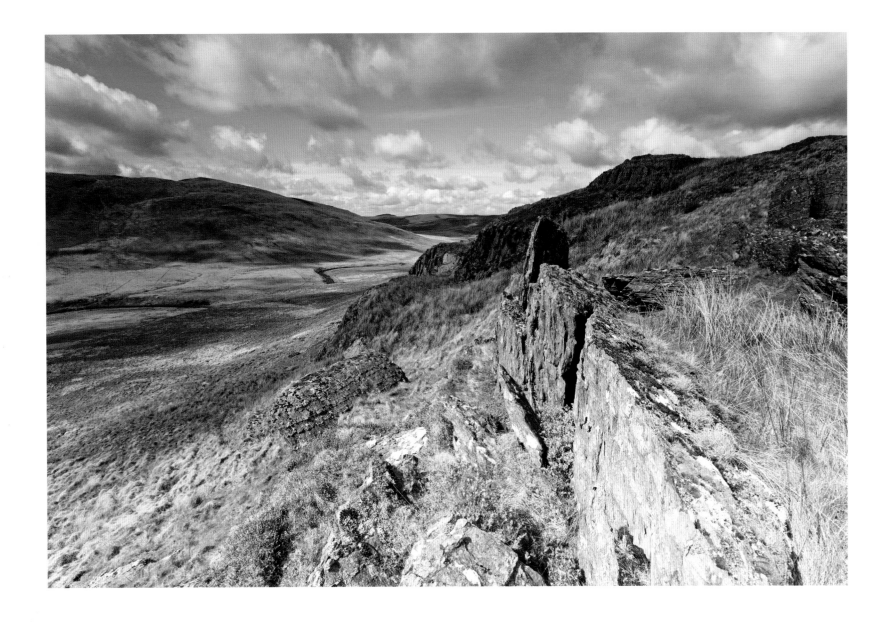

PUMLUMON FAWR

Cambrian Mountains, Ceredigion, Wales

The Pumlumon project, led by The Wildlife Trusts in Wales, stretches over more than 40,000 hectares of the northern Cambrians. Pumlumon is the largest watershed in Wales and is the source of the rivers Wye, Severn and Rheidol. This is a place of big skies and raw beauty, but also a place where overgrazing and intensive land use have taken their toll, resulting in degraded habitats and increased flooding in the lowlands. By working with local people, the project's vision is to guide a major change in the way in which this land is managed, creating a more varied landscape that is rich both in wildlife and in opportunities for local communities.

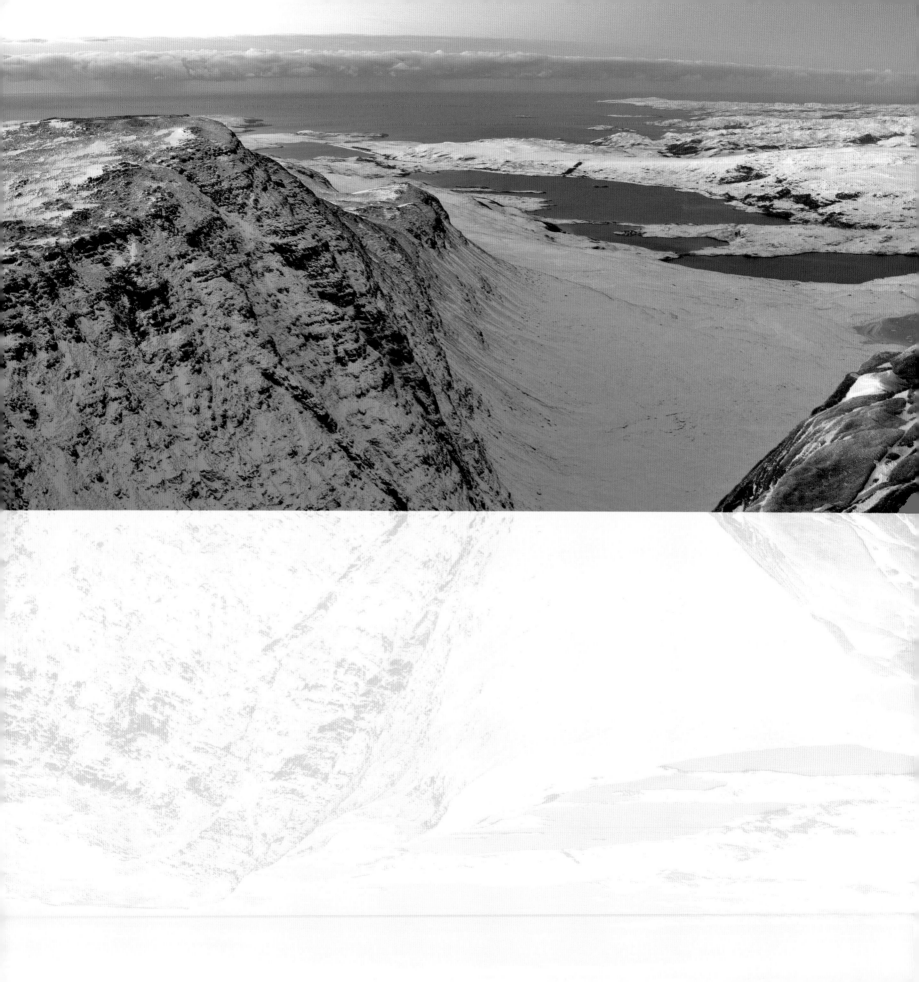

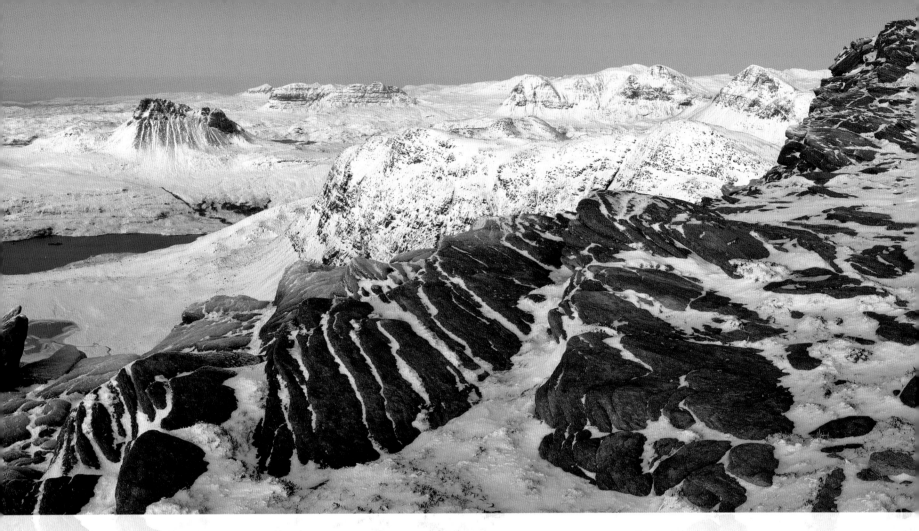

Water trap. Workout zone. Refuge.

More than just some *hills*

More than just a...

RIVER

INTRODUCTION

Rivers are regaining their voices. What were once muted by drainage works or distorted by concrete channels are beginning to sound natural again. And the range of those sounds is as wide as the variety of rivers themselves.

Think of a river, and what do you hear? The chuckle of a chalk stream over riffled shallows, as it feeds a pool where trout glide past? The scarcely audible whisper of a wide, deep reach, where a river runs through the heart of a city, drowned out by the sound of traffic and people? The roar of a cascade, where an upland torrent splashes rocks where a dipper bobs, past banks where an otter's paw prints mark the mud?

Those are a tiny fraction of the possible sounds and scenes along British and Irish rivers. Across these lands, the patterns of major

rivers and their tributaries branch out in life-bringing networks. Look at any map of them and you'll see it – the way that the tiniest of streams join, then tributaries converge, then rivers widen to coil across lowlands, before merging with the sea.

River networks have the most natural of shapes, like the way twigs, stems and trunks connect in trees, or how vital blood vessels spread throughout a human body. The river networks would also have been the routes – multi-branched and useful – along which some of the earliest colonists of our countries could travel: an appealing alternative to trying to navigate on land composed mainly of dense woodlands.

River names are some of the oldest words we have still in use, including a high percentage of names taken over by Anglo-Saxons

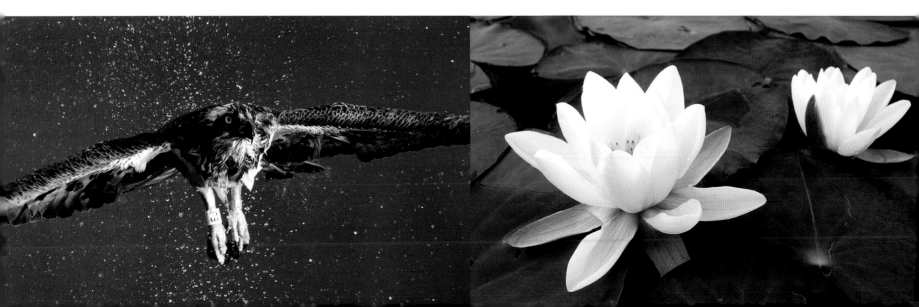

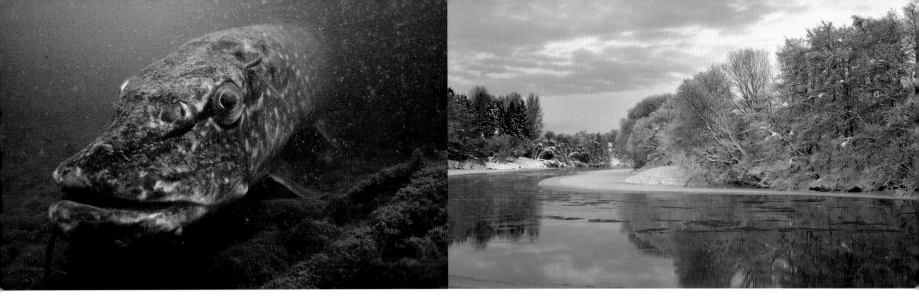

from British tribes. Avon (England has several) and Dee (a river name in England, Wales and Scotland) are among them. And again and again, rivers are the setting for thriving and long-established cities. The combination is no coincidence, because by providing connections to the sea, rivers have always been channels for trade and interaction, both national and international. Their presence has helped to build the wealth, as well as aspects of the culture, of the cities by their banks. The Mersey, the Clyde and the Tyne, linked to Liverpool, Glasgow and Newcastle, are just three of the rivers that shaped the look and life of those cities, and whose names are celebrated in song.

The Thames, world renowned, is London's river. And the way it relates to that city is both intriguing and intimate, with the main river, together with its tributaries, stretching into every one of London's 33 boroughs. Here, as with every river network, the waters have enormous potential to bring benefits for wildlife, people and the wider environment, including through how an area can feel at a time of warming climate. The trouble is, the thrust of a great deal of 'river engineering' work in the past seemed to be motivated by fear: fear of flooding. This has had serious consequences for the vitality and usefulness of rivers in the present.

It's not surprising, when floods can claim lives, wreck buildings and sweep away bridges and other infrastructure, that big steps have been taken to try to tame the power of rivers. During much of the second half of the 20th century, a great deal of that work seemed so obsessed with containing 'peak flows' (the ones that could produce floods) that it ignored the benefits of more organically

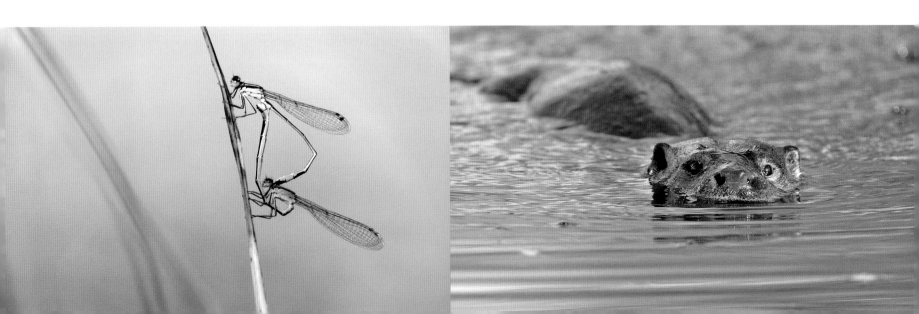

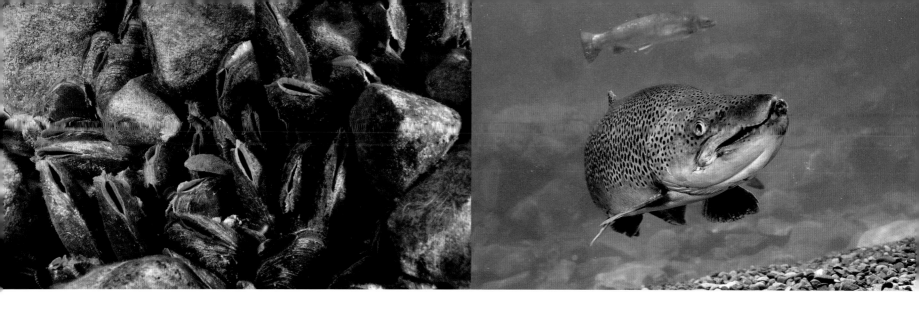

shaped, natural channels. Again and again, straightened, reinforced channels – which might simply shift a flood problem downstream, not solve it – confined rivers. At the same time, removal of trees and other natural vegetation along their banks made these, among the most natural of features, ugly. They also became much less valuable for recreation and for wildlife, such as water voles, kingfishers, otters and more.

Luckily, times have been changing in the river management world, and changing fast. Inventive schemes have been introduced to allow rivers to run more as they could and should once more. Sometimes, this has been low cost and low tech, such as in simple but effective work on the River Bure, perhaps the best-known Broadland river, which is navigable for 50km.

Here, whole trees were felled into the channel to make the river's flow more complicated. Because of this, faster-flowing water in

some parts has removed sediment and exposed clean gravel beds where brown trout can thrive once more. In slower-moving water, aquatic plants can now take the time and find the space to take root and spread out.

On a much larger scale, work across whole landscapes in the headwaters of the River Thames has put England's most famous river and its tributaries at the core of major habitat restoration and creation projects. Across the Cotswold counties of Gloucestershire, Wiltshire and Oxfordshire, this will lead to new green corridors, expanded wetlands, woodlands and grasslands, including water meadows beside river channels.

In Scotland, ambitious work on the River Tweed (now the best river for Atlantic salmon in the world) has involved many different partners. Work here has been both practical, such as in large-scale planting of native trees (good for reducing both soil erosion from

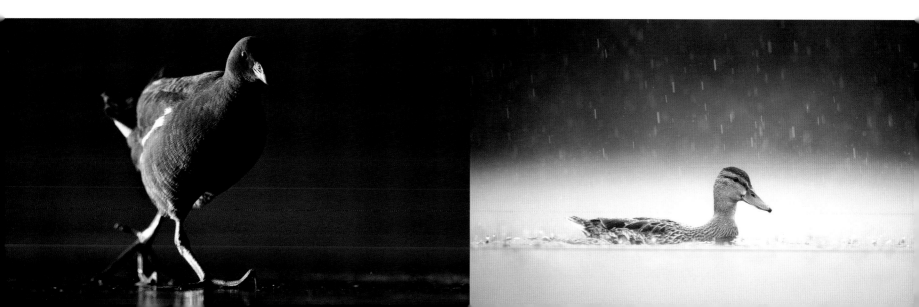

the hills and flash floods) and scientific. Biological research, careful monitoring of results and tireless hands-on work by volunteers, farmers and other landowners have all played a part in enhancing the River Tweed.

Aquatic plants and wildlife are benefiting, as are the people who fish the river or those who come to enjoy the way its natural scenes can bring peace and refreshment to the senses. Rivers are good at this, in a host of different ways and situations.

There's an enormous contrast between a small, lowland river, in a stretch beneath trees whose leaves let sunlight fall in dancing patterns on the surface, and a wide, rushing channel in a treeless landscape near an estuary. But both hold abundant natural pleasures. Add the flash of a kingfisher to the lowland scene, or an osprey to the large river, and the enjoyment is enhanced.

Along the Tweed and other good salmon rivers, some of the places where the silver-skinned fish leap clear of the water to move upstream to spawning grounds take on a magical quality which is believed to have been appreciated for millennia. Old Celtic stories, especially one about the 'salmon of wisdom', celebrate the fish and its dramatic life cycle as something sacred and powerful. Images of salmon on ancient Pictish carved stones transform the jumping fish into an icon.

These tales and carvings, together with the work now being done to boost numbers of salmon and many other water creatures, are symbolic of the power, the beauty and the potential for rivers to run wilder once more.

Listen: is that the sound of a salmon, splashing as it plunges from the edge of a cascade to dive into the tranquil waters of a cool, deep pool?

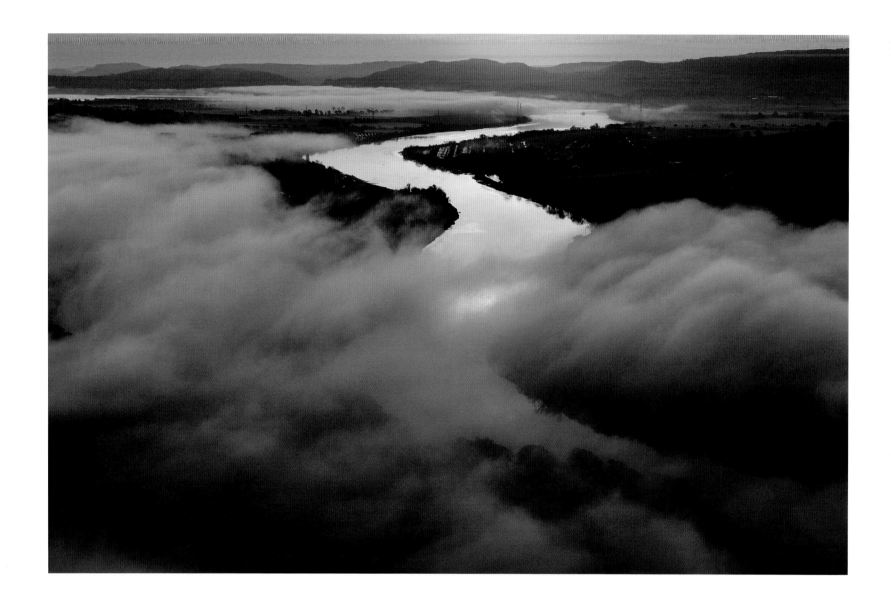

RIVER TAY AT DAWN

Perthshire, Scotland

Having dabbled for years with a bit of straightening here and a bit of dredging there, the realisation that a river can't be managed in isolated sections has spawned catchment-scale thinking, like here on the Tay, Scotland's longest river, with a catchment of 2,000 square miles.

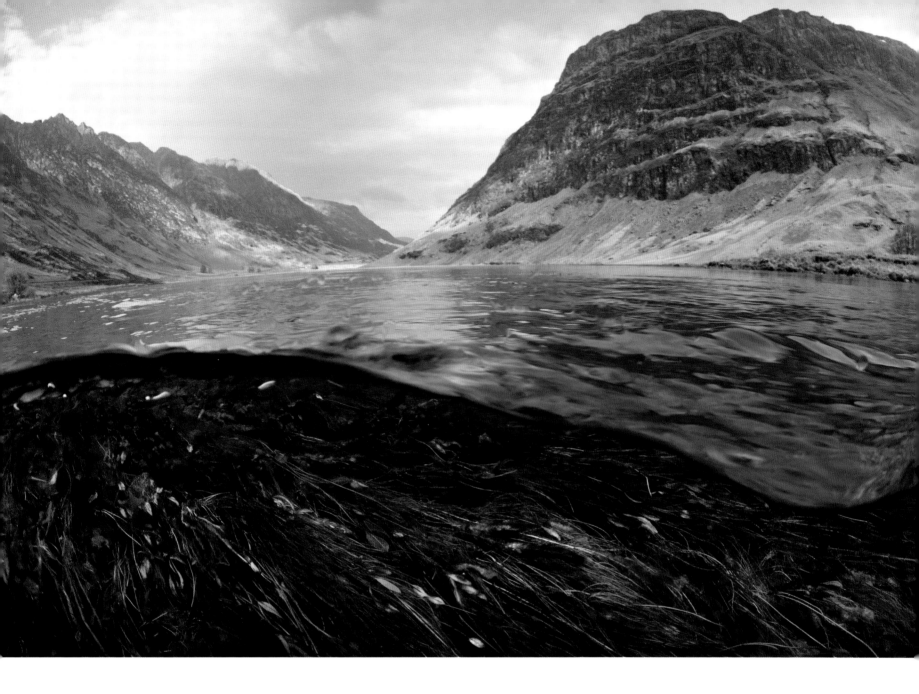

RIVER COE

Lochaber, Scotland

Some of the UK's rivers cut through wild country, their banks shadowed by towering hills, but in the main, our rivers dissect a cultural landscape where people live, work and play. The building blocks for healthy, vibrant river systems are nevertheless the same and require us to think big and think long term. It might also require allowing rivers to do what rivers do rather than what we want them to do.

Rivers are the lifeblood of the countryside, a vital part of the food chain for all wildlife, and a great place to be.

Pete Marshall, angler and lover of wild places

OTTER AT THE FOOT OF A WEIR

Dorset, England

The recovery of otters in British rivers is one of the great conservation success stories of recent years. After hunting and unchecked pollution drove otters to the remotest corners of the country, their return is a potent symbol of changing attitudes towards both otters and the rivers and wetlands in which they live.

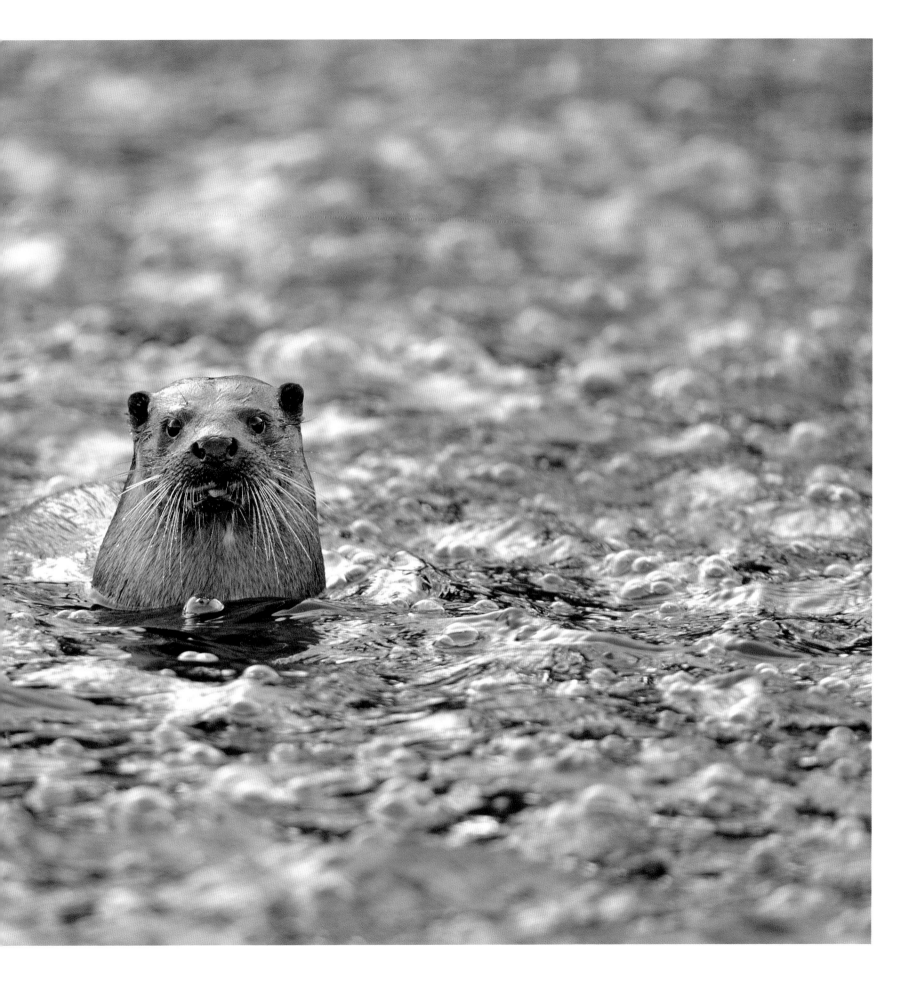

I loved plunging into peaty waters on assignment for 2020VISION, swapping my normal blue office for one that is orangey-brown. Alex Mustard, 2020VISION underwater photographer

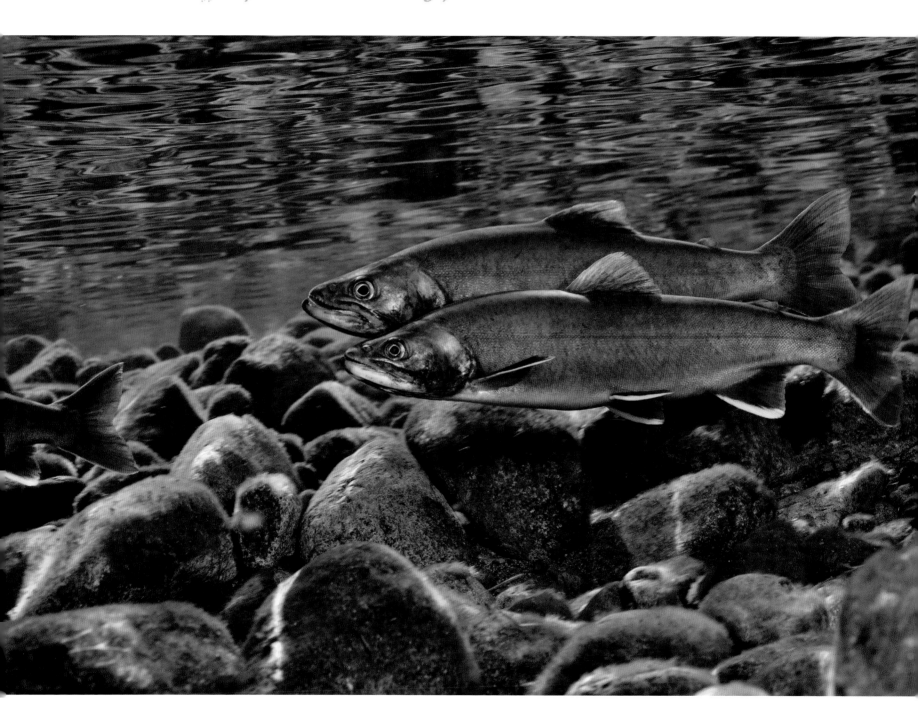

COMMON TOAD →

River Orchy, Argyll, Scotland

Given that an estimated 20 tonnes of toads are killed each year on our roads, the health of rivers, lakes and ponds where toads breed is brought into sharp focus. The flip side of this shocking statistic is that Froglife's Toads on Roads project saves around 60,000 of these migratory amphibians each year.

← ARCTIC CHARR IN BREEDING COLOURS

Cumbria, England

England's only migratory Arctic charr population is found in the Ennerdale Valley in Cumbria and until recently was declining in number. These fish are sensitive to physical barriers preventing their spawning as well as to fluctuations in water quality. Work carried out by the Wild Ennerdale Partnership has improved conditions for both charr and salmon, resulting in their populations recovering considerably.

THE GEOGRAPHY OF HOPE

ROBERT MACFARLANE, NATURE AND TRAVEL WRITER AND ADVOCATE FOR WILD PLACES

In 1960, the novelist and historian Wallace Stegner wrote what would become known as the 'Wilderness Letter'. It was addressed to an official involved in a federal policy review of America's 'Outdoor Recreation Resources', and over the course of the letter, Stegner argued that particular places and landscapes were worth more than could ever be revealed by a cost–benefit analysis of their economic value. No, Stegner explained – we need such places because they remind us of a world beyond the human, and also because they allow us to see ourselves as 'part of the environment of trees and rocks and soil...part of the natural world and competent to belong in it'. Taken together, he concluded, such places constitute a 'geography of hope'.

The phrase is memorable; its sentiment is invaluable. There are, as Stegner knew, certain thoughts and feelings that can be had only in certain places: cognition is site-specific as well as motion-sensitive. It has long seemed to me that we might imagine landscapes as holding specific ideas and experiences just as they hold certain stones, minerals or species; that we might even talk of landscapes as growing ideas as they grow plants. And that, by extension, when we lose certain places – when they are destroyed incidentally, or deliberately – we lose not only the life that they held but also the thoughts that they enabled.

Yes, thought – like memory – inhabits external things as much as the inner regions of the human mind. Forests, moors, rivers, mountains, lakes, heathlands, sea cliffs, islands...but also parks, copses and nature reserves: these are places that can kindle new ways of being or thinking in people, can urge their imagination differently. It is valuable and disturbing to walk through a woodland containing oak trees that take 300 years to grow, 300 years to live, and 300 years to die. Such knowledge, considered seriously, changes the grain of the mind.

Over the past two years I have been involved with a mental health project called Gateway to Nature, designed to improve access to natural places for homeless and vulnerable people in the Midlands. The project is led by a deeply inspiring man called Graeme Green, who is convinced of the worth of contact with nature – of the new kinds of feeling that it can provoke in profoundly troubled individuals, as well as in the more fortunate. Graeme's group have planted an orchard on one community allotment, and have grown vegetables on another. They have been taught the basics of birdwatching, nature photography and botany, and they have learnt to lay hedges, cook outdoors and read maps. They have gone for walks together along rivers, in country parks and through other nearby green spaces. The gains have been slow but unmistakable: they speak of new feelings of confidence, of balance, of calmness. Taken together, the places to which these people have been have come to constitute their geography of hope.

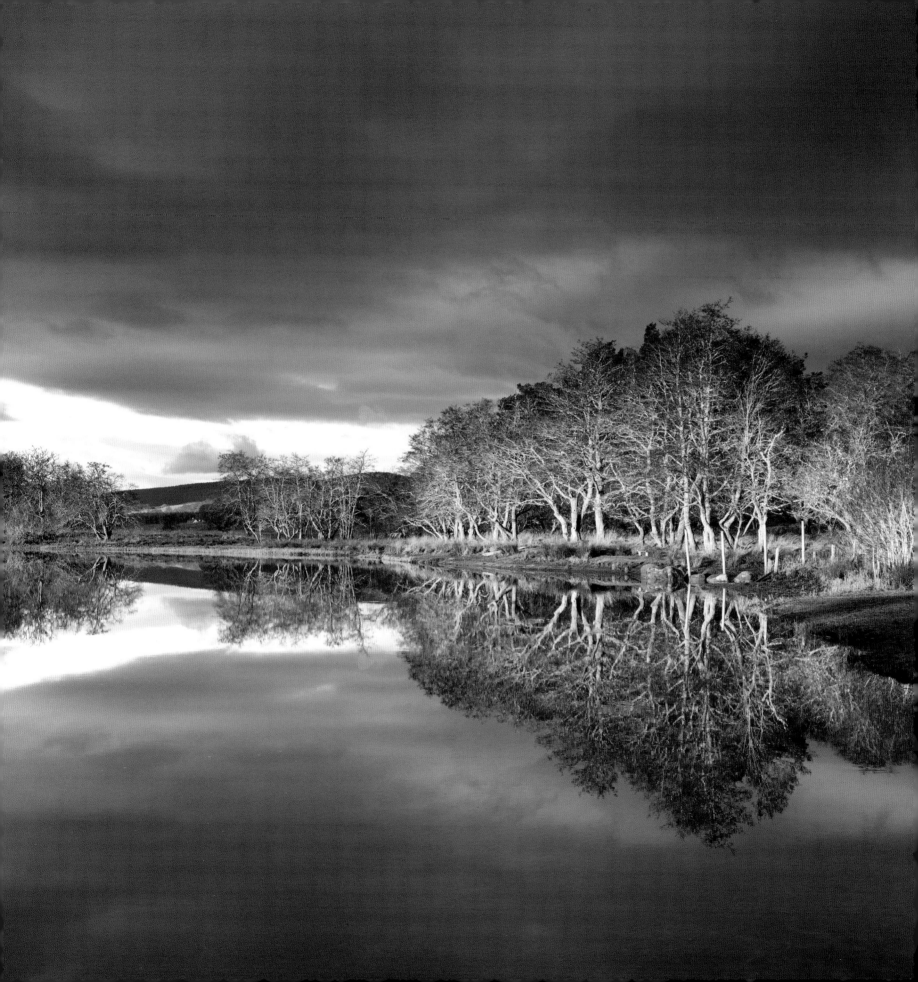

↑ **CHALK RIVER LANDSCAPE**

WATER VOLE FEEDING AT RIVER'S EDGE →

River Itchen, Hampshire, England

River Itchen, Hampshire, England

The chalk rivers that flow through much of southern England are iconic and abundant in life. They are also under threat. By 2020, an increasing population will mean demand for water is likely to be around 5% higher – that's an extra 800 million litres of water per day! Several chalk rivers are already classified as 'over-abstracted'.

Through its Rivers on the Edge project, WWF UK is working on better ways to use and manage our water – presently one-third of the water taken from our natural environment is wasted. By taking only what we need and using it more efficiently, we can meet our needs and still leave enough for species such as the water vole.

The river changes from year to year and that's why I find it a place of wonder and excitement. James Wright, student, Somerset

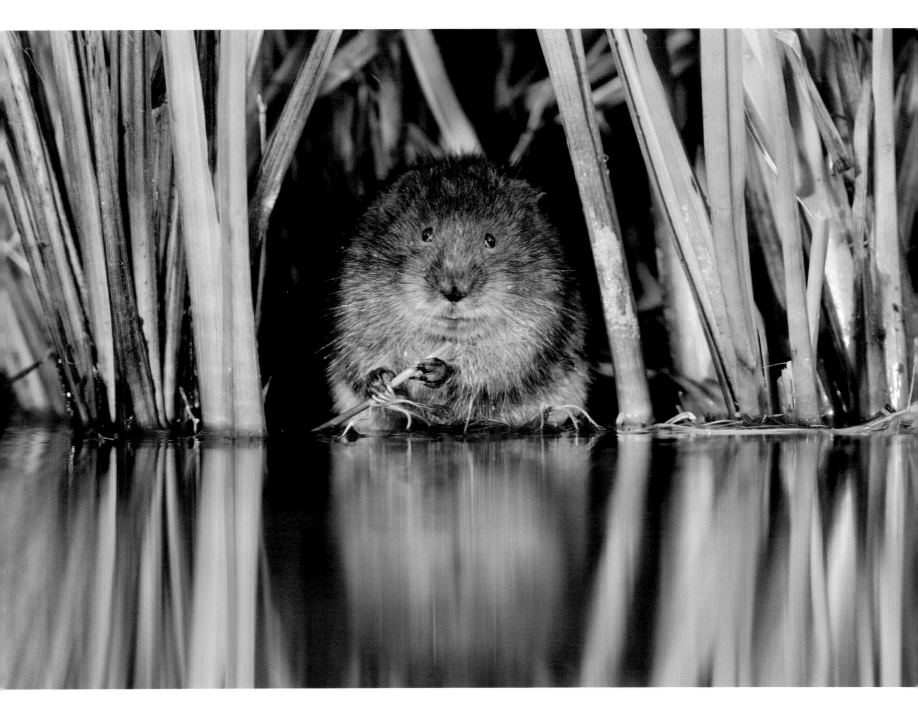

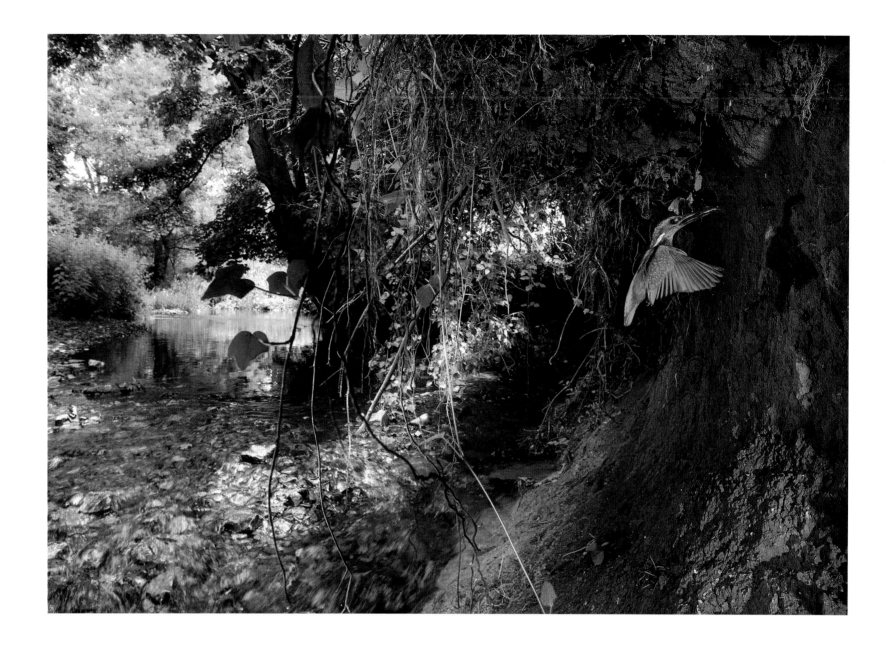

KINGFISHER RETURNING TO THE NEST WITH FISH

Devon, England

Landscape-scale thinking is starting to influence how we manage our river systems –
like here in North Devon, where the Torridge river catchment has been chosen as one
of 12 UK Nature Improvement Areas. Restoring wider ecological health to the river
and its surrounding habitats will not only create a wildlife-rich ecosystem, it will also
improve the quality of water courses and stimulate local economies.

A river is so much more than water between two banks; it shapes and sustains the whole landscape through which it winds. Rose Timlett, Rivers on the Edge Project Officer, WWF UK

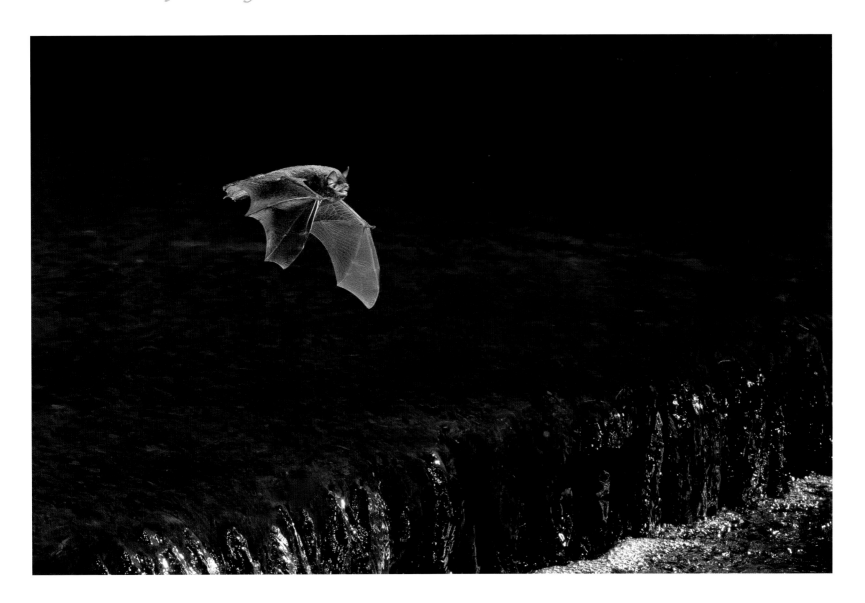

DAUBENTON'S BAT HUNTING FOR INSECTS OVER THE RIVER DUDWELL

East Sussex, England

Daubenton's bats emerge at twilight flying low across rivers and canals, often using their large feet to trawl for insects from the water's surface. They are efficient hunters and after just one hour of foraging can increase their body weight by over 50%.

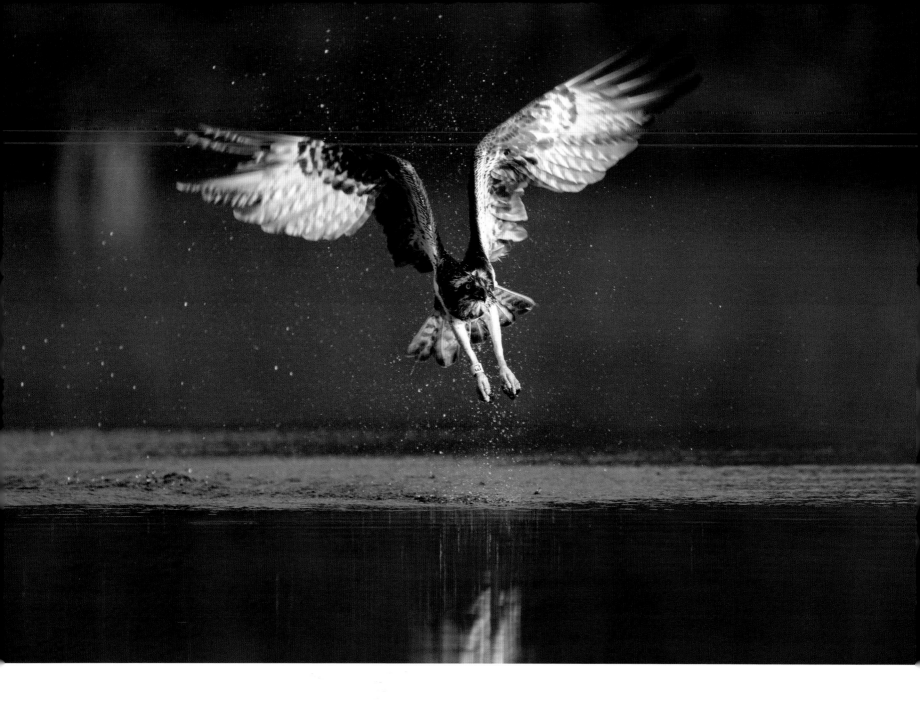

OSPREY FISHING

Cairngorms, Scotland

Just 50 years ago, ospreys were believed to be extinct in the British Isles until a single pair famously appeared at the shore of Loch Garten in the Cairngorms. Since then, the osprey has found its way back across much of Scotland and now breeds in growing numbers across England and Wales. As with otters, the improving health of river systems – along with the building of artificial nests by osprey enthusiasts – has fuelled the spread of this spectacular fish hunter.

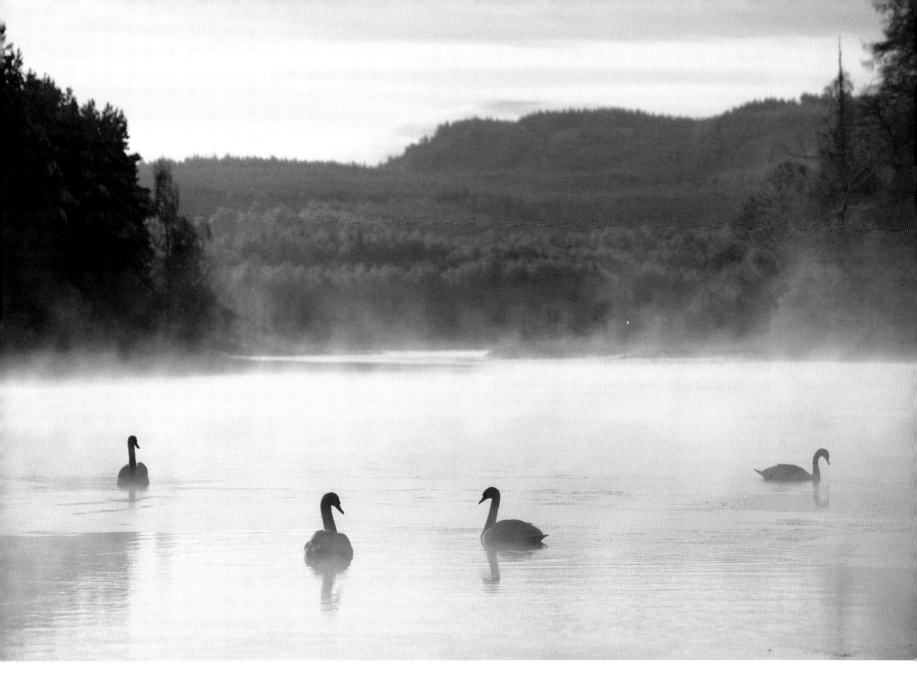

MUTE SWAN QUARTET

River Spey, Scotland

The River Spey meanders its way through the Insh Marshes, one of Europe's most important wetlands and home to wintering geese and swans as well as high numbers of breeding waders in the summer. The Spey is rightly famous for its salmon fishing and is protected for its populations of ospreys, freshwater pearl mussels and otters, but is perhaps valued most for the pure spring waters it provides to Speyside's whisky industry!

River in numbers

389,000km: The combined length of the UK's rivers.

25: The number of coarse fish species found in the Thames.

296km: The length of the Thames Path – the longest riverside walk in Europe.

13 million: The number of people who use inland waterways each year.

£23 million: The annual income raised from boating licences and mooring fees.

150 tonnes: The amount of litter removed by volunteers during the annual UK Towpath Tidy.

354km: The length of the River Severn, the longest river in the UK.

£18 million: The amount of Defra funding allocated to meeting water quality and ecology targets by 2015.

100%: The proportion of English counties with rivers containing otters.

£9 million: The amount invested in the Tweed Rivers Heritage Project.

6: The number of species of mussel found in the River Wye.

90%: The amount of London's water provided by the Thames and Lee.

£1 million: The amount raised for charity by comedian David Walliams' 140-mile Thames swim.

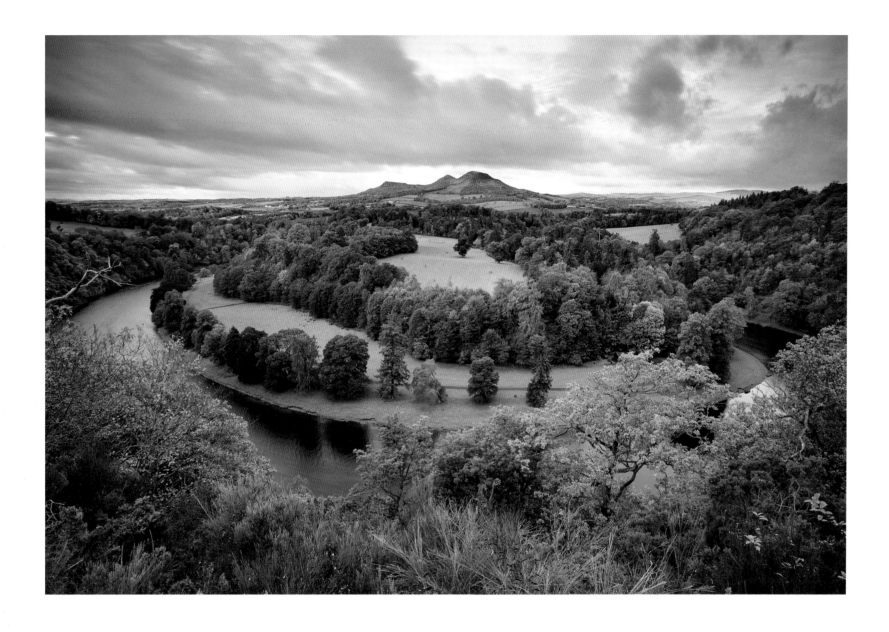

SCOTTS VIEW, RIVER TWEED

Scottish Borders

The Tweed is one of the great salmon rivers of Britain, running for 160km primarily across the Borders region. The Tweed Forum, formed in 1991, brings together many different partners with varied interests in the long-term health of the river; although protecting salmon stocks is an inevitable priority, this can only be done by protecting the river's living systems from source to sea. Catchment thinking!

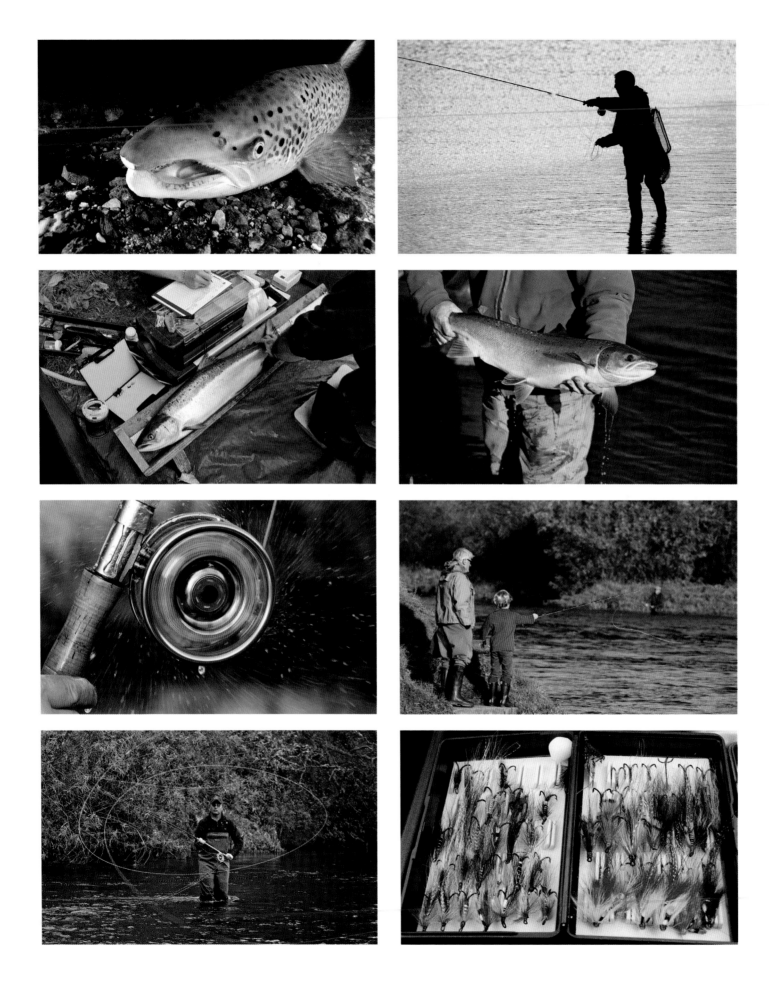

Fishermen pay quite a lot to fish here and spend a lot when they are here – so for the local economy salmon are particularly important.

Nick Yonge, Director of the Tweed Foundation, Roxburghshire

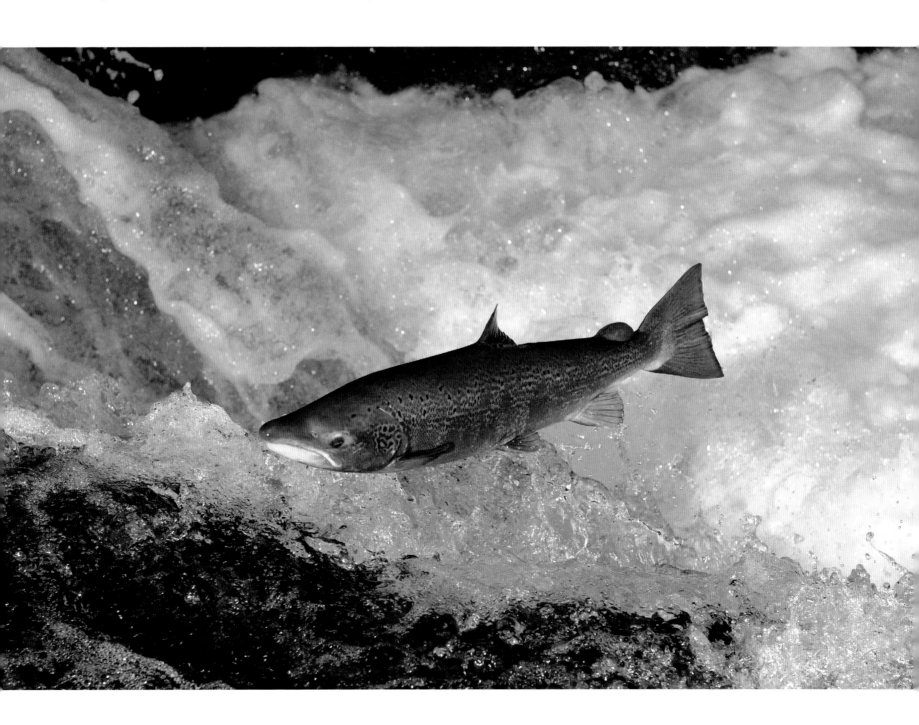

Flood defence. Artery. Irrigator.

More than just a *river*

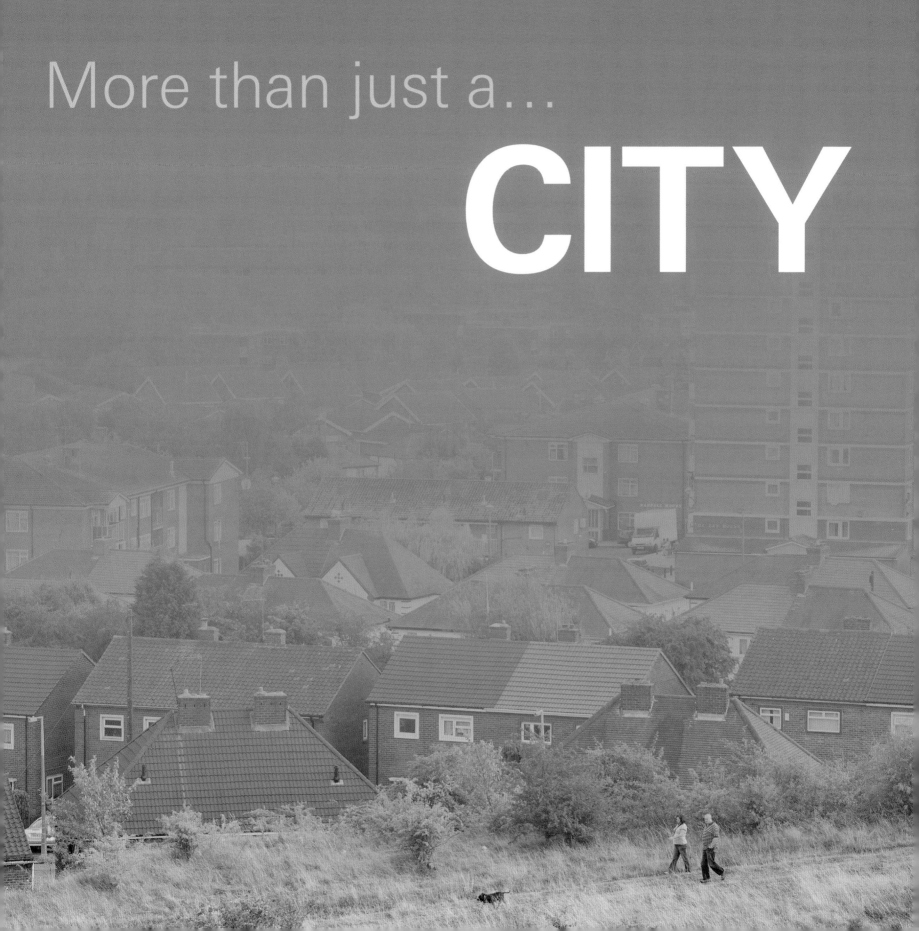

More than just a...

CITY

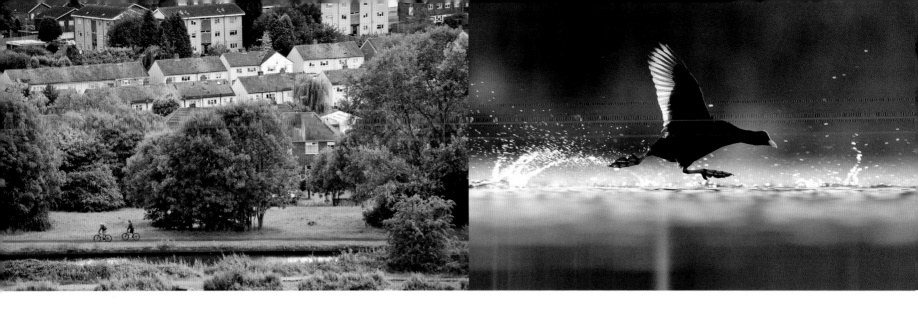

INTRODUCTION

Ask a group of people what their ideal living place might be and many would think of somewhere rich in natural resources; a place full of diverse sounds, colours and textures. It might be a cottage tucked away amid peaceful woodland, or a place where a river flows gently down to the sea beside a quiet beach. It might be an area of rolling hills, small meadows and scattered farms. It might be an island that combines many of these elements – leafy, watery, airy, naturally varied.

For the majority of us, whether in Britain and Ireland or worldwide, the reality is different. There's no doubt that we are now an urban species and that we will continue to be even more linked to towns and cities for the foreseeable future. Globally, the shift from majority rural dwelling to majority urbanite happened several years ago, and the global population of city dwellers is now growing by around 1 million a week. By 2030, roughly six in every ten people on the planet will live in metropolitan areas, formed by large cities and their connected, urban surrounds.

The size of some of the world's largest urban areas is already enormous, and is set to become even more mind-boggling. In China, there are plans to create the world's biggest 'mega-city' by merging nine smaller cities. This will be a metropolis twice the size of Wales, with a population 14 times larger.

In Britain, the shift from country living to town living began many generations ago, accelerating to a flood through the 1800s and beyond. By the turn of the 20th century, four out of every five people in England and Wales and more than two-thirds of Scots lived in towns and cities. The change in Ireland took longer to come about.

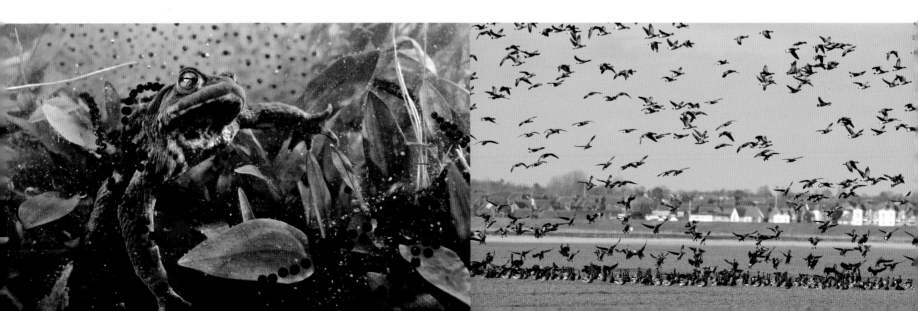

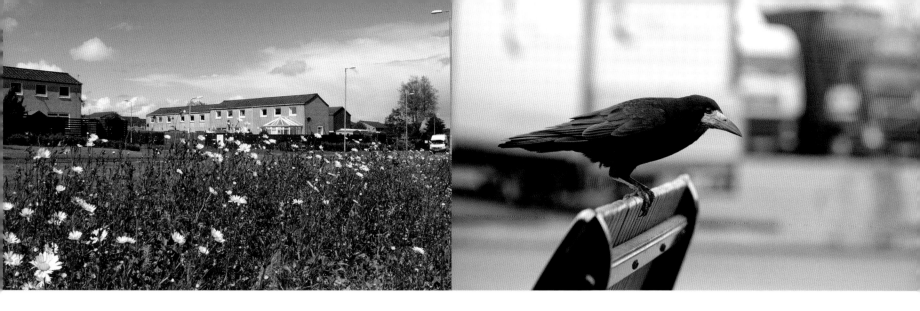

But there too, the majority of Irish people have been urban dwellers during the past half-century.

So urban quality of life is now of great importance to the average human being. Get it wrong, and vast numbers of people will suffer. Improve it, and millions, or even billions, will benefit. There's a growing body of evidence showing a host of ways in which city life can be improved for people. And the good news is that many of these can also benefit wildlife and help to reduce human impact on the planet's natural resources and climate. Some of those building blocks for healthy city environments should come as no surprise: they're leafy, watery, airy, naturally varied.

More good news is that many cities in Britain and Ireland already have these blocks already there, but often in need of better connections

between them. It's a bit like having jigsaw puzzles of healthy, green cities that have several of the pieces missing. But teams are working hard to fill in those gaps.

London is a superb case in point. With more than 7 million inhabitants, London is by far the largest city in Britain and Ireland (Birmingham, the next largest, hasn't yet topped a million). A surprising amount of land in London has trees. There are around 7 million individual trees, many of them native species. Gardens also cover nearly a quarter of London, adding greatly to the amount of green vegetation in the city.

Within the greenery of London, exciting new wildlife discoveries are still being made. In 2011, for example, a leafhopper (a small, plant-juice-sucking insect) never before seen in the UK was found on trees

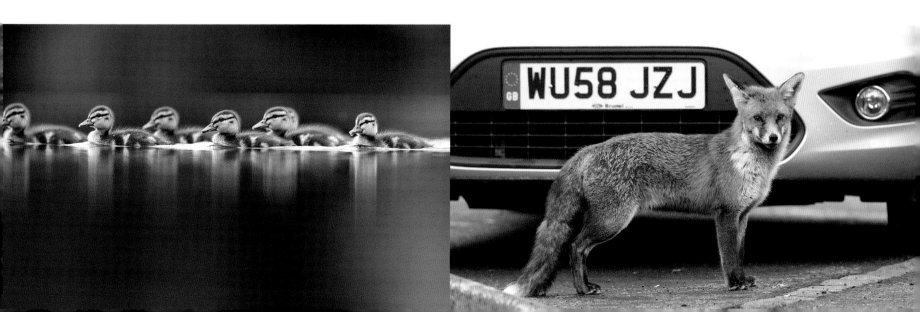

↑ JUVENILE PEREGRINE FALCON

London, England

Peregrine falcons have become ambassadors for urban rewilding. Taking to skyscrapers, cathedrals and office blocks as they would take to coastal cliffs, the fastest animal on the planet now lives in many UK cities and several pairs breed within Greater London.

PEREGRINE FALCON CHICKS IN THEIR NEST →

London, England

With a plentiful supply of fast food (city pigeons), peregrines are prospering in London, Derby, Chichester, Manchester and many other major conurbations. Their visibility means they are fast becoming media celebrities. Tens of thousands of people watch these birds each year, blogs and diaries plot their story, and the London Peregrine Partnership works with the police, conservation groups and local communities.

But there too, the majority of Irish people have been urban dwellers during the past half-century.

So urban quality of life is now of great importance to the average human being. Get it wrong, and vast numbers of people will suffer. Improve it, and millions, or even billions, will benefit. There's a growing body of evidence showing a host of ways in which city life can be improved for people. And the good news is that many of these can also benefit wildlife and help to reduce human impact on the planet's natural resources and climate. Some of those building blocks for healthy city environments should come as no surprise: they're leafy, watery, airy, naturally varied.

More good news is that many cities in Britain and Ireland already have these blocks already there, but often in need of better connections between them. It's a bit like having jigsaw puzzles of healthy, green cities that have several of the pieces missing. But teams are working hard to fill in those gaps.

London is a superb case in point. With more than 7 million inhabitants, London is by far the largest city in Britain and Ireland (Birmingham, the next largest, hasn't yet topped a million). A surprising amount of land in London has trees. There are around 7 million individual trees, many of them native species. Gardens also cover nearly a quarter of London, adding greatly to the amount of green vegetation in the city.

Within the greenery of London, exciting new wildlife discoveries are still being made. In 2011, for example, a leafhopper (a small, plant-juice-sucking insect) never before seen in the UK was found on trees

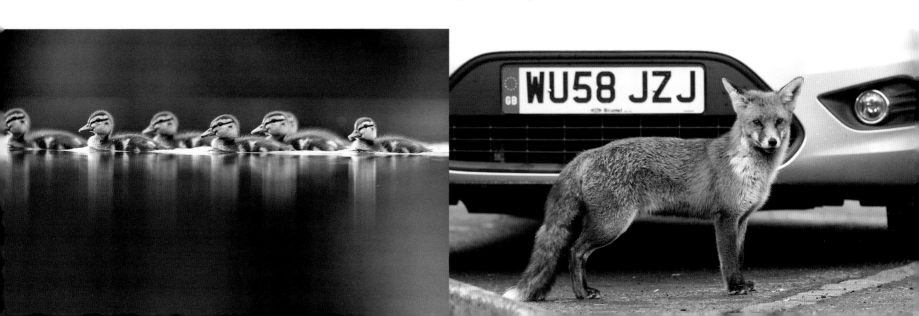

in Peckham. Pride in city trees and open-access urban green space has been strong in London for a long time. In 1897, it's thought that some 15,000 people gathered at One Tree Hill to protest at its enclosure by a golf course. Popular pressure pushed the local council to buy the hill as open space for public benefit. The hill is now wooded, and its eastern slope is home to many allotments where keen gardeners have created ponds for wildlife, tend beehives and run a local composting network.

That's a small-scale example of working to make an urban space better for people and wildlife. On a much larger scale, the Futurescape project for the Greater Thames area extends over 1,000 square kilometres from Tower Bridge to the North Sea. This area holds some brilliant wetlands. Different groups and agencies are working together to halt the loss of these wetlands and to make a network of green corridors to allow plants and wildlife to disperse between them.

Just north-west of Birmingham, the area known as the Black Country is the old engine room of England. It was the world's first industrial landscape and one of the most intensively industrialised regions of the UK. The region took its name in the 1800s from how smoke from thousands of iron foundries, fuelled by coal from thick seams there, darkened the skies and blackened buildings, not to mention the faces and clothes of the people who worked there. The glowing foundries and belching smoke led Elihu Burritt, the American Consul to Birmingham in 1862, to describe it as 'black by day and red by night.'

Now, the Black Country Living Landscape project is working to change the area's tarnished old image for good (in more ways than one). One of a dozen Nature Improvement Areas that have won government backing across England, it has put wildlife at the core of urban renewal projects. Wetlands, rivers, heaths and woodlands are part of work being carried out by many different partners.

In the middle of Scotland, the unfolding Central Scotland Green Network (CSGN) is the largest green space project of its kind in Europe. It covers 10,000 square kilometres. Within the next few decades, it should benefit 3.5 million city and town dwellers, or about seven in ten of the entire Scottish population. According to its many partners, the CSGN hopes to support sustainable economic growth and benefit the health and wellbeing of both people and wildlife at a time of changing climate.

Those are big claims. Luckily, there is a growing amount of evidence, from urban areas worldwide, to show how greener cities can equal healthier, wealthier, happier people and richer wildlife. City trees, for example, give shade and coolness in the summer months and can help to reduce flood risk.

Access to good-quality urban green spaces improves health and – amazingly – the present evidence is that it can even increase length of life. Green spaces also help to bring people together, helping them to meet and socialise, and can reduce local crime.

Greening also boosts local economies, including through making an urban area more desirable as a living place and business location. For wildlife, a wide range of species, from the very common to the very rare, now thrives in British and Irish cities and could be helped by further, greener changes.

So the ideal living place for a person in the 21st century might be described as something like this: a city area with plenty of trees (hear the birds); clean streams running through it (see the fish); and green areas where people can walk, meet, exercise and relax (watch the smiles).

Leafy, watery, airy, naturally varied. That's how it already is in some city areas. That's how it needs to be in many, many more.

↑ **JUVENILE PEREGRINE FALCON**

PEREGRINE FALCON CHICKS IN THEIR NEST →

London, England

London, England

Peregrine falcons have become ambassadors for urban rewilding. Taking to skyscrapers, cathedrals and office blocks as they would take to coastal cliffs, the fastest animal on the planet now lives in many UK cities and several pairs breed within Greater London.

With a plentiful supply of fast food (city pigeons), peregrines are prospering in London, Derby, Chichester, Manchester and many other major conurbations. Their visibility means they are fast becoming media celebrities. Tens of thousands of people watch these birds each year, blogs and diaries plot their story, and the London Peregrine Partnership works with the police, conservation groups and local communities.

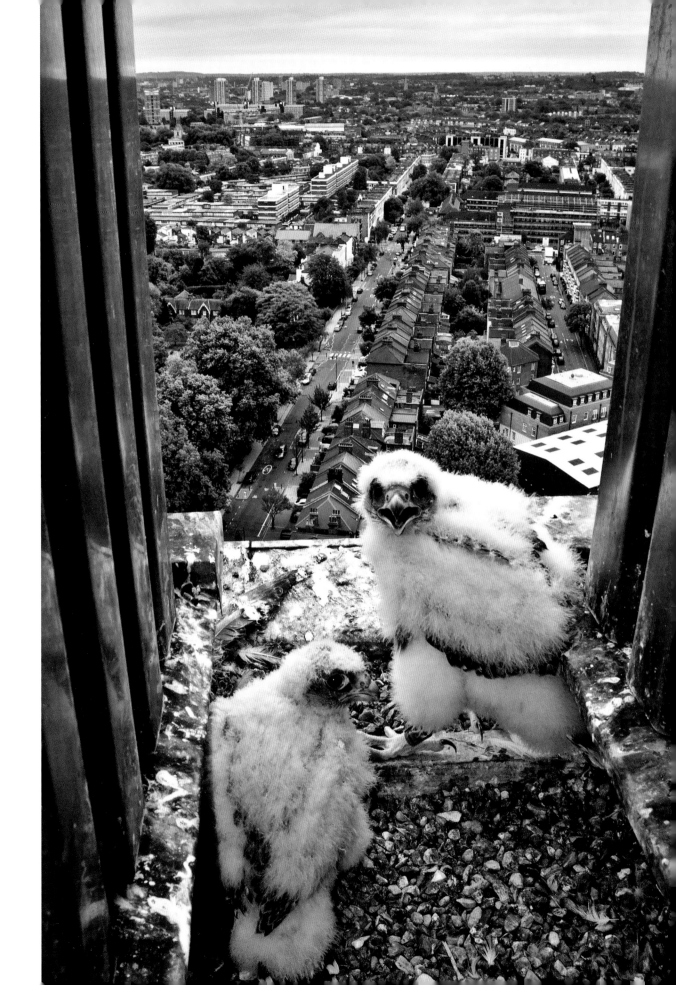

Cities are my favourite places to find wildlife. I'm always on the lookout for a peregrine swooping between skyscrapers or a fox dashing across the street.

Bertie Gregory, 2020VISION
Young Champion

GREY SQUIRREL IN REGENT'S PARK

London, England

In a city dominated by people's needs, it's easy to imagine that there is no space for wildlife, but that's not true. London's parks are havens for a range of species and their tolerance of people ensures there's plenty of opportunity for close encounters.

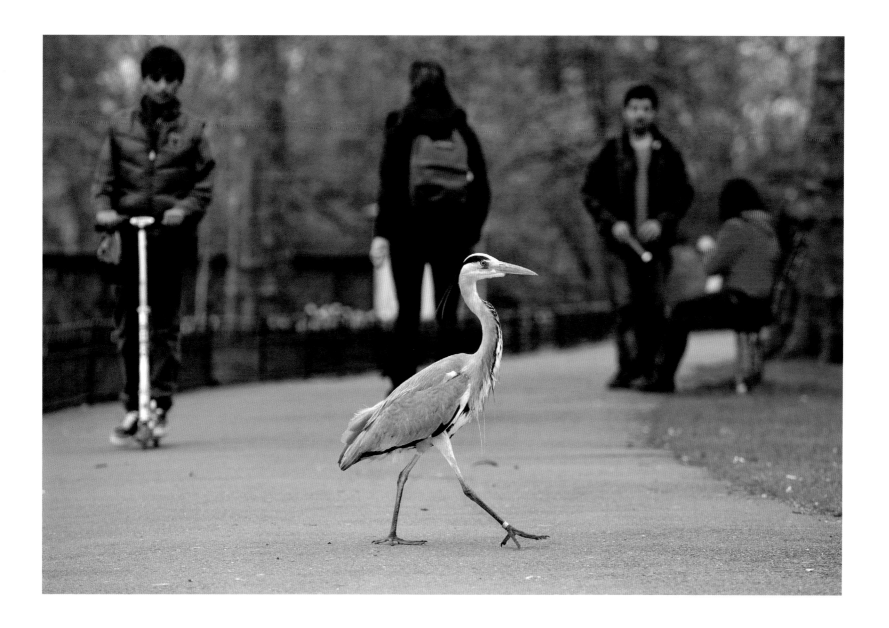

GREY HERON IN REGENT'S PARK

London, England

Beyond its parks and heaths, London is home to one of the most ambitious nature regeneration
projects that the UK has ever seen. The Greater Thames Futurescape, led by the RSPB, is a partnership
of over 100 organisations working together to transform 1,000 square km of the Thames catchment.

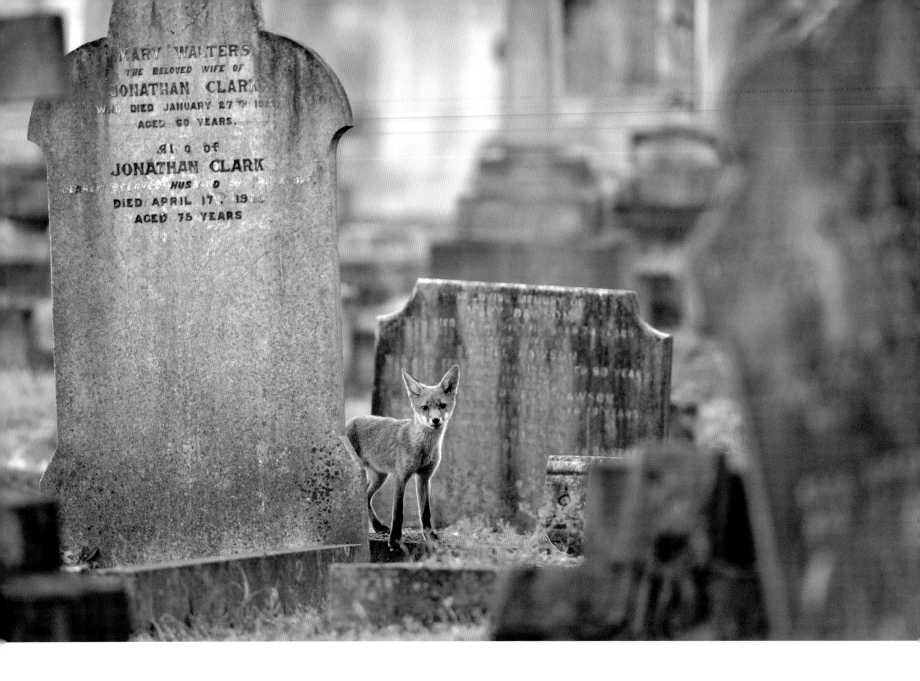

RED FOX IN CEMETERY

London, England

The Greater Thames Futurescape will create diverse habitats for wildlife alongside green space for people. These long-term inspirational initiatives can also inform our thinking on how we manage other urban areas, such as cemeteries, roadside verges and public parks, as well as our own gardens, all of which can become real oases of life amidst the sterile functionality of many of our urban centres.

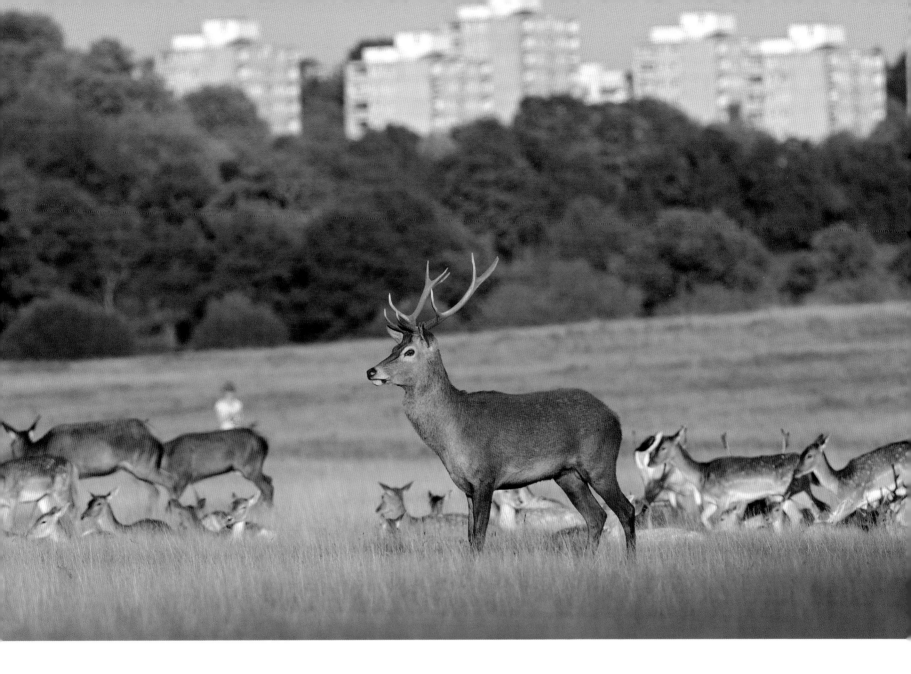

RED DEER HERD, RICHMOND PARK

London, England

Marrying the needs of wildlife and people is tricky on a tiny, crowded island like ours. Yet imaginative coexistence brings rich rewards. Time spent in green spaces with other species broadens the mind, lends a perspective to our lives, and teaches our children life lessons that cannot be taught in the classroom. Wildness – even in our biggest cities – is a necessary reminder of where we come from.

Urban green space is the heart and soul of a city. Steve Mason, Greenspace Management, London

LANDFILL SITE

Pitsea, Essex, England

Pitsea is the country's biggest landfill site and, beyond the obvious attraction to scavengers, a hostile place for both wildlife and people. But the Greater Thames Futurescape project plans to turn this festering waste mountain into a vibrant green space. The managers of the site, Veolia Environmental Services, will also harness the methane gas from the landfill to provide energy for years to come. This is not just a physical change but a change in philosophy: recognition that conservation must look beyond nature reserves and become integral to our thinking rather than a bolt-on extra in the good times.

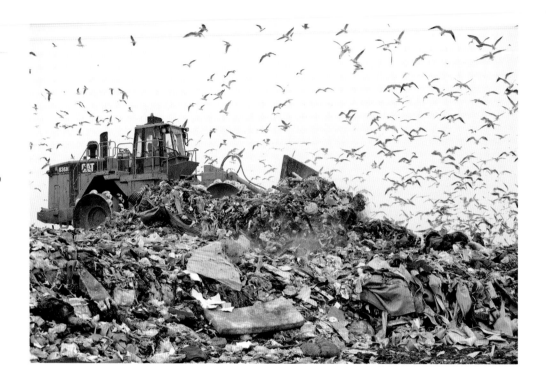

GARDEN SNAIL IN AN URBAN GARDEN

Wiltshire, England

Even the smallest of gardens – urban, suburban or rural – are valuable pieces of natural capital, potential links in an ecological chain across a whole city, county or even country.

BUILDING CITIES WITH NATURE IN MIND

DAVID LINDO, WRITER, BROADCASTER AND 'THE URBAN BIRDER'

When I tell you that I am passionate about restoring some of Britain's fragmented landscapes, what do you visualise? In your mind's eye, do you see some beauty spot well away from habitation in a secluded part of the countryside? Or do you see a bit of parkland with a small wood surrounded by housing and factories? Well, I see both. In my view, despite the fact that it is imperative that we preserve our wild environments for future generations, the concept of conservation has to spawn from our cities, because that is where most of us live.

I was born and bred in London and it seems that from the moment I popped into the world I have been observing nature and in particular birds in urban environments. My interest in urban wildlife was born out of necessity. I grew up in Wembley, north-west London, and as a kid I had no mentors nor did I have any relatives or friends who could whisk me away to Shangri-La, also known as the countryside – the place where, in my innocence, I thought that all wildlife endured. Instead, I was stuck in the city and, more precisely, my immediate neighbourhood.

Over the years I have grown to realise just how important urban habitats are for our wildlife and, conversely, how few city dwellers actually realise this. It has been shown that urban areas are now essential to the survival of bees and that they provide superb roosting, nesting and feeding sites for some bird species. Brownfield sites and certainly fallow land can be magnets for a plethora of wildlife, even if some urbanites view these areas as 'waste ground' or, at best, somewhere to walk the dog. The nature of the beast is that almost any area of open land in a city environment is deemed fair game by developers, whose dark shadows loom over these sites as they plan the building of yet another shopping mall. Don't get me wrong; we do need new housing and offices – that is what cities are all about. But what is stopping the architects and planners from building with nature in mind? Surely it is not that difficult to provide inbuilt nesting and roosting sites within new structures and design the surrounding green areas using native flora and lakes with reedbeds?

Over 80% of the UK's population live in urban areas and a large number of those people are disconnected from nature, believing that wildlife is either to be found on television or out in the depths of the countryside. My feeling is that if you cannot get these people into the countryside, then the countryside should be brought to them.

So why should we consider certain parts of our towns and cities as places worth rewilding? For me, the answer is quite simple. We all need space to breathe, contemplate and reflect. It is a prerequisite for healthy minds. By making urban spaces more hospitable to nature we will ultimately benefit from the tranquillity and beauty that result, even in the heart of a big, bustling city.

At the nursery where I work, the children grow their own vegetables on site and they just love it! Sarah Hazell, nursery cook, Derby

City in numbers

1 million: People attending Love Parks Week events.

200: Bird species recorded at WWT London Wetland Centre.

7: Bat species recorded at WWT London Wetland Centre.

100 acres: The area of land occupied by the WWT London Wetland Centre.

£450 million: The funding given to UK urban green spaces through the Urban Parks Programme and Public Parks Initiative.

£1.2 million: The grant awarded by the Access to Nature programme to fund six natural environment projects in London.

10%: The percentage increase of green cover required in order to keep maximum surface temperatures in high-density urban areas at or below the 1961-90 level.

3°C: The difference in temperature between a London park shaded by trees and a neighbouring unshaded shopping street.

4.9%: The reduction in surface run-off when green cover is increased by 10% in residential areas.

5.7%: The reduction in surface run-off when tree cover is increased by 10% in residential areas.

2.5 tonnes: The volume of carbon per hectare per year absorbed by an urban beech tree.

10%: The energy saving made on heating/cooling buildings sheltered by trees.

Cities often conjure up the image of a concrete jungle, but look between the cracks and you will find all sorts of wildlife. Nick Gardner, Project Dirt, London

MALLARD IN EVENING LIGHT

Birmingham, England

The Black Country Living Landscape in central England is another example of urban greening with many objectives and benefits. Led by the local Wildlife Trust, the ambitious programme of works will transform this industrial landscape into a healthier, more diverse place to live with nature at its heart. Mallards, a familiar sight on city ponds and rivers, are one of many species to benefit from the revitalisation.

RED KITE SWOOPING FOR FOOD

Chilterns, England

Once widespread across the whole country, these spectacular birds of prey survived in just a few small pockets of Wales until a series of reintroductions kicked off in the late 1980s. Since then, red kites have been reintroduced to several areas in England and Scotland, providing a wildlife spectacle that would have been unimaginable just a generation ago.

THE NORTHERN KITES PROJECT

Gateshead, England

The Northern Kites project in north-east England was a world first in returning kites into an urban fringe within 20 minutes of 1 million people. This flagship initiative is not just about establishing a red kite breeding population; it aims to show the crucial link between a healthy environment and the overall quality of life for local people.

I love the way that our urban wildlife means that we can all continue to be inspired by nature on a daily basis, wherever we live.

Steve Rowland, Public Affairs Manager, RSPB

Trying to look beyond the immediate needs of just one species is something that our society finds difficult, but all over the UK there is fresh thinking about how our urban centres are best planned, designed, built and regenerated to become more than just places that provide shelter and jobs. We're all affected by air and water quality, waste disposal issues, climate change, access to outdoor recreation and the potential for flooding, and yet, to address these issues we still need to shift our mindset as well as change our behaviour. Urban rewilding initiatives such as the Greater

Thames Futurescape and the Black Country Living Landscape, as well as others like the Central Scotland Green Network, are in their infancy and yet they are growing because at their heart there are people: good people, committed people, people with a vision that they want to share.

Urban green spaces are vital for our health and wellbeing. They are biodiversity spaces in our cities.

Sandra Wynn, primary school teacher, Croydon

Green lung. Soakaway. Refuge.

More than just a *city*

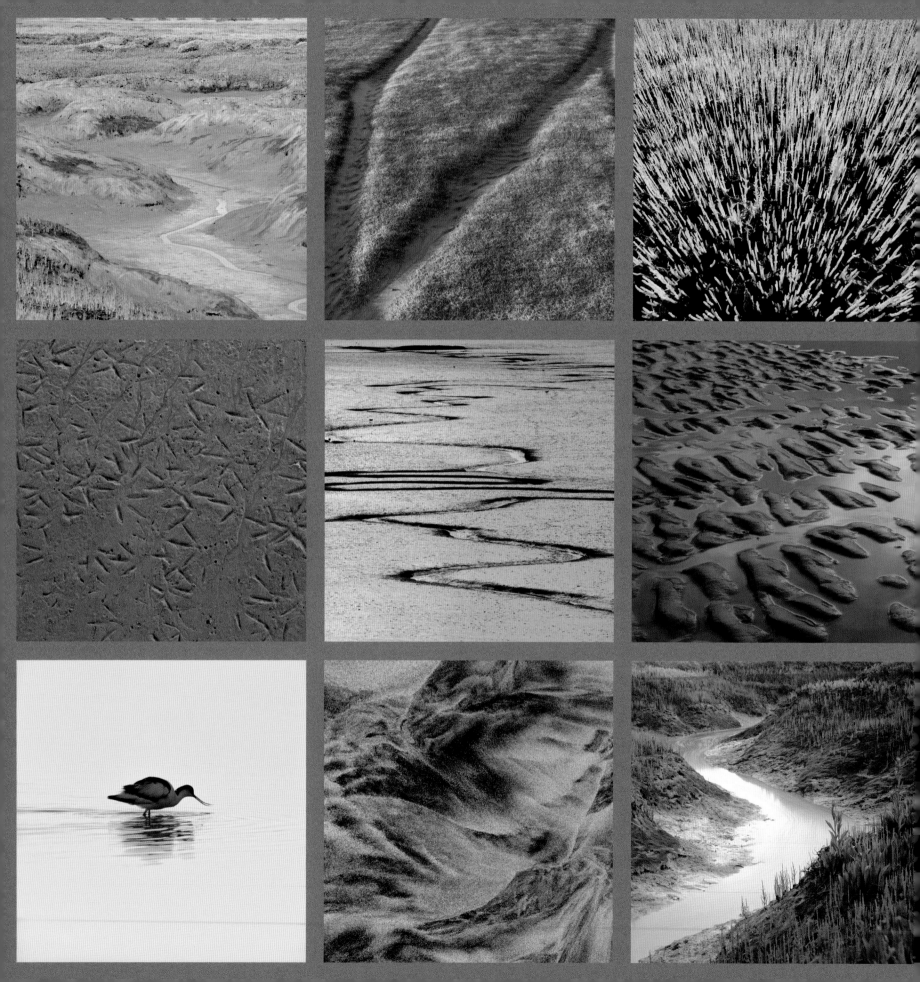

More than just a...
SALTMARSH

INTRODUCTION

Perhaps surprisingly, the rather featureless-looking vast, flat expanses of mud and sand that are found at the meeting of salt and fresh water can be some of the most life-rich places on the planet. The sediments in these estuaries are stuffed with different small creatures. In turn, these become food for larger ones, especially birds.

Just think of some of the figures. One square metre of mudflat in a Scottish estuary can hold up to 28,000 small mud shrimps. That's more than 200 million in an area the size of an international football pitch. Keep the football pitch in mind, and add 300 million tiny snails and several million other, larger molluscs such as tellin and cockles. Now add marine worms, such as lugworms. Cue shoals of small fish at high tide, and expose beds of eelgrass to give greenery around the edges when the tide recedes.

For many kinds of wading birds, ducks and geese, this combination of estuary creatures and plants has a simple, life-supporting meaning: these places are natural, all-you-can-eat takeaways. There are more than 90 estuaries in the UK, and although many have been modified, some still hold their star ratings as bird dining areas of international importance. The Wash, Morecambe Bay, Solway and Dee are some of the largest and most bird-rich. But every estuary here is an asset, particularly for birds that may have travelled thousands of miles to reach it.

Britain and Ireland are in prime locations as resting, refuelling and long-stay stopovers on what is called the East Atlantic Flyway. Millions of birds use this every year, going to and from breeding grounds that could be in the far north (countries such as Siberia, Greenland and Arctic Canada) and wintering grounds further south,

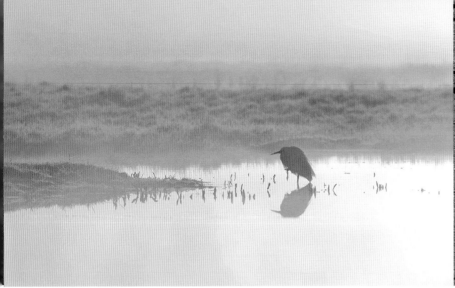

some in Africa. The birds on an estuary could include some from any of these places, and others besides, including Iceland and Svalbard. So when they are here, are they British or Irish? Or are they an asset for the whole of the northern hemisphere?

Whatever the answer might be to those questions, the impact of estuary birds can be simple, and stunning. A flock of knot, dunlin or other waders over shimmering mud can look like living smoke as it swirls and billows. A thousand geese flying in to roost can raise neck hairs with their wild calls. And when the mud and sand glisten in the low sun of a winter's morning, an estuary can seem much, much more than the word 'mudflat' conveys.

The worth of estuaries stretches further than their wave-washed lower levels. What happens at the fringes is also good for wildlife,

and could be increasingly important to people, as sea levels rise with warming climate. Salt meadows or saltmarshes are green, flat places that sit at the boundary between dry land (often farmed) and the sea on soft estuary coasts, or at the inland limit of sea lochs in the west of Scotland.

Plants here need to be tough enough to cope with lashings of salt on their leaves and stems, or to survive being underwater for parts of the day. They're often low-growing, but can include species that have a delicate beauty, such as sea aster, with pale lilac flowers, or a strange shape, such as glasswort, named for its past use in glass manufacture.

Sheep or cattle often graze on saltmarshes, further helping to keep the grasses low. On the Cumbrian coast of the Solway, for example,

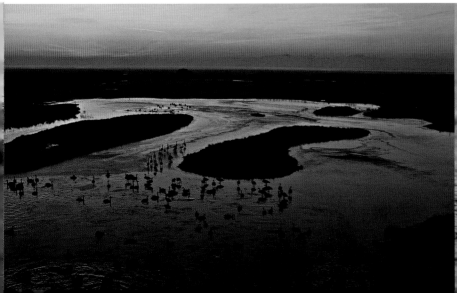

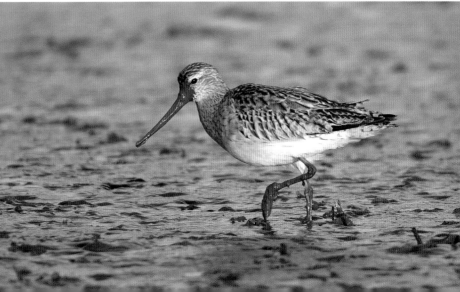

KNOT FLOCK

The Wash, Norfolk, England

For these wintering waders from the north, the vast expanse of windswept mud found in Britain's estuaries is like a motorway service station – a place to rest and refuel.

Islands of saltmarsh amongst shimmering pools and rippled sand are key elements of the rich tapestry that is the estuary as a whole.

Pam Taylor, Solway Firth Partnership, Dumfries

I've fished Morecambe Bay all my life, as have four generations before me, and I'm still in awe of it. Jack Manning, cockle fisherman, Morecambe Bay

HEADLANDS TO HEADSPACE AT MORECAMBE BAY

Cumbria, England

Morecambe Bay is the largest intertidal area in the UK, where four estuaries join in a horseshoe-shaped bay of spectacular scale. It is a kaleidoscope of water and light, sea and sky; a mosaic of shimmering sandbanks and shallow channels where the calls of curlew and pink-footed geese keep time with the ebb and flow of the tide. Morecambe Bay is also a place where people live and work, with traditional fishing for cockles and mussels signifying a strong cultural heritage and a sense of place so often found in communities who live on the coastal fringe.

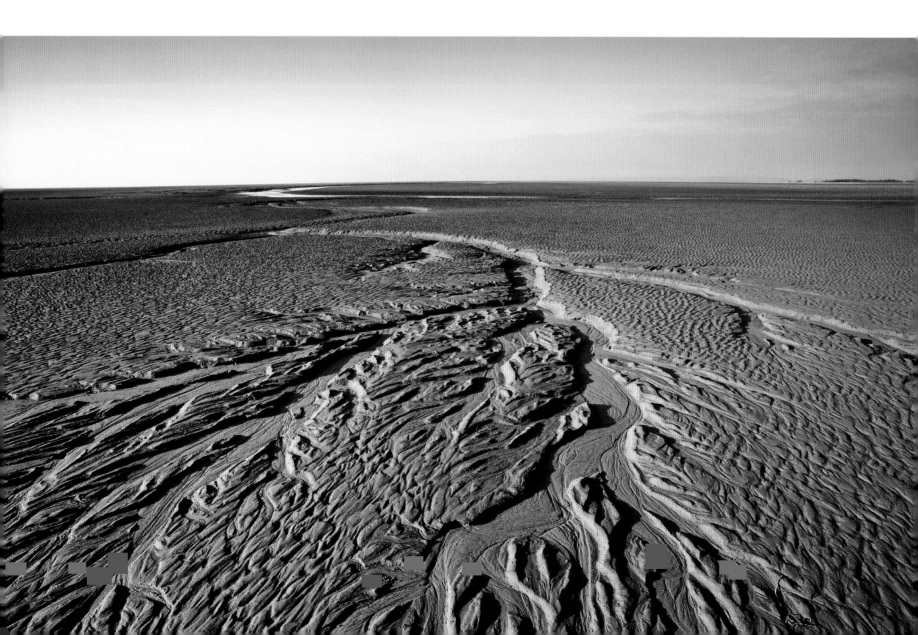

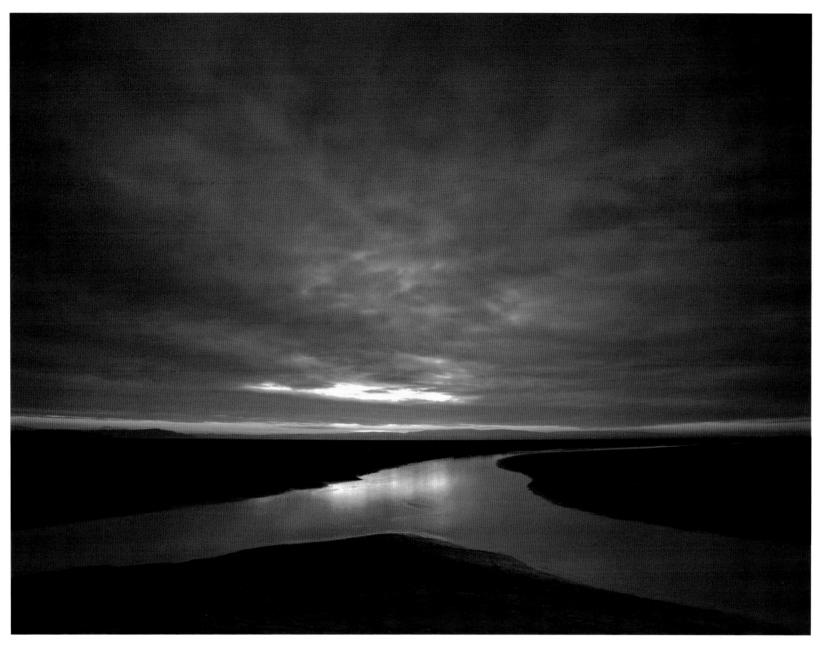

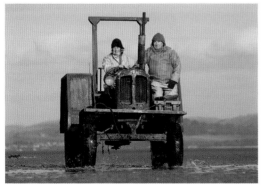

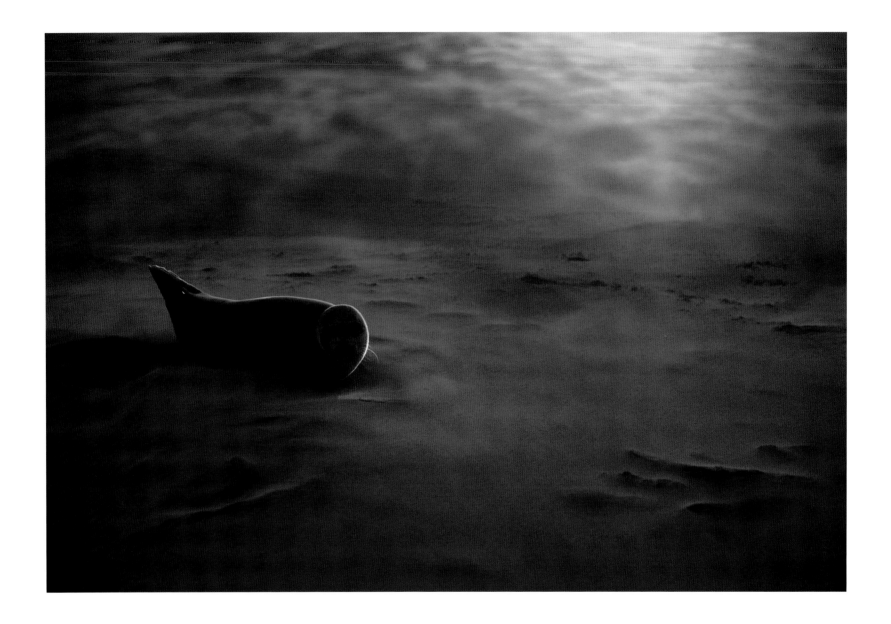

↑ **COMMON SEAL PUP IN A SANDSTORM**

MALE EIDER FLYING ACROSS AN ESTUARY →

Cumbria, England

Cumbria, England

The Headlands to Headspace (H2H) project aims to conserve and restore Morecambe Bay's natural and cultural riches. The project recognises integral links between the ecological integrity of the bay and its hinterland and the future prosperity of local communities.

In addition to 220,000 wintering waders and wildfowl, Morecambe Bay is home to the most southerly eider colony in the country. The birds profit from the high concentration of shellfish, something that is also valued by local people.

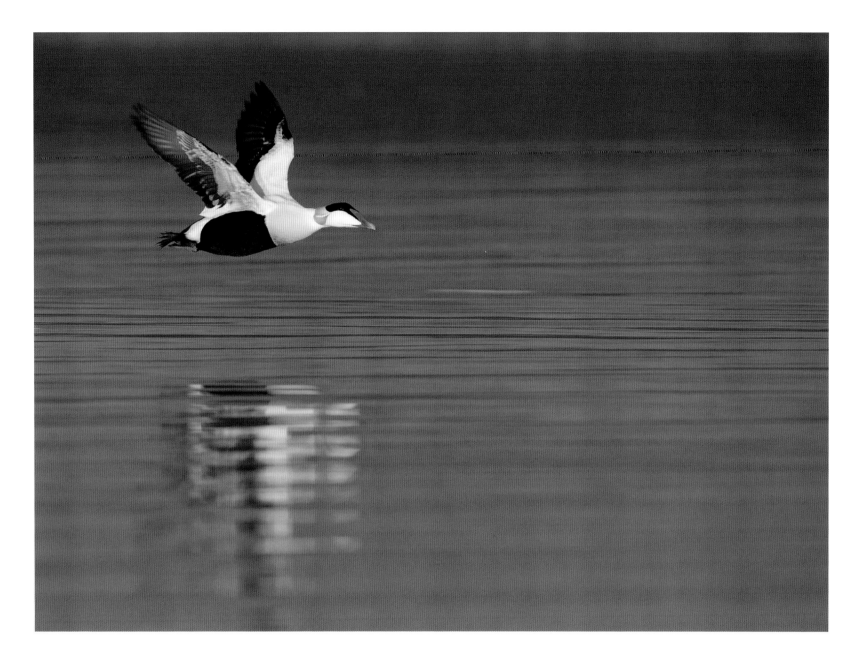

I have grown up with saltmarshes and hugely enjoy the wildlife they sustain.

Alan Smith, wildlife watcher and photographer, Morecambe Bay

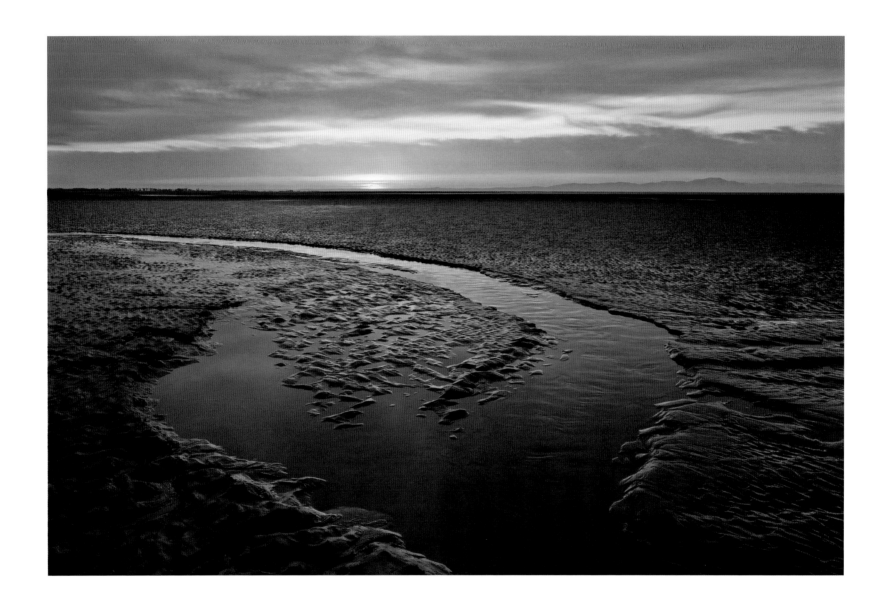

SUNSET OVER THE SOLWAY FIRTH

Dumfries and Galloway, Scotland

Further north, the Solway Firth straddles the border between England and Scotland. These massive expanses of life-filled mud and the surrounding saltmarsh that merges the sea with the land are natural flood defences and if, as predicted, sea levels continue to rise, it's not just wintering birds that will rely on them.

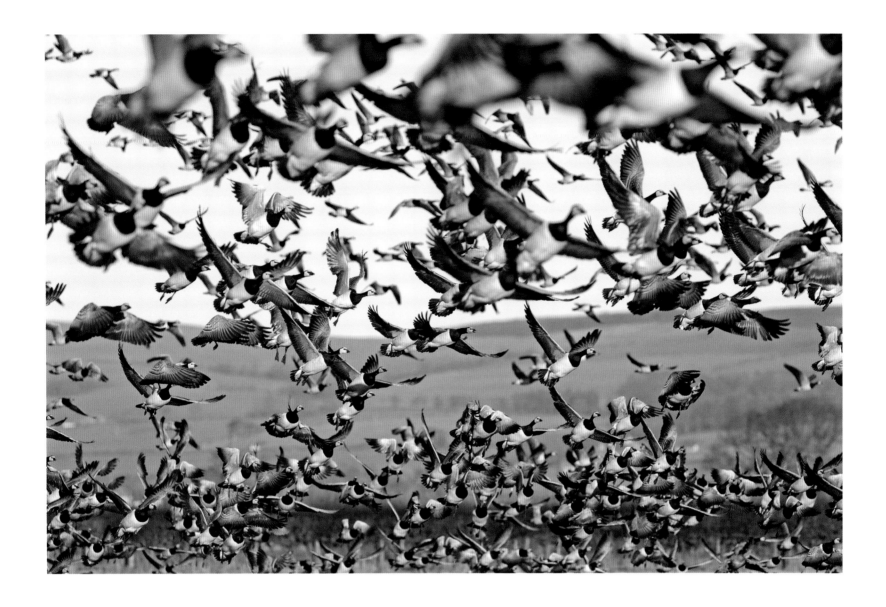

BARNACLE GEESE, CAERLAVEROCK

Solway Firth, Dumfries and Galloway, Scotland

In a cacophonous explosion, hundreds of barnacle geese take to the air. Each year over 20,000 of these Arctic breeders fly south from Svalbard to spend the winter in the relative comfort of the Solway Firth. The Wildfowl and Wetlands Trust reserve at Caerlaverock is one of the best places to see (and hear) the geese as they move back and forth between the mudflats and the coastal saltmarsh.

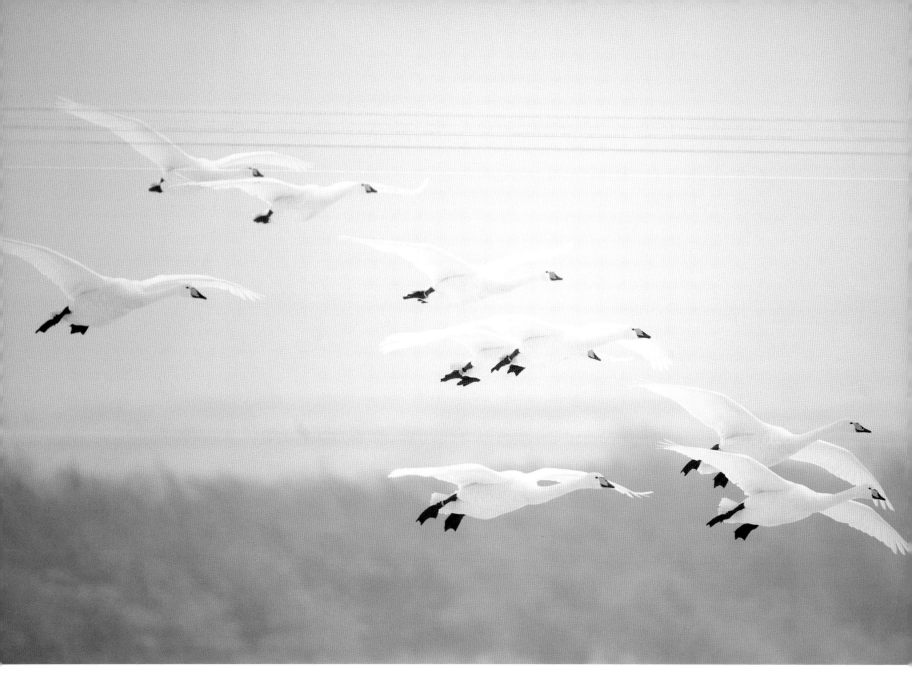

WHOOPER SWANS

Caerlaverock, Solway Firth, Dumfries and Galloway, Scotland

Each winter the barnacle geese are joined by the equally vocal whooper swans
that fly south from their breeding grounds in Iceland to take advantage of the rich
pickings on the Solway.

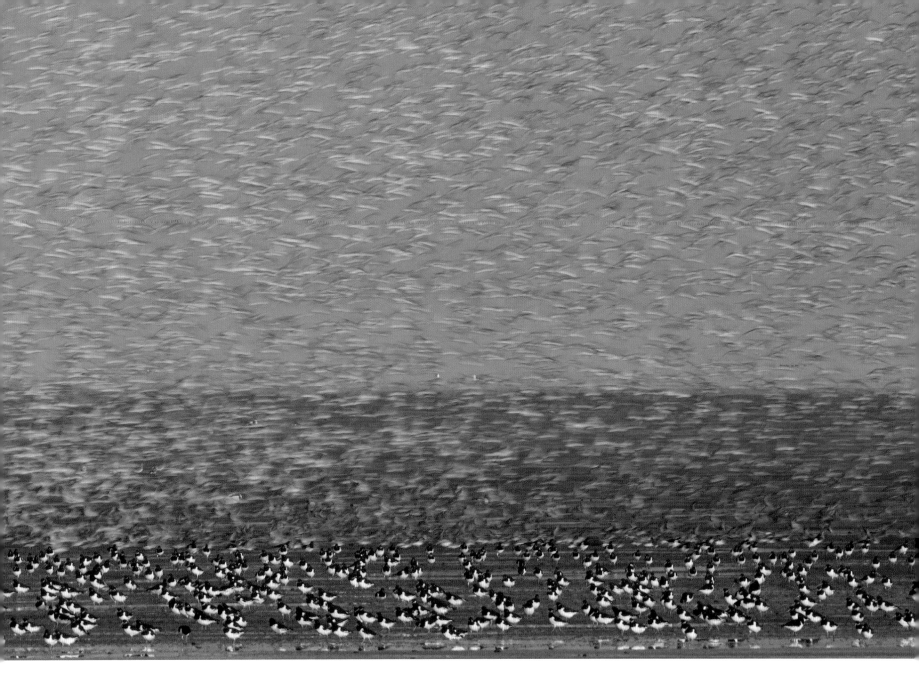

SWIRLING FLOCK OF OYSTERCATCHERS AND KNOT

The Wash, Norfolk, England

For tens of thousands of wading birds that visit the UK's estuaries each winter, mud is the key. Unglamorous it may be, but the food-rich squidgy stuff, full of shellfish and worms, keeps these birds alive until they return to their breeding grounds – often thousands of miles to the north – in the spring.

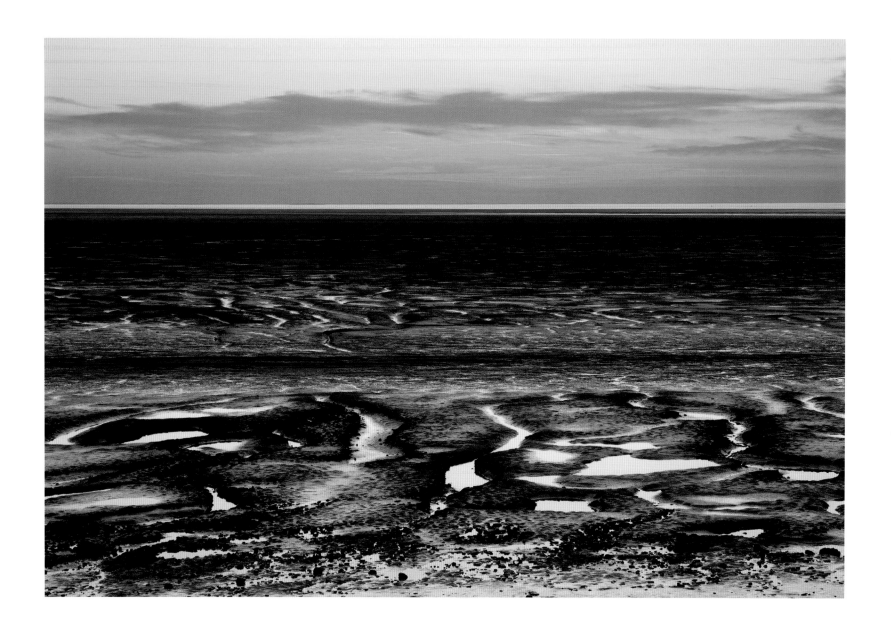

↑ **SUNSET ACROSS THE MUDFLATS**

The Wash, Norfolk, England

With the tide receded, the swirling mass of waders is gone. The mewing of gulls or the occasional piping of a redshank or oystercatcher is all that breaks the silence as the Wash settles down for the night.

PINK-FOOTED GEESE AT DAWN →

The Wash, Norfolk, England

As a winter dawn breaks across the estuary, thousands of honking geese take to the skies from their overnight roost. Below them, the hundreds of birdwatchers gathered at RSPB Snettisham to witness this spectacle stand in silence.

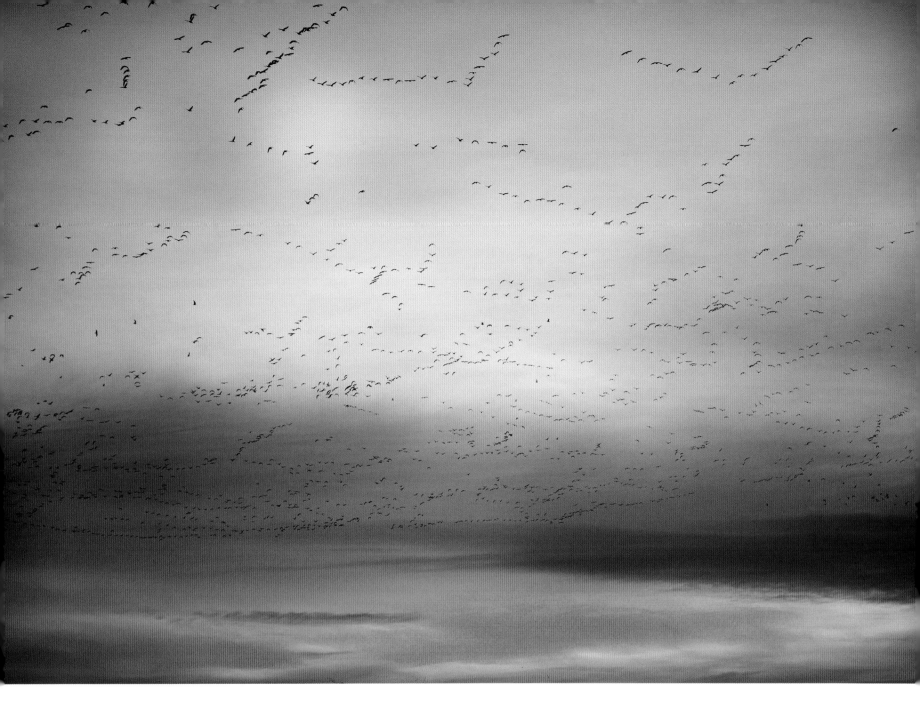

I find saltmarshes great places in which to feel melancholy
and just let your emotions go.

Karen Rawlins, lover of bleak places

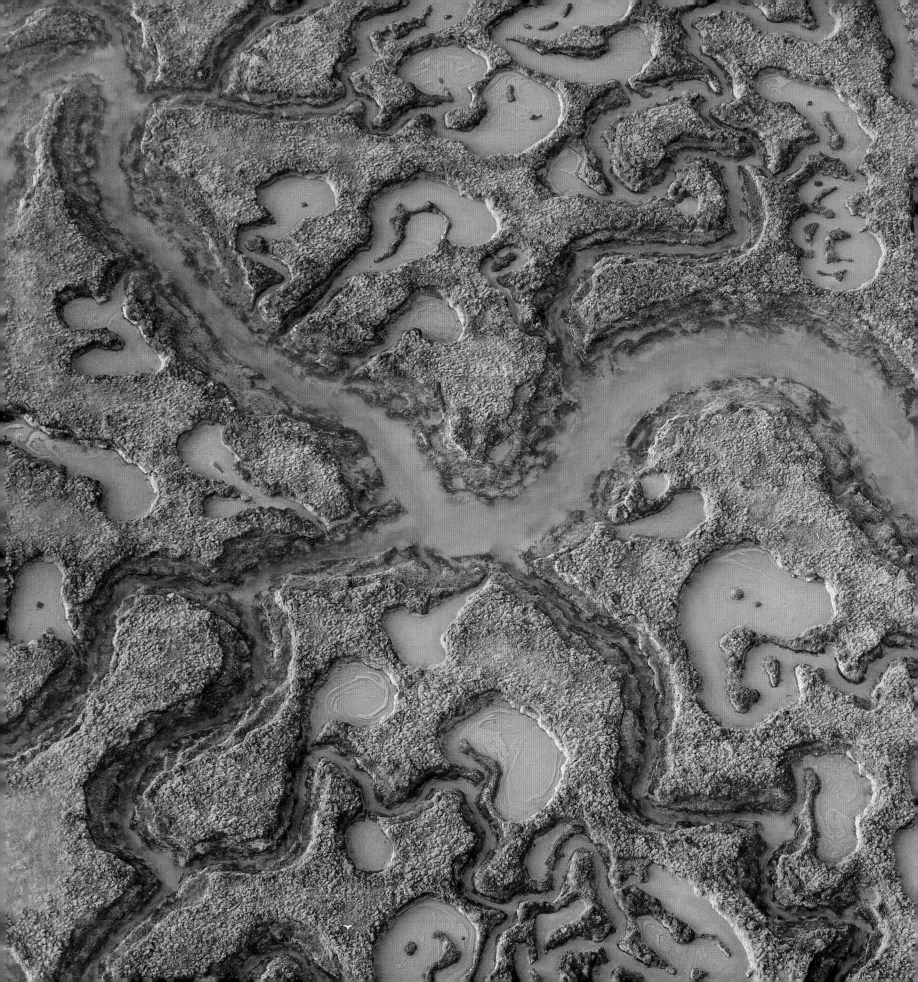

saltmarsh in numbers

15,000: The number of Hydrobia snails found in 1 square metre of Thames Estuary mud.

5%: The amount of the UK's electricity that could potentially be generated by the Severn Estuary if its tidal power is harnessed.

293: The number of invertebrate species inhabiting British saltmarshes.

148: The number of invertebrate species that are found exclusively in British saltmarshes.

50%: The proportion of the UK's breeding population of redshank supported by saltmarsh habitat.

33%: The amount of the UK's extant natterjack toad colonies found on saltmarshes.

£4,600: The savings per metre of sea wall coastal defence that is equalled by the protection provided by an 80m-wide saltmarsh.

23%: The area of British saltmarsh dominated by English cordgrass (*Spartina anglica*).

4: The number of different types of saltmarsh recognised in the UK: pioneer marsh, low marsh, upper marsh and transitional marsh.

10,000 years: The age (early post-glacial) of archaeological artefacts found in buried soils (palaeosols) under saltmarshes.

25,000: The number of barnacle geese that winter on the saltmarshes at the WWT Caerlaverock reserve.

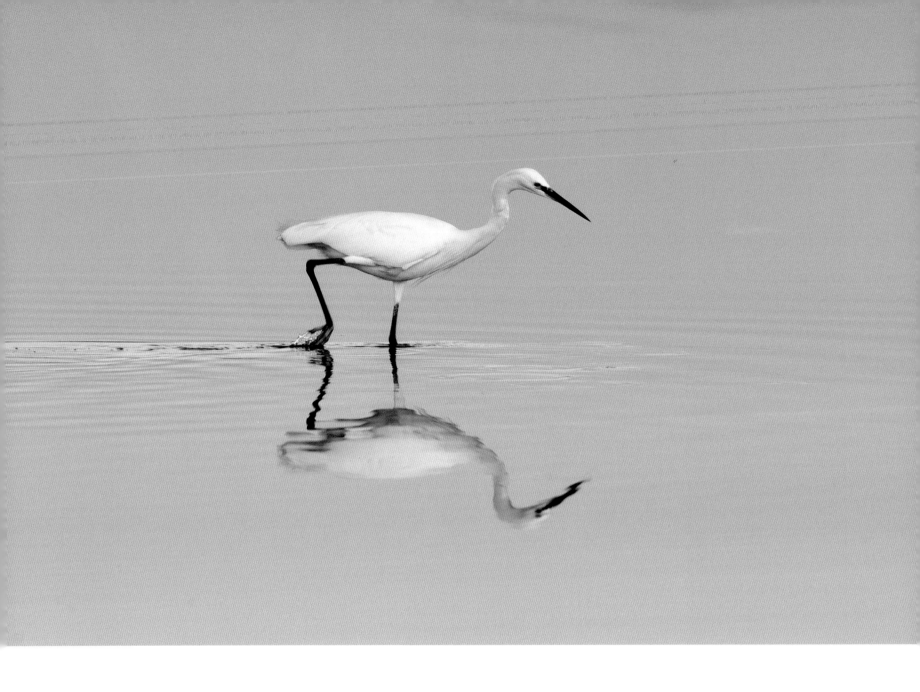

REWILDING WALLASEA ISLAND

Essex, England

The Wild Coast project on Wallasea Island in Essex is landscape change on an industrial scale. As the threat of coastal flooding grows with rising sea levels, the RSPB plans to recreate a natural landscape of mudflats, saltmarsh and wetlands, which will ultimately benefit some of our most spectacular wildlife as well as providing a natural flood defence system. This landmark conservation and engineering scheme is the largest of its type in Europe and will need 10 million tonnes of excavated soil, which, in part, will be shipped in by boat from Crossrail's new tunnels in London. The restoration will take until 2019. Now that's big thinking!

There is nothing more ethereal than standing alone on a seemingly desolate saltmarsh and hearing the ascending, bubbling call of a curlew.

Alex Rhodes, student, Bristol

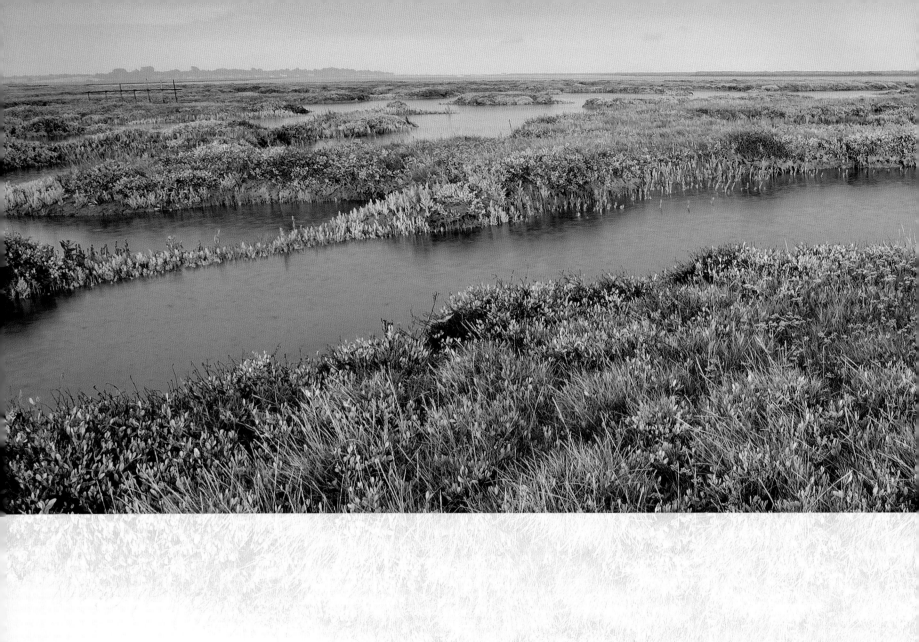

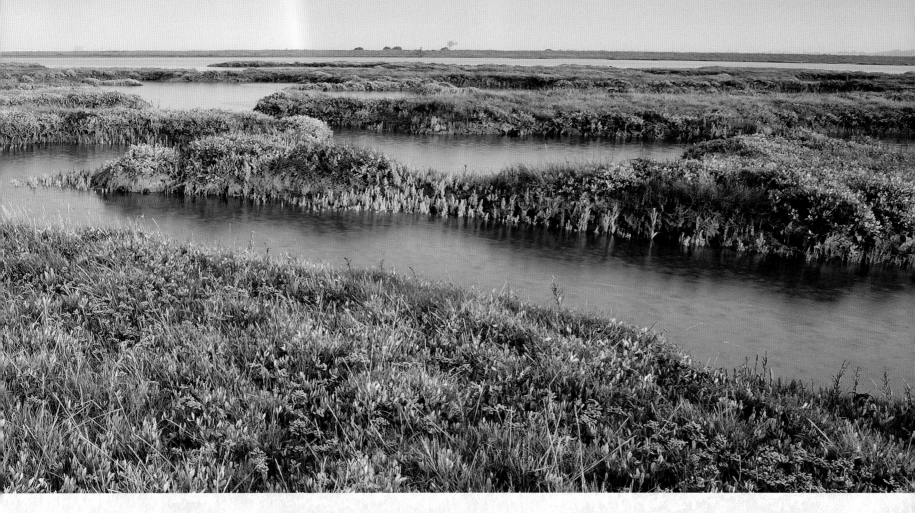

Seafood bar. Dynamo. Flood defence.

More than just a *saltmarsh*

More than just a…

FARM

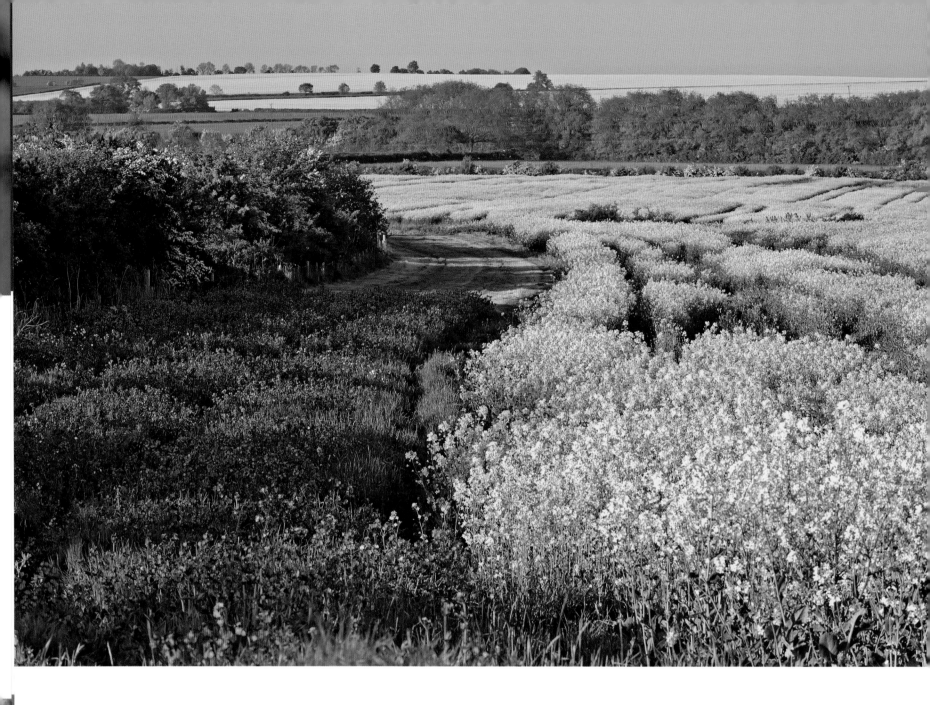

We've increased our farmland bird numbers by 200% and at the same time we've increased our crop yield and maintained our productivity.

Ian Dillon, Farm Manager, RSPB Hope Farm, Cambridgeshire

RSPB HOPE FARM

Cambridgeshire, England

Some say that marrying profitable, productive farming with a strong eye towards biodiversity is just wishful thinking, but the RSPB's 180-hectare Hope Farm in Cambridgeshire is proving that it can be done. Since taking on the farm in 1999, yellowhammers, linnets, reed buntings and skylarks have at least tripled in number. Grey partridges, yellow wagtails and barn owls also breed at Hope Farm.

↑ **CORN BUNTING SINGING IN OIL SEED RAPE**

GOLDFINCHES SQUABBLING OVER TEASEL SEED →

Cambridgeshire, England

Cambridgeshire, England

The Government's target to reduce the decline in farmland birds by 2020 is measured through the FBI (Farmland Bird Indicator), which monitors the populations of those species most dependent on farmland.

Corn buntings and goldfinches are sensitive to how our farmland is managed and both are included on the FBI list. At Hope Farm, through careful management, the RSPB has delivered a dramatic threefold increase in FBI species.

Hope Farm proves that wildlife can prosper alongside agriculture by putting the right measures in the right place and managing them in the right way. But what about profit? That too has been maintained, even increased, at a time of economic uncertainty.

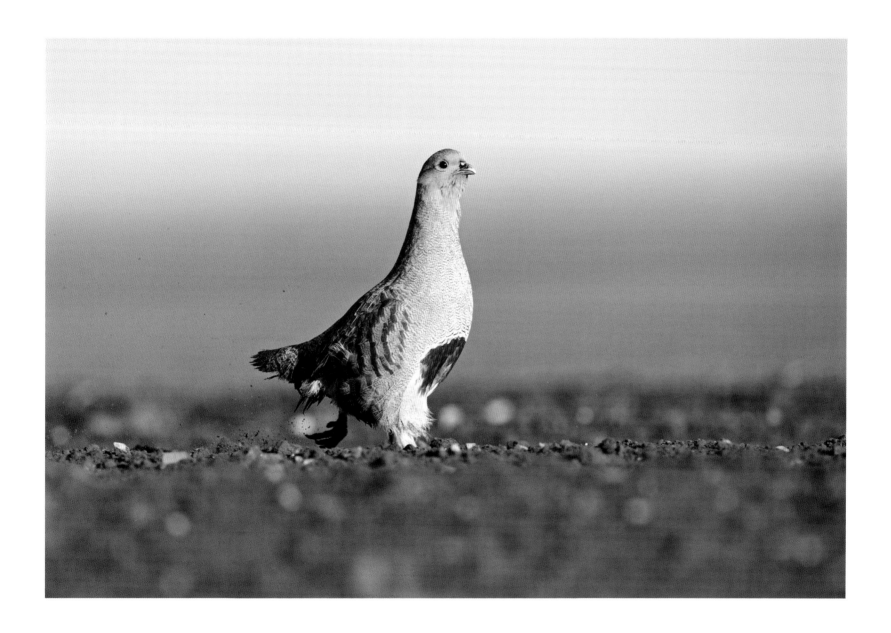

GREY PARTRIDGE ON A FURROWED FIELD

Norfolk, England

This once ubiquitous game bird is the canary in the mine when it comes to the way we farm. With a reduction of 80% in just 40 years, grey partridges are telling us something. Pesticides have reduced the number of insects, which in turn impacts on chick survival, and the lack of grassy margins and hedgerows on many farms reduces the availability of nesting sites.

OX-EYE DAISIES IN A WILDFLOWER MEADOW

Somerset, England

Since 1930 the UK has lost 97% of its wildflower meadows, with disastrous consequences for many birds and insects, including pollinating bees. Across the UK, The Wildlife Trusts' Living Landscape programmes are working with farmers to restore species-rich grassland, hedgerows and ponds to create a wildlife-friendly landscape.

BROWN HARE IN A HAY MEADOW

Norfolk, England

A hundred years ago our farms looked very different; a patchwork of fields provided year-round grazing and cover for brown hares. This is not just about brown hares, however, or farming for that matter. We can all do our bit for wildflowers – roadside verges, village greens, gardens, even green rooftops, are all potential oases of life just waiting to be created.

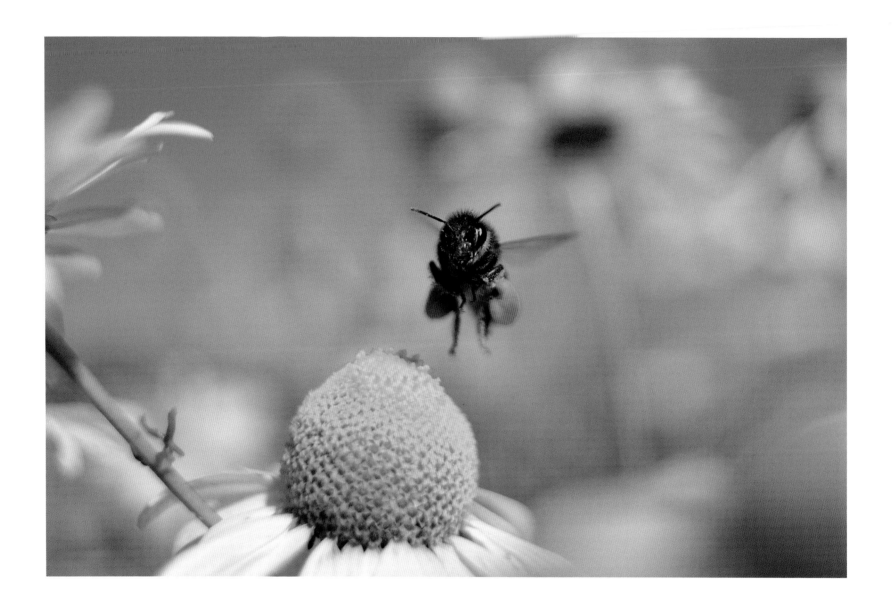

EUROPEAN HONEY BEE FEEDING ON MAYWEED

Perthshire, Scotland

As key pollinators of our wildflowers and crops, bees are an essential bedrock for life. Their demise in recent decades coincides with the extensive loss of hedgerows and hay meadows and the draining of marshland. Put simply, fewer wildflowers mean less pollen and nectar and that means fewer bees. But there's good news on that front. The Bumblebee Conservation Trust has teamed up with the RSPB and created the world's first bumblebee sanctuary at Loch Leven in Scotland. This is only one piece of a complex jigsaw, a jigsaw that we can all help in putting back together.

Pollination is an important ecosystem service. In Britain it's worth £440 million a year just in terms of pollinating crops. Matt Shardlow, Chief Executive, Buglife, Cambridgeshire

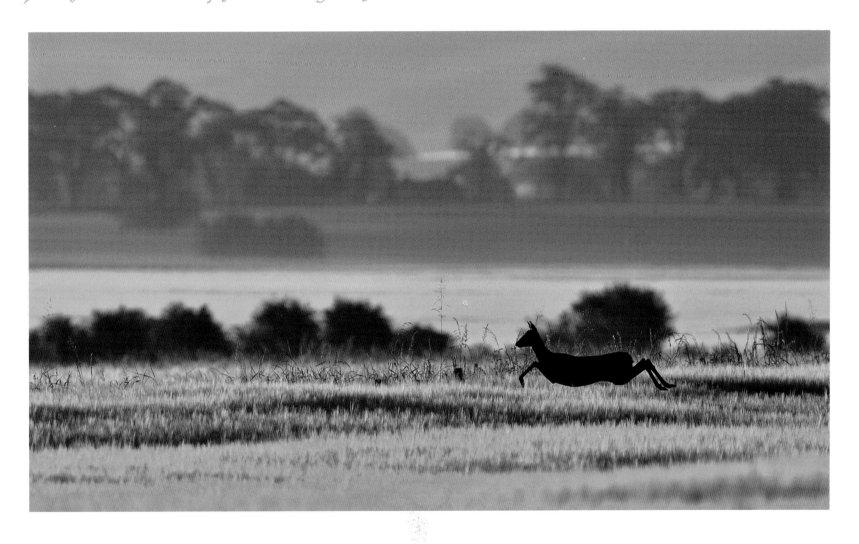

ROE DEER IN A FIELD OF BARLEY AT DAWN

Northumberland, England

Even the hardest of hearts would struggle not to be uplifted by such a sight on a summer's morning.

BADGERLAND

BETHAN ROBERTS, MASTERS STUDENT, OXFORD UNIVERSITY

Falling in love with the natural world was never something I intended to do. In fact, it crept up on me. As I grew up, nature was a part of my Imagination, a setting for sword fights, a tree to be conquered, a pond to be dipped into. Perhaps I was lucky. Growing up in a sleepy suburban seaside town, I was often left to my own devices, and the world beyond the garden fence beckoned. Heading out with our reluctant golden retriever, Crosby, I remember those days as some of the happiest of my life, and yet the most simple. Building dens in the rhododendron bushes, searching for creepy-crawlies under fallen logs, carving our names into the sandstone rocks, imagining who had been there before us, we experienced the natural world with a sense of excitement as only children can.

My parents despaired of me as our brand-new show home fell victim to muddy footprints, but thankfully for my mum's carpets, I soon became preoccupied elsewhere. The land opposite our house became the stage for a fierce battle between developers and protesters, who succeeded in halting construction to save a badger's sett. I rejoiced in the victory, and made it my mission to investigate these creatures. My dad would sometimes take me out at night to scour the 'badgerland'. Teetering barefoot on the fence and peering out into the darkness, my first encounter with this ungainly yet impressive animal has stuck with me. Even now when I see one, I am reduced to my eight-year-old self, standing in the garden in my pyjamas, mesmerised.

There is something unique about experiencing nature as a child, when the unselfconscious ability to be captivated by magic and wonder is so strong. This is perhaps why I was so shocked when I met Ava. Thinking that childminding would be an easy summer job, I was sorely mistaken. I thought her world of Pokémon on the computer on a summer's day isolated and strange, but as I came to realise that loneliness was the source of her misbehaviour, I felt overwhelmingly sorry for her. So, much against her will, I banned the computer, lathered on the factor 50, and dragged her outside.

At first she loathed it, terrified of dirt, screeching like a banshee at a bumblebee. But my persistence paid off, and by the end of the summer we'd had a great time capturing caterpillars and watching them turn into butterflies, strawberry picking and collecting flowers to press. I hope I left her with some memories, but, equally, she had a huge impact on me. Through her I realised how my earliest experiences had helped me to forge a connection with the natural world, one that children today, like Ava, may never fully experience or explore. This worries me, for how can we hope that people will fight to save something that they neither know nor love?

Nature is essential to us all in a biological sense, but what it gives to us spiritually is what is truly indispensable. We ourselves are a part of nature, so to be divorced from it is to be apart from our very selves. We must seek to re-establish these connections, to allow our children to experience the beauty of the natural world, to learn its many secrets, to cherish it, to keep it safe when we are gone, for it is truly our greatest treasure.

Farms can be fantastically diverse habitats for a vast range of species. As a photographer you could spend years documenting the lives that exist within a single farm without ever repeating yourself.

Andy Parkinson, 2020VISION photographer

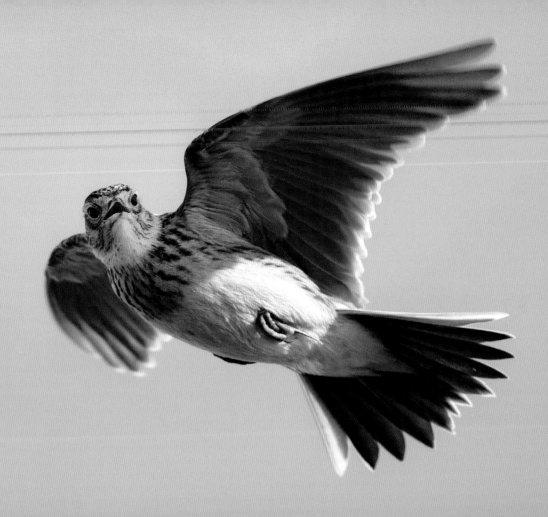

Farm in numbers

20: The number of skylark plots per 100 hectares of arable land required to halt the decline of the species.

350: The number of moth species recorded at RSPB Hope Farm.

35,378: The number of English orchards identified by the People's Trust for Endangered Species.

1,800: The number of species that rely on the decaying wood of old fruit trees.

60: The percentage of our food needs fulfilled by UK agriculture.

535,000: The number of people working in agriculture in the UK.

300: The number of birds released to date as part of the RSPB's Cirl Bunting Reintroduction project.

300,000: The number of children reached by the Farms for Schools programme.

240,000: The number of commercial beehives in the UK.

47: The number of species of conservation concern in the UK for which farmland hedgerows provide habitat.

100: The number of species of flowers, grasses and sedges in Denmark Farm's meadows.

Denmark Farm's rich array of meadows, woodland and wetland is a vibrant study in bringing biodiversity back to 'ordinary' countryside.

Angie Polkey, Senior Projects Officer,
Denmark Farm Conservation Centre, Ceredigion

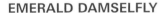

EMERALD DAMSELFLY

Ceredigion, Wales

Twenty-five years ago, Denmark Farm in rural Wales was an intensive livestock farm, with little wildlife. Today, the farm is rich in flowers, birds, butterflies and dragonflies. This restoration has been achieved without major expense, just a will to see it come alive.

THE MACHAIR LIFE PROJECT

Western Isles, Scotland

There are few places in the UK more challenging to farm than on the very edge of our west coast. As the Atlantic pounds wild golden beaches, the machair, a rare coastal hinterland habitat made up of windblown sand and shells, supports not only local crofting communities but internationally important populations of breeding waders. The four-year Machair LIFE project aims to demonstrate that traditional crofting, the bedrock of the machair's rich diversity, has a sustainable future. Machair LIFE is another model that aims to show that profit and biodiversity can be bedfellows.

If I drove a lorry instead of a tractor I wouldn't get to hear skylarks every break time. Bob Aitken, tractor driver, Angus

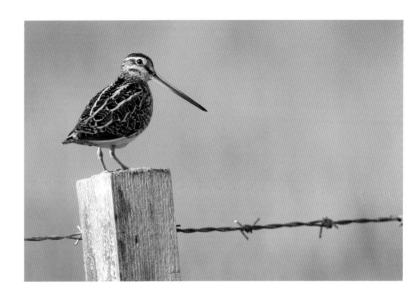

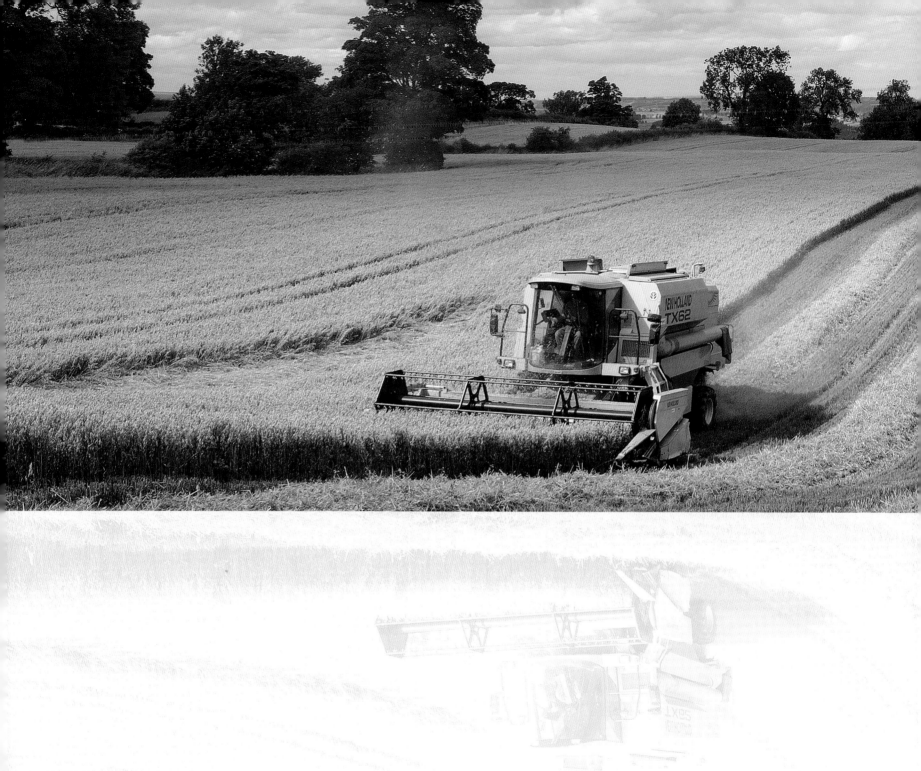

Delicatessen. Fuel station. Honey factory.

More than just a *farm*

More than just a...

WETLAND

INTRODUCTION

It's like hide-and-seek for the senses. There's a bird singing nearby, the notes a jazzy outpouring. But the singer is unseen. Then there's a blur of movement through the tall reeds; a small, flying shape – seen for a fraction of a second, then gone.

Where a large pool opens in the vegetation, sky and clouds are mirrored in its calm. A blur of electric blue, brighter than the sky, darts across and disappears behind the screen of plants. A kingfisher? A damselfly?

Such things are part of both the pleasure and the strangeness of low-lying wetlands in Britain and Ireland. These are places whose scale can be hard to fathom, at close range; where wildlife can be plentiful, but where sight and sound of the creatures that live here can be fleeting, tantalising.

Shallow waters where fish dart quickly past and otters dive; channels between reeds where stems stretch overhead; the smell of warm mud; sounds that are hard to pinpoint; the swirl of a starling flock flying off to roost at dusk, its movements like those of a giant amoeba: all these things can be experienced in a typical wetland scene.

The venues for such pleasures are now few. There was always one type of limit on them – a natural one – because of a divide between uplands and lowlands in the character of freshwater areas.

Upland waters are often deep, with rocky shores and waters poor in food for plants and wildlife. Lowland waters, over soft beds of mud, clay or peat, tend to be both shallower and richer in the types of food that can support abundant life.

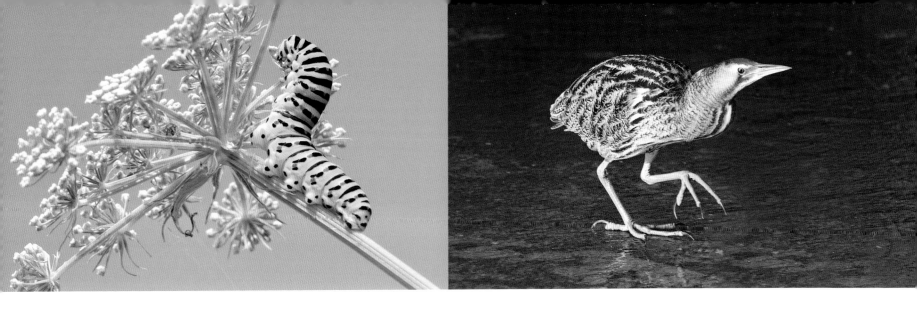

In England, many of the surviving shallow, lowland wetlands are artificial, created or expanded by people in the past following extraction of gravel, minerals or peat. That's the case with the Norfolk Broads – the flooded East Anglian flatland awash with channels, lakes and reedbeds. Huge amounts of peat were dug from here in the Middle Ages. As the pits where peat was removed filled with water, they were eventually abandoned, with a halt to the diggings as a whole by the 1300s.

There's something both surprising and inspiring about that history, since the Broads are now of international importance for the wildlife that lives there. This is also now one of the major national honeypots for people who enjoy recreation in watercraft of many kinds. What was an unplanned by-product of one activity – the gathering and sale of a natural fuel – is now the basis for many other things.

So, just think what could be achieved if wetland expansion were planned. Better yet, consider what is already being achieved. Wetland conservation and growth are now happening across different lowland areas on a scale that would have seemed impossible just a few years ago. For until the late 20th century, the lowland wetland story was one of massive reduction: of drainage, division and pollution.

The Cambridgeshire Fens are a classic example. Here, there was once a vast complex of wet grassland, wet woodland, raised bog, reedbeds and other variations on a sodden, life-rich theme. The fish and some other wetland creatures were a food source for local people. Wet meadows were good grazing land for sheep and cattle. The reeds (as found in the Norfolk Broads and elsewhere) yielded material for the thatching of houses. It was a sustainable system that benefited people and supported wildlife.

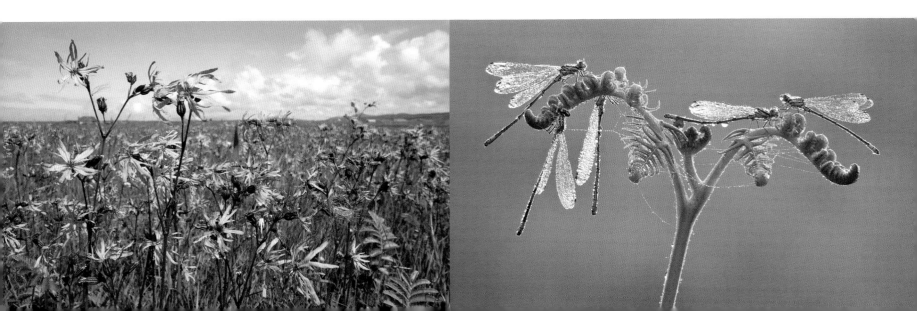

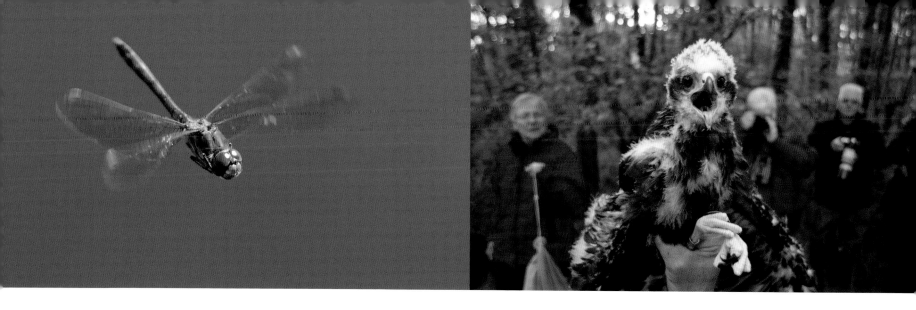

Drainage over several centuries to create year-round dry land to grow different crops and feed more livestock changed all that. Now only a handful of fenland fragments survive.

But things are changing. The Great Fen project is restoring a large area of fenland between Huntingdon and Peterborough. Arable fields are being returned to wetland, to create a link between ancient, surviving fenlands at Woodwalton and Holme Fens. The Great Fen shelters migratory birds, around 450 species of fungi and the insects that feed on them, and rare plants such as the fen violet.

Cambridgeshire's Wicken Fen is one of the very few fen areas never to have been drained. It was the very first nature reserve purchased by the National Trust, and since 1899 has been cared for in ways that have maintained the health of its wetland wildlife. More than a dozen kinds of dragonfly live here, for example, including the emperor – one of the largest in Britain and Ireland.

Now Wicken is at the hub of the biggest project of its kind in lowland England. The vision is to create a new, super-wetland reserve over more than 50 square kilometres between Cambridge and Wicken Fen. It could take a century to achieve this, say the Wicken Fen visionaries. But it seems they're ready and willing to commit to the long haul.

Elsewhere, such as in the Somerset Levels in the south-west and Leighton Moss in the north-west of England, conservation and care of major wetlands are allowing many people to have close-up encounters with some of the choice wildlife that lives there, including otters, dragonflies and kingfishers.

Across England, a large partnership of government-linked and conservation bodies has set out a bold, 50-year vision for wetlands. This shows where new ones could be created and current wetlands restored. It also states, very clearly, that healthy wetlands can bring

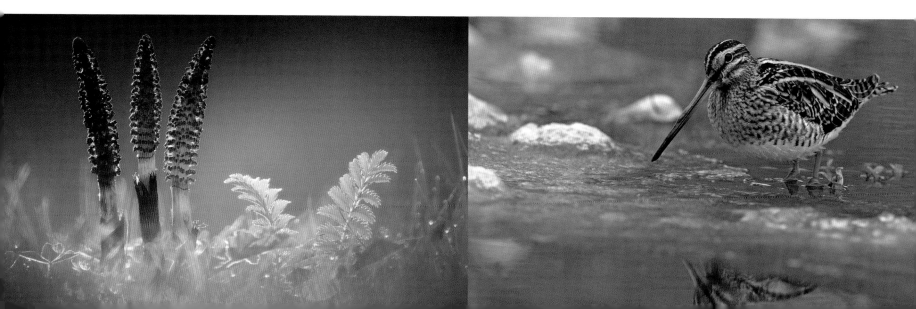

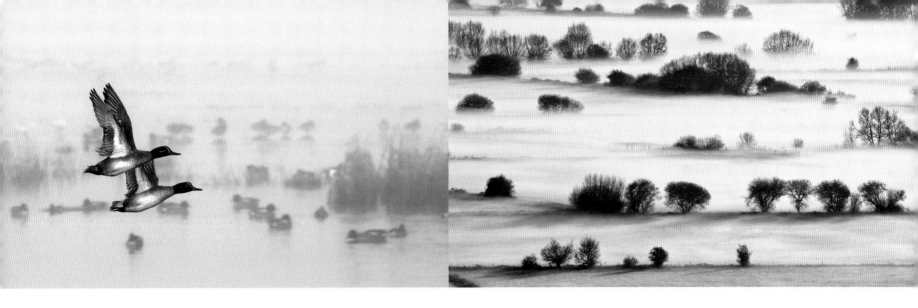

many benefits, including through helping both people and wildlife to cope better with climate change.

Part of that help comes from the way in which wetlands can be huge water stores, able to soak up what comes into them, from rivers, rainfall and run-off from surrounding land, then release it, slowly. An acre of wetland might store as much as a million gallons of water. More frequent floods are predicted at this time of global warming. But big wetlands can act as natural flood protection, helping to buffer both farmland and towns from all but the worst flood events. Creation of wetlands in and downstream of towns and cities can also be really useful, helping to counteract the fast, high-volume run-off from pavements and buildings at times of torrential rain.

In addition, wetlands can both filter and purify water, thanks to reedbeds and other aspects of their plant and microscopic life. Reedbeds are now planted on a small scale as natural water cleaners near some places away from large wetlands, such as homes and office buildings.

Peatlands (a type of wetland) are amazingly good carbon stores – the best on the planet. Lowland wetlands may also be efficient at locking up carbon, although research on this is still developing to understand the value of their contribution.

But there's even more. The final part is the trickiest to pin down. It's to do with enjoyment of these wild, wet places and with trying to glimpse elusive, interesting wildlife. It's the pleasure of how wind sounds when it shakes the reeds, or how the boom of a bittern (Britain's loudest bird) sounds across water, like a foghorn in the mist.

It's the excitement of what yet could be, as we seek the wetland wilds and let them spread again, in all their sodden splendour.

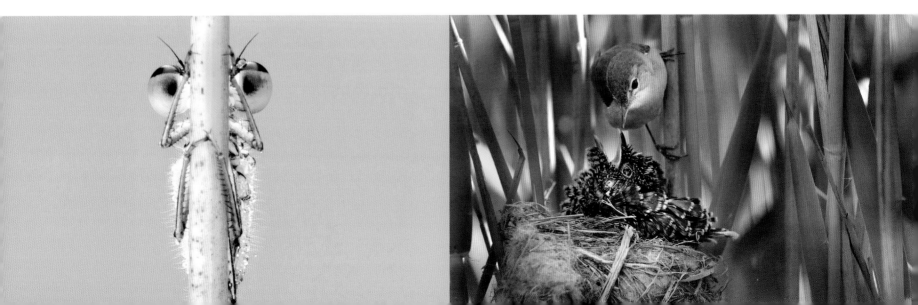

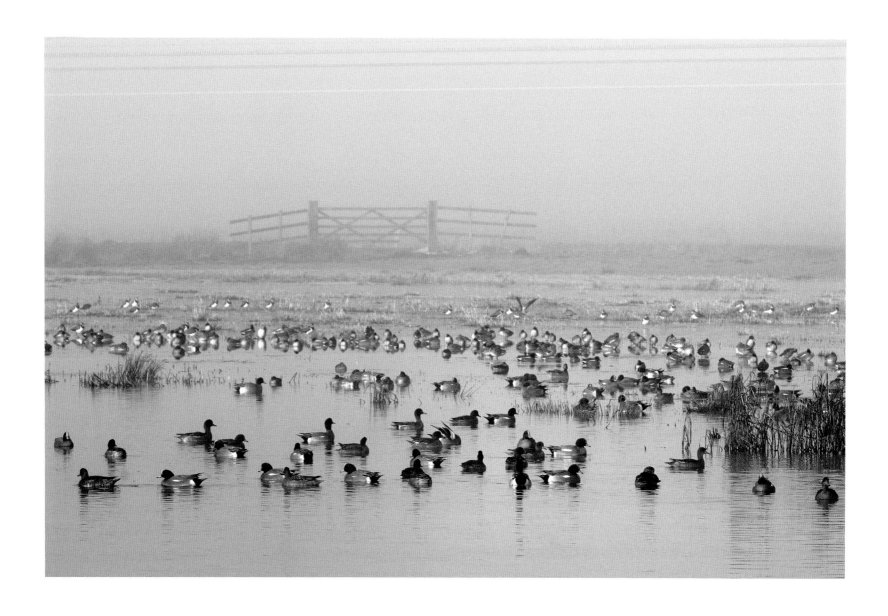

WINTERING DUCKS AND WADERS

Somerset Levels, England

The Somerset Levels stretch over 600 square km between the Quantock and Mendip Hills in south-west England. An important flood defence system and provider of clean water, the Levels are a mosaic of coastal plain and wetland, rich in life, and the focus of several landscape-scale restoration projects that seek to work with the community to expand and better connect patches of important habitat.

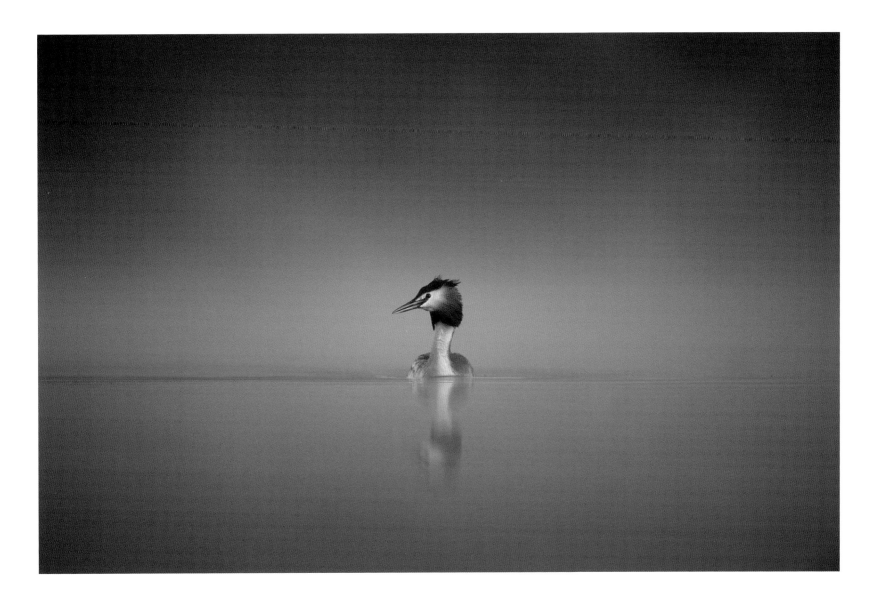

GREAT CRESTED GREBE IN MORNING MIST

Somerset, England

The Brue Valley Living Landscape project is managed by the Somerset Wildlife Trust, working with local landowners to create a profitable countryside enriched with wildflower meadows and interconnected wetlands.

It's a beautiful place: quiet, with lots of birds, insects and butterflies, and the children love it.

Lisa, Emily and their children, Somerset Levels

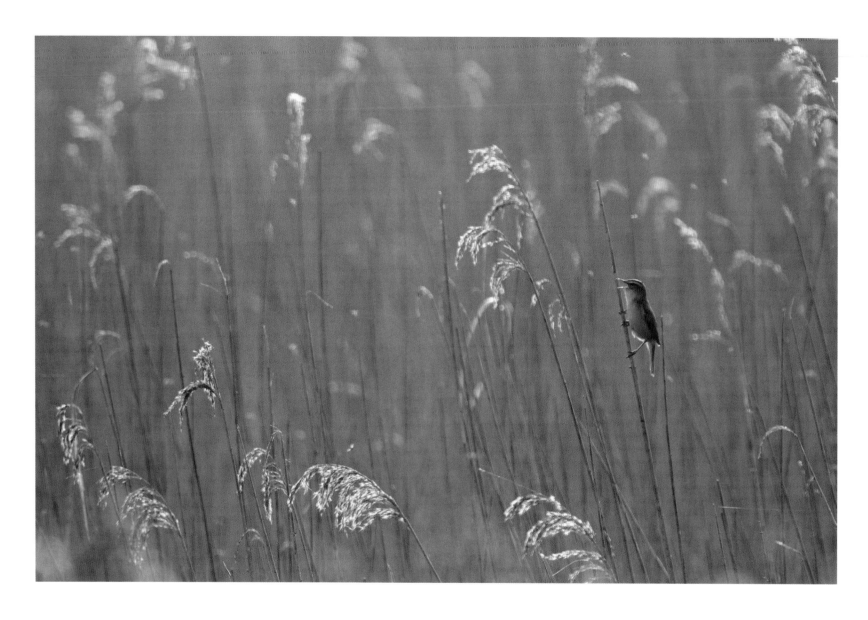

Youngsters are coming out to these areas and experiencing a different environment and they're just having a great time out in the natural world.

Martin Prothero, Education Officer, Somerset Wildlife Trust

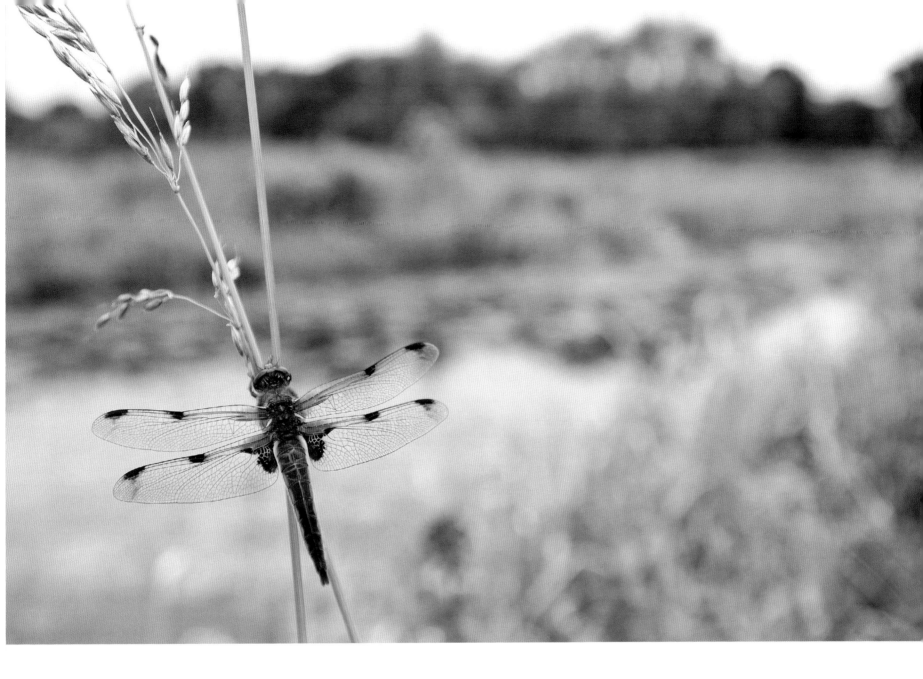

SEDGE WARBLER SINGING IN A REEDBED

Somerset, England

Elsewhere on the Levels, the Avon Wildlife Trust has similar aims with its North Somerset Wetland Programme, which embraces the mudflats and saltmarsh of the Severn Estuary. Collaborative thinking and, more importantly, co-ordinated action will join these individual landscapes together.

FOUR-SPOTTED CHASER DRAGONFLY

Shapwick Heath, Somerset, England

Managed by Natural England, Shapwick's 500 hectares of meadow, woodland, fen and open water are home to flagship species such as otter, marsh harrier and bittern, as well as mind-boggling flocks of winter starlings. But the less obvious foundations that support these wetland icons are equally spectacular in close-up.

ORCHID QUARTET

Somerset Levels, England

Some may think that the 'smaller things' like orchids, beautiful as they are, make no real difference to our world. But rebuilding Living Landscapes requires a holistic approach, an understanding that the whole is greater than the sum of its parts. Wet meadows, or grazing marsh, store carbon, encourage pollination and play a vital flood protection role. These orchids are much more than just a pretty face!

It's not about nature and people living alongside one another, it's about them being part of the same thing.

Emma Cox, Interpretation and Community Officer, Great Fen, Cambridgeshire

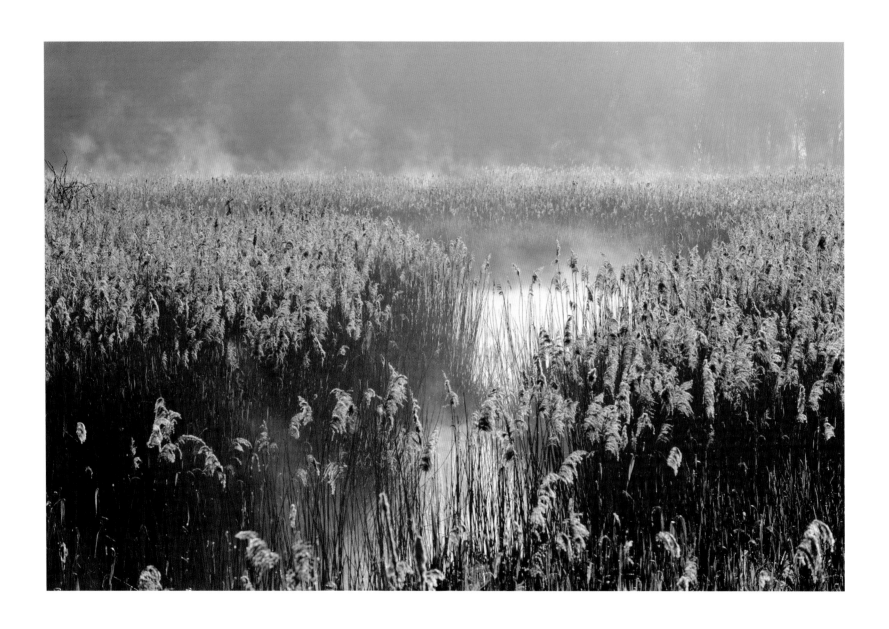

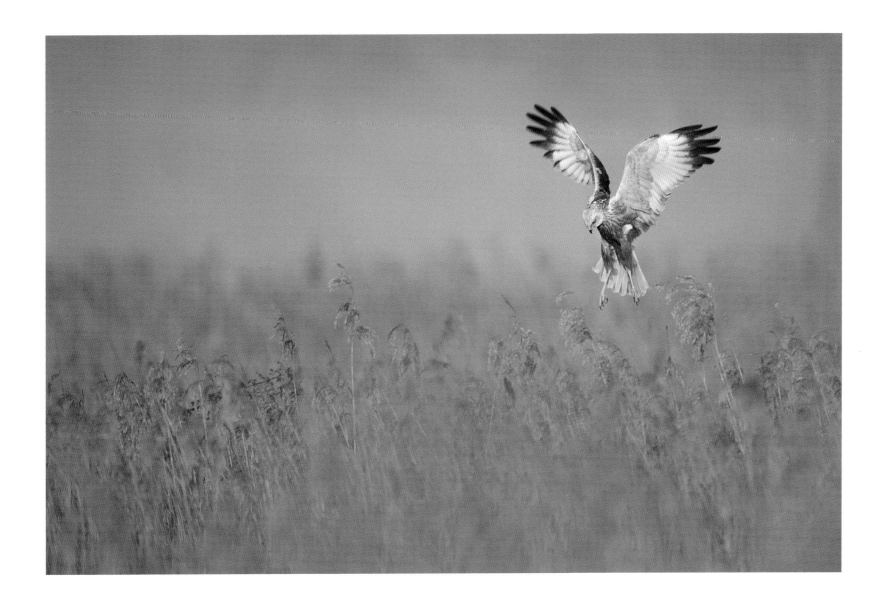

← **LAKENHEATH FEN AT SUNRISE**

Suffolk, England

Until the mid-1990s this vibrant reedbed, now home to bittern, marsh harrier and bearded tit, was intensively farmed arable land. Elsewhere in eastern England wildlife is returning, thanks not only to practical conservation efforts but also to a change in our mindsets and in our priorities.

MARSH HARRIER FLYING INTO NEST ↑

Norfolk, England

These spectacular raptors are making a comeback thanks to initiatives including the Great Fen project in Cambridgeshire, where, in an area of dense human population, the restoration of nearly 4,000 hectares of meadow, reedbed and woodland will provide vital breathing space for people of all ages.

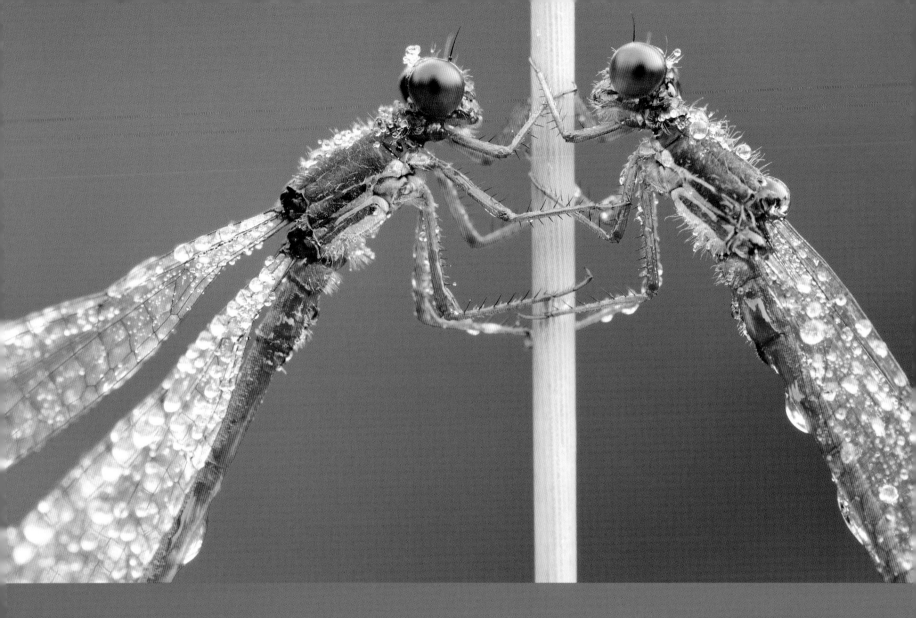

Wetland in numbers

1 million: The annual number of visitors to the Wildfowl and Wetlands Trust's nine reserves.

£6.7 billion: The estimated value of 'services' provided by UK wetlands each year.

3,700 hectares: The area of wetland that will be created by the Great Fen project between Huntingdon and Peterborough.

100: The number of birds that will be introduced by the Great Crane project between 2010 and 2015.

100: The number of breeding male bitterns recorded at wetland sites across England in 2011.

12.5 million: The number of birds relying on Britain's wetlands.

99%: The amount of traditional fen wetland lost since 1600.

85,000: The cubic metres of floodwater that can be stored since the restoration of the River Quaggy and its floodplain in London.

600: The number of homes and businesses with reduced flood risk as a result of the River Quaggy restoration.

250: The number of plant species supported by the Broads fens.

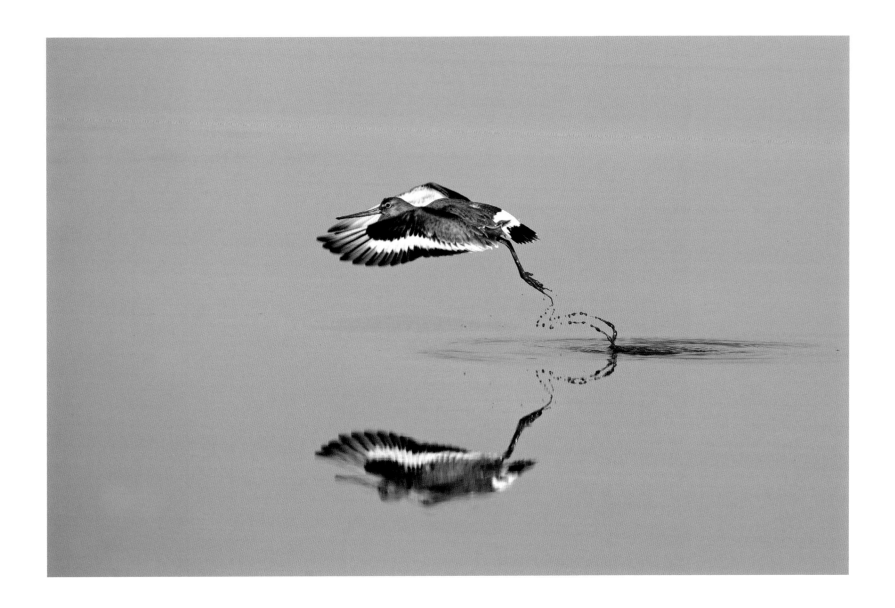

BLACK-TAILED GODWIT TAKING OFF FROM COASTAL LAGOON

Norfolk, England

The Norfolk Broads are Britain's largest protected wetland and home to a wealth of rare wildlife. Within the wider Broadland landscape, Trinity Broads make up 14% of the open water. Here, a partnership including the Broads Authority and Essex and Suffolk Water is working to maintain the rich biodiversity of Trinity Broads alongside encouraging recreation and community involvement. Crucially, however, the aims of managing this wetland include ensuring a high-quality and sustainable supply of drinking water.

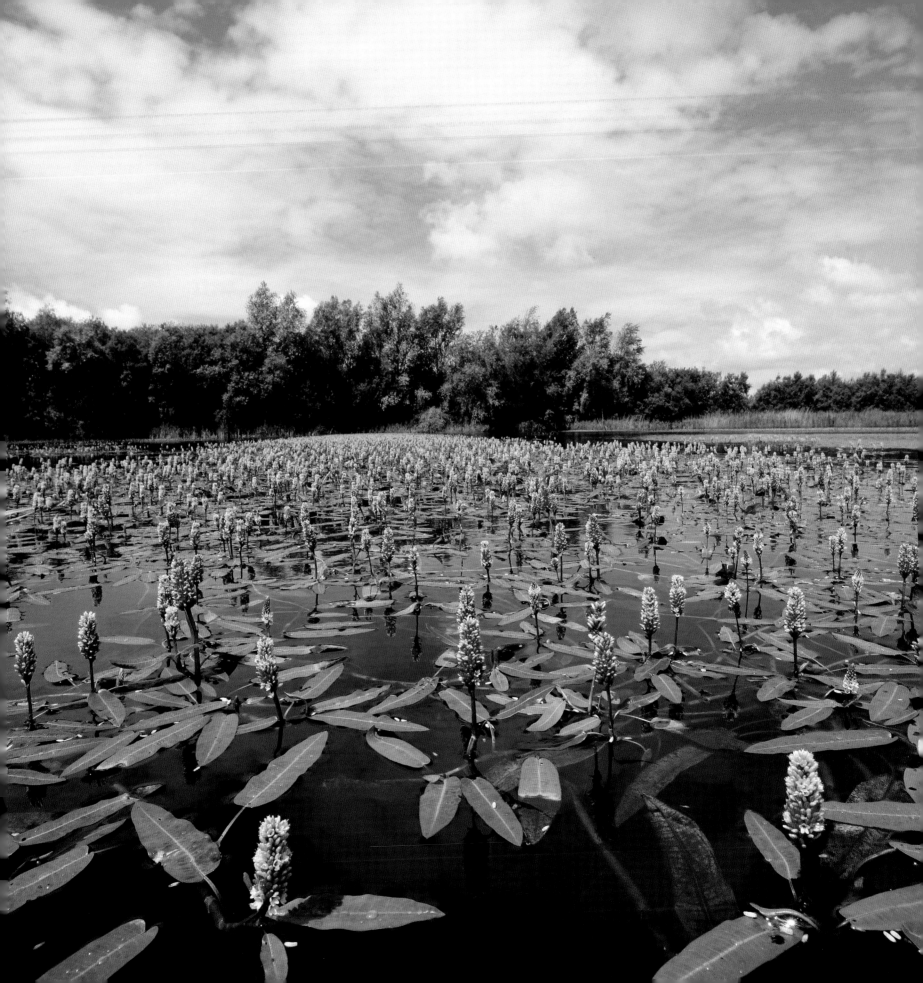

THE THEATRE OF THE NATURAL WORLD

LUCY McROBERT, ENVIRONMENTAL HISTORIAN, UNIVERSITY OF NOTTINGHAM

Not long ago, someone gave me a present that has since become a treasured possession. It is not particularly beautiful or expensive; it isn't fashionable or glamorous; you can't wear it or drive it or show it off at parties (well, not the kind of parties that I go to, in any case). It is a book published in 1965 entitled *My Favourite Stories of Wild Life*, edited by the naturalist and broadcaster Peter Scott, and it sums up, through a combination of fiction and fact, the human affinity with nature.

Scott was a man who was infinitely in tune with his natural surroundings, particularly birds (a passion that he and I share) and many of his chosen tales reflect this. 'Waterfowl at Fallodon' by Viscount Grey is in part a guide to keeping ducks and geese, and reminds me of Slimbridge Wildfowl and Wetlands Trust, founded by Scott in 1946. Scott's vision was to unite people and wildlife for the mutual benefit of both, an ambition that has been continued by many through the 20th century, but the simplicity of which has been clouded by layers of scientific interpretation. Modern buzzwords such as 'sustainability' and 'eco-friendly' seem to have distorted the intimate relationship with nature that Scott envisaged for the people of Britain, a relationship that I have recently rekindled.

The wetlands of Britain, particularly Slimbridge in Gloucestershire and the Ouse Washes of East Anglia, hold a special place in my heart. There is something enchanting about the diversity of the sodden landscape, from the majestic marsh harrier coasting low across the fens to the pied wagtails with their stark white masks, hopping cheekily along only a few feet away, that evokes a sense of tranquillity in me. The world of science and progression recedes and is replaced by an appreciation and genuine love for the theatre of the natural world. I envy the stately swans and painted ducks that epitomise freedom as they embark on their onerous journeys across the globe. I admire the bold, sea-blue and fire-orange beauty of the kingfisher on a mossy fence post. Wetlands provide me with a haven, a parallel universe, into which I can retreat when the real world becomes a little too heavy.

Sir Thomas Browne, a 17th-century Norfolk doctor, writer and naturalist, insisted that 'if you want to know what animals are like, the thing to do is look at them, not at what other people have written about them'. Scott, who lived by this maxim, continues the sentiment: 'This may seem obvious, but the battle has not yet been won.' What was true in the 17th century was true for Scott in the 1960s, and remains so today. Seeing the wholeness of nature without obscured, cluttered vision is fundamental on our journey to ultimate accommodation with the natural world.

At Slimbridge, Scott encouraged us to appreciate nature for what it is: beautiful, diverse, accessible. For me, conservation started with an appreciation of what I wanted to conserve, which was something personal, wild and emotional; now that I love the natural world, I can help to save it for my own sake.

Ecotourism is important; these reserves draw a vast number of people to the area. Shapwick Heath itself gets in excess of 80,000 visitors a year.

Simon Clarke, Reserve Manager, Shapwick Heath National Nature Reserve, Somerset

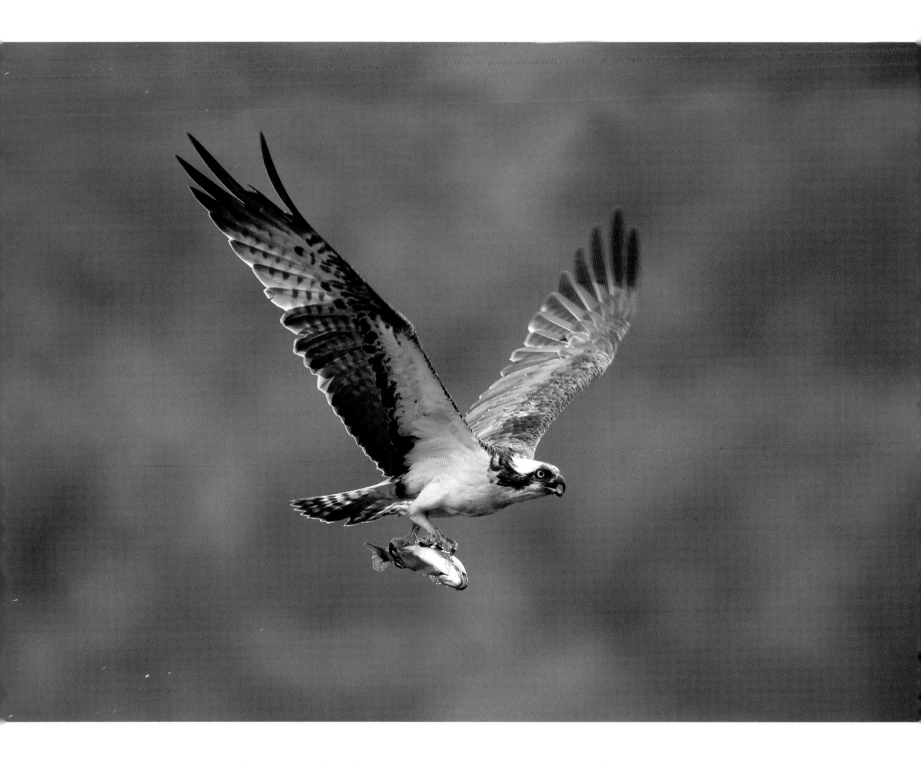

It's easy to forget that Rutland Water is a supply of drinking water for many people, as well as a fantastic place for wildlife. Ciaran Nelson, Anglian Water

I like that they're protecting this reserve, because if they just ploughed it over then it wouldn't be good because of all the animals and trees.

Calum Mortimer (age 9), East Anglian Fens

THE RUTLAND OSPREY PROJECT

Rutland Water, England

2001 was a milestone. For the first time in around 150 years, ospreys bred successfully in England. Rutland Water, the country's largest reservoir, played host to a translocation programme whereby osprey chicks were moved from Scottish nests and reared at Rutland. The project, managed jointly by Leicestershire and Rutland Wildlife Trust and Anglian Water, has become a major success with the ospreys now right up there as A-list celebrities of the wildlife world.

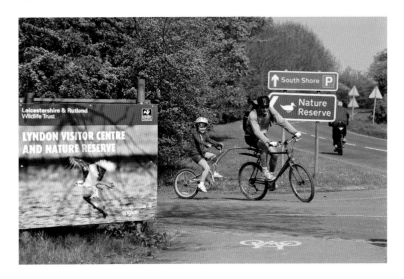

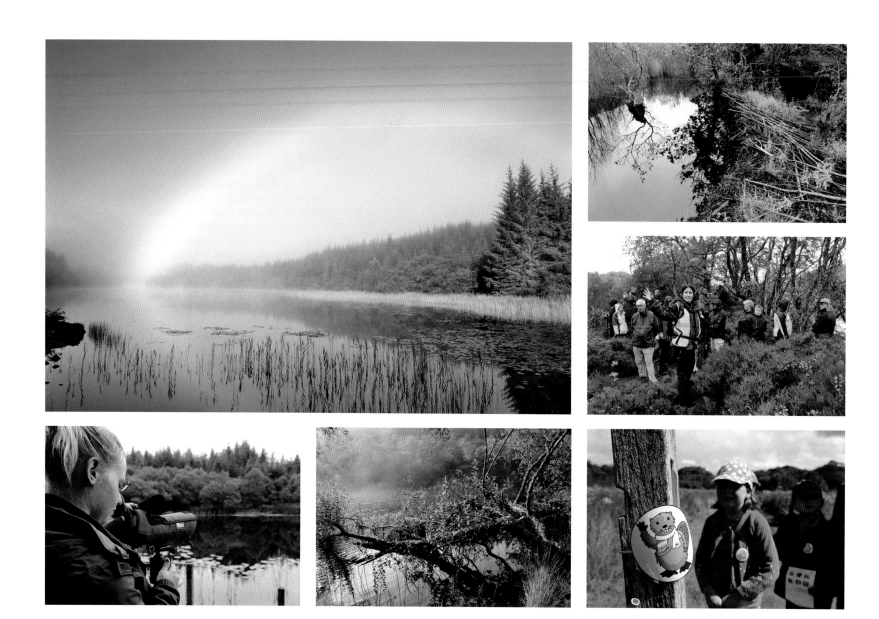

THE SCOTTISH BEAVER TRIAL

Argyll, Scotland

The scientific knowledge required to reintroduce ospreys, red kites, sea eagles and now cranes has been hard won but is now well established. Returning a mammal that has been absent for several centuries, however, is a different thing. In May 2009, beavers were returned to Knapdale Forest in Argyll on a five-year trial to evaluate the potential for a wider beaver reintroduction. Beavers do stuff to a landscape: they change it, sometimes quite dramatically. Our perception of this change is a barometer perhaps for the wider potential for rewilding our landscape. A significant element of the Scottish Beaver Trial is to engage with visitors and local people so that they are better informed about beavers and the ecological, as well as economic, value they could provide.

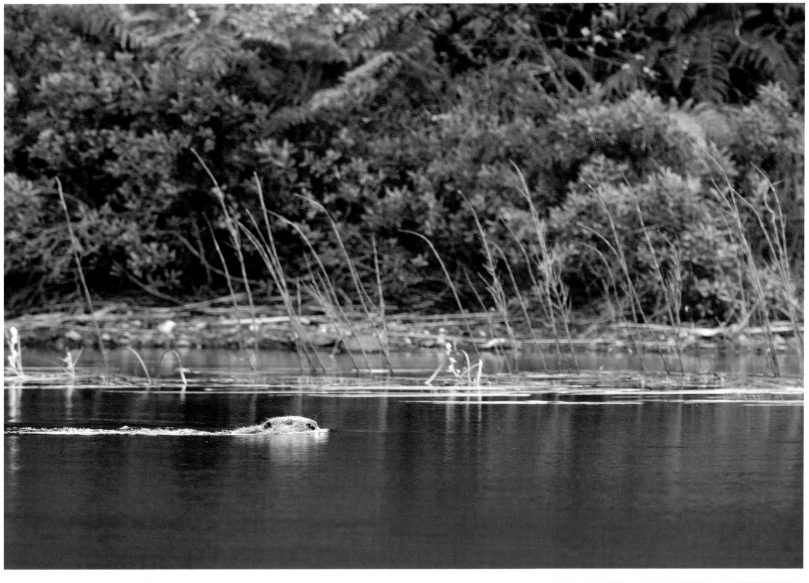

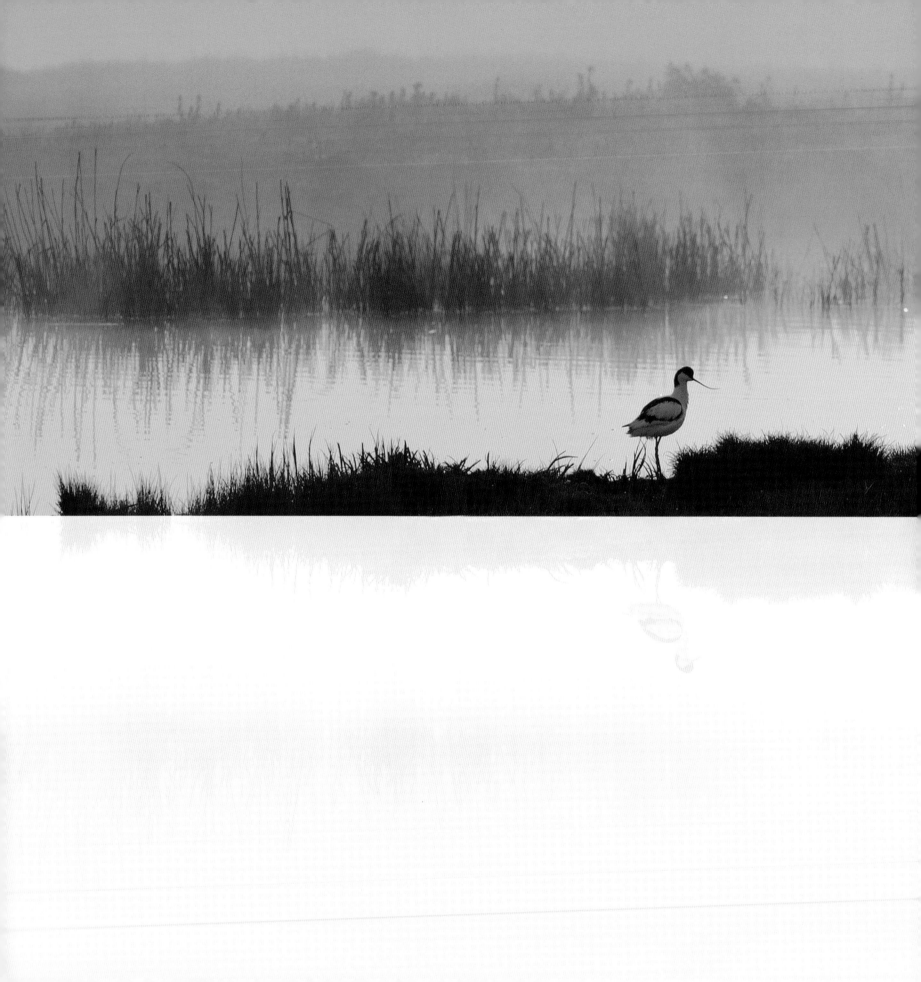

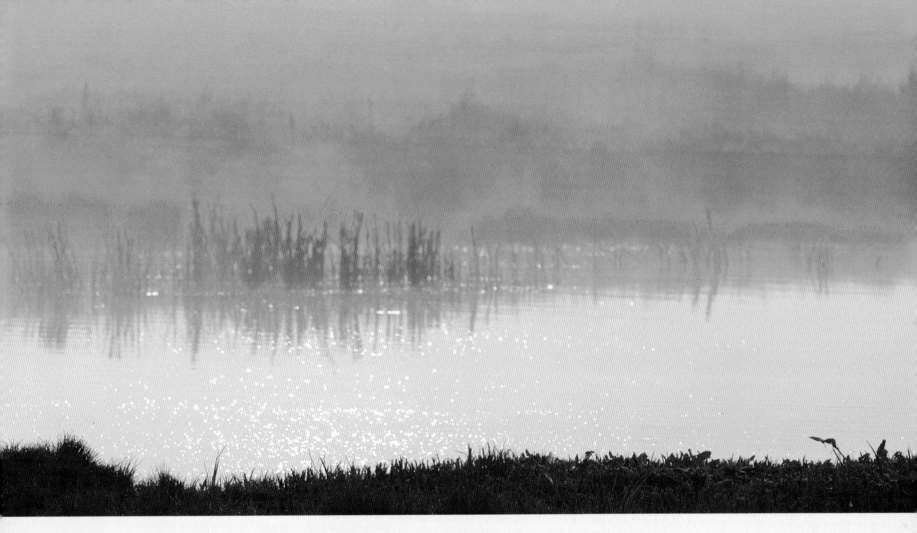

Water filter. Sponge. Roofing supplier.

More than just a *wetland*

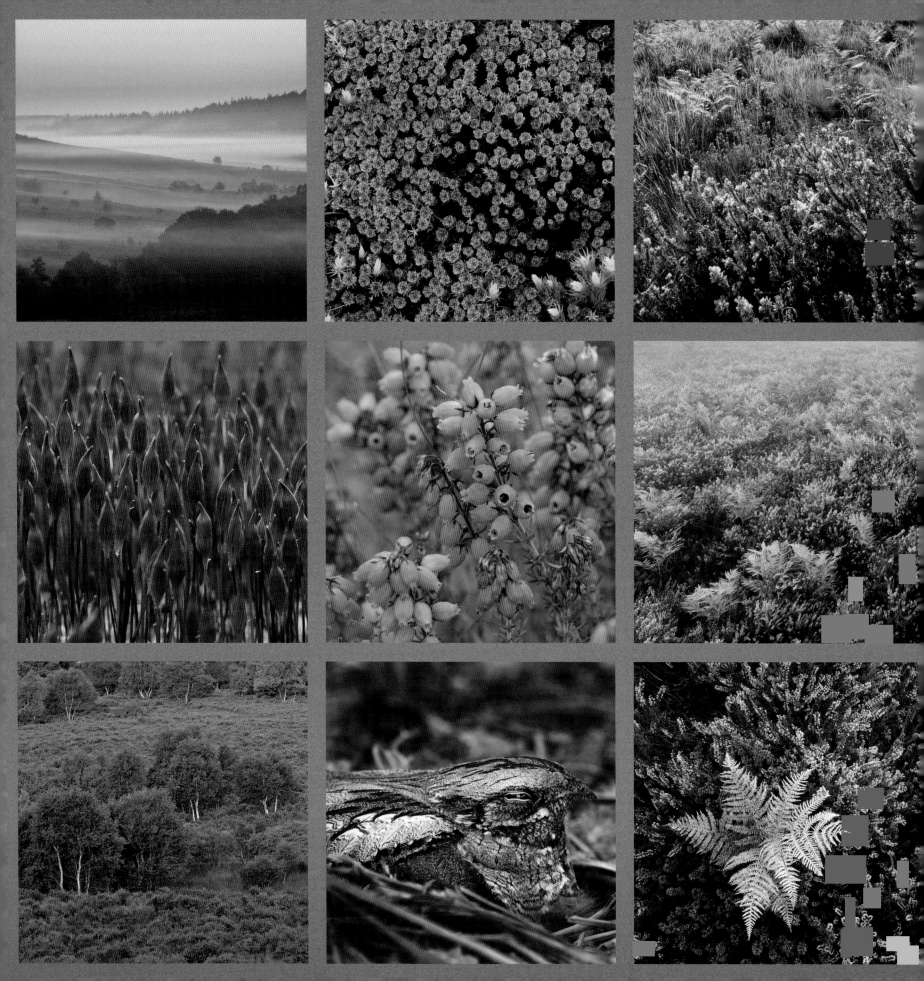

More than just a...

HEATH

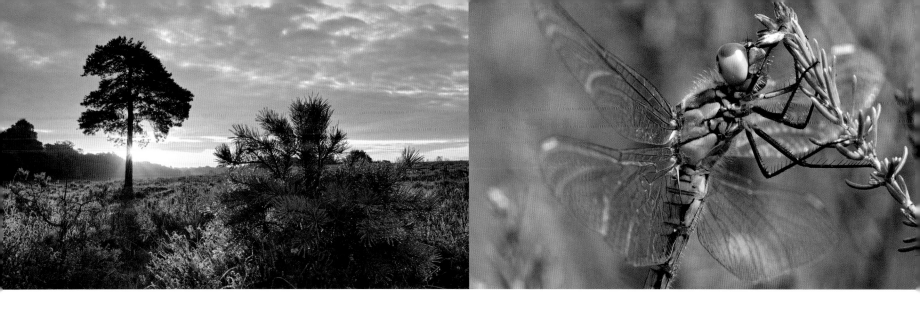

INTRODUCTION

A thousand shades of pink and purple; vibrant greens, gold and yellows: heathlands are hot, for anyone who loves colour. Over flatlands and low hills, they paint the landscape in ways that can rival the most inventive of artists.

Their link to people is a close one, not only because they can look so appealing. In the uplands, heather moors are maintained by careful schedules of burning in order to boost numbers of red grouse for shooting. In the lowlands, heathlands of different kinds have developed over thousands of years, thanks to particular patterns of agriculture.

These lowland heaths may first have developed on a large scale when Bronze Age people (perhaps around 3,500 years ago) began to graze livestock on quick-draining soils that are poor in plant food.

By a couple of hundred years ago, lowland heaths covered an area as large as Cornwall.

Since then, changes in agriculture, plus the removal of heathland to make space for housing and other commercial development, have massively reduced their number and extent. Over four-fifths of Britain's lowland heathland has been lost since 1800. Today, its strongholds are in the south-west, south and south-east of England and in parts of Wales. Even after the losses, the UK is still home to about one-fifth of all the lowland heathland in the world, showing just how rare this kind of place is; how important the opportunities to conserve or expand it.

The canvas has been cut into fragments, but the colours are still there, as is the potential to make a bigger, brighter picture. That

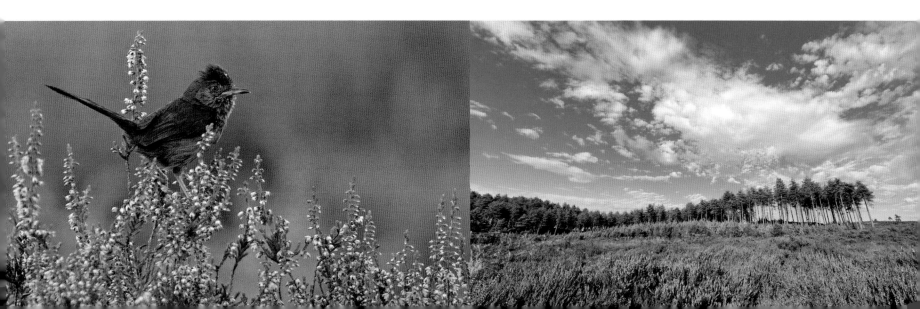

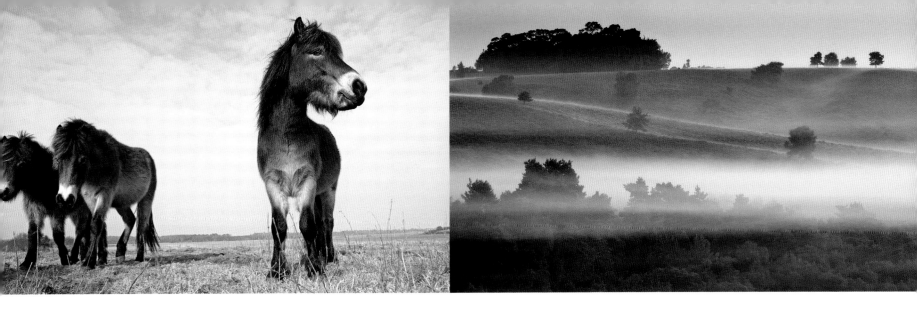

picture includes the vibrancy that many kinds of plants and wildlife bring to lowland heaths, through their colours, shapes, sounds and scents. Some of these species are so widespread that they have become part of the background canvas, such as the gorse that adds drifts of coconut perfume to the summer air over many heaths. Some are among the rarest species in these islands.

Dwarf shrubs with woody stems are part of the common heathland colour themes. Cross-leaved heath, common heather (ling) and bell heather ring changes of pink and purple as they bloom, in turn and together, from mid to late summer. These blossoms are sought after by bees, some of whose honey can then be enjoyed by people with a taste for the subtleties of different honey flavours. Connoisseurs will pay high prices for honey derived from blossom which is thought to contain healing properties.

Brother Adam of Buckfast Abbey in Devon, one of the most renowned beekeepers of the 20th century, described heather honey as: '...red brown, like the water of a peat bog. A gift of nature carrying the tang of moorland air.'

Some of the rarest inhabitants of lowland heaths are reptiles. The cool climate in Britain and Ireland isn't ideal for such cold-blooded creatures, which need warmth to be active, so both their variety and abundance are low here, making a sighting all the more memorable.

Some people, of course, may be quite happy never to encounter a snake or lizard. But for those who appreciate them, southern heaths are the very best places we have to see them at close range. Some of these heaths are home to all six species of reptiles that live in Britain. These include sand lizards (nationally rare wearers of some

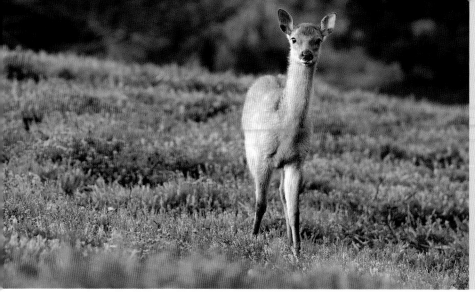

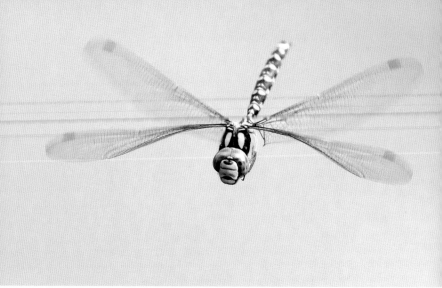

exotic shades of green) and smooth snakes (also rare). Adders, with their distinctive zigzag markings, have been found in the heathlands of the New Forest in Hampshire. They are Britain's only breed of venomous snake.

Among birds, the tiny Dartford warbler is one of the rarities that almost vanished from the lowland heathland map a few decades ago. It stays in Britain all year round (unlike almost all the other warblers that nest here, which migrate to Africa after breeding), so prolonged, freezing conditions can be deadly for it. An exceptionally harsh winter in the early 1960s knocked the population down to a mere 11 pairs. Now, fortunately, there are several thousand, nesting in a wider variety of places than before, but still most closely linked to lowland heaths.

A Dartford warbler's plumage is a gorgeous mix of mid-grey and dark wine-red, unlike any other British bird. Gorse bushes are among its favourite nesting places and song perches. So combine the colours of bird and bush, and you've got a classic image of an unusual natural sight.

And if you venture out on a heathland on a still, summer's night, when sounds and scents become the dominant ways of experiencing the scene, you could hear one of the strangest natural sounds: the churring, changing song of the male nightjar. Most active at night, this medium-sized bird – a bit like a cuckoo or kestrel in size and shape – comes to the heathlands in summer. Males make display flights in the dusk and dark, trying to impress females with their songs. Sometimes, their rising, falling, hypnotic calls can fill the heathland air – as beautiful, in their way, as the songs of nightingales in southern woods.

So lowland heaths combine many qualities, from the simplicity of wide, largely treeless spaces where a ramble can be refreshing and

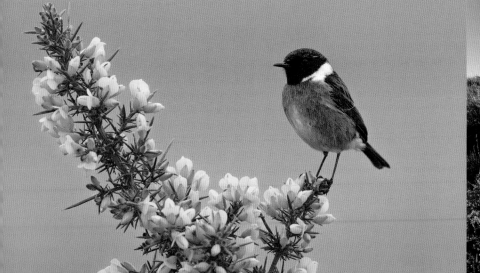

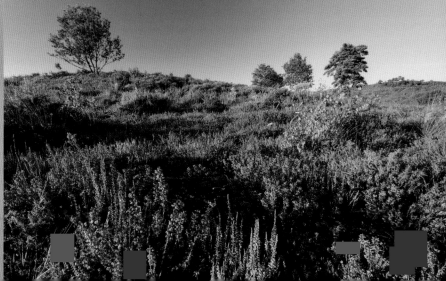

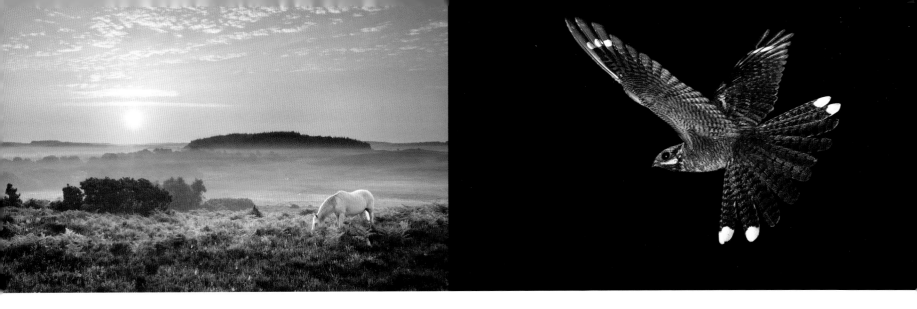

fun, to the complexity of the rare, the strange and the fascinating creatures that live in them. And although lowland heaths have been retreating in the past, some are now in good shape again. Work to conserve, expand and (with luck) reconnect major patches of heath has been having encouraging results. All over Britain, trees are being cut down to allow the heathland to re-establish, drains have been blocked to restore water tables and ponies and cattle are grazing heathlands again.

The Sandlings is a stretch of coastal heath that once ran from north Suffolk to Ipswich. Much reduced, its further loss has been halted. This is thanks to work to clear trees and scrub that threatened remaining heathland areas, including through the careful reintroduction of grazing. The results both look good, including for walkers who enjoy the Suffolk coast, and have boosted the fortunes of wildlife such as the silver-studded blue butterfly, the woodlark, the Dartford warbler and the nightjar.

Rare birds and butterflies have also benefited from work to remove densely planted conifers from Farnham Heath in the Surrey Hills. This has allowed more sunlight to shine directly onto the heathland ground, encouraging dwarf shrubs such as purple heather and yellow flowering gorse to grow and spread once more.

Lowland heaths are always likely to be scarce places, both in world terms and within Britain and Ireland. But that's part of their special quality and excitement; part of the reason why it's all the more important to save and to celebrate the surviving heathlands.

Think of them as galleries of colour possibilities; as breaths of fresh, honeyed air. Think of them as sources of strange and inspirational sounds by night, and light and life by day. Think of how and when you might experience such things, and be thankful that in Britain you still can.

THE SUN SETS OVER THE NEW FOREST NATIONAL PARK

Hampshire, England

The New Forest was first set aside by William the Conqueror as a hunting area almost a thousand years ago, but only became a designated national park as recently as 2005. Today it is the largest remaining area of lowland heath in Europe, supporting a rich diversity of wildlife, and representing a much-valued recreational area and breathing space in the otherwise densely populated south of England.

On a summer evening I love to feel the warmth radiating from the sandy soil and, just as the sun sets, the churring song of nightjars commences.

Alex Cruickshank, Project Manager, Hampshire and Isle of Wight Wildlife Trust

A MISTY DAWN IN THE NEW FOREST

Hampshire, England

An early morning mist shrouds the heathland landscape, punctuated by the silhouettes of a few statuesque Scots pine trees. Such evocative scenes have inspired great works of art and literature over the centuries and, with specific reference to heaths, the novels and poems of Thomas Hardy in particular.

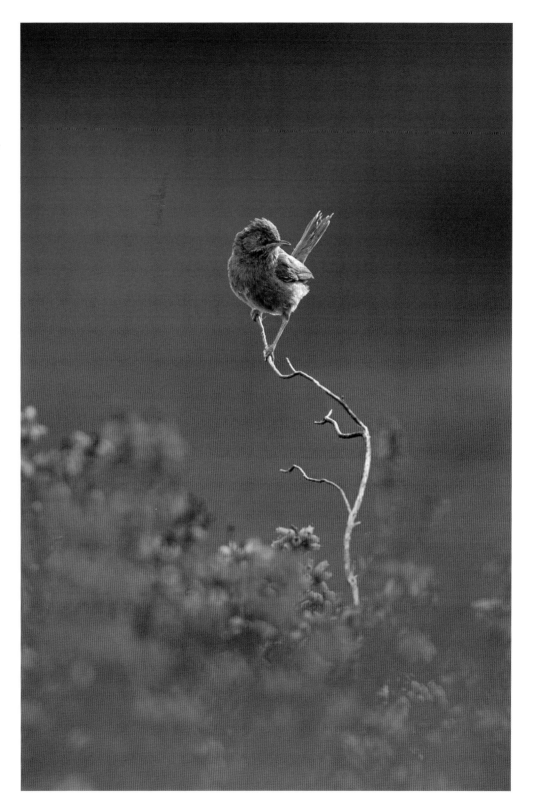

DARTFORD WARBLER IN A SEA OF BELL HEATHER

Dorset, England

Dartford warblers are at the northern edge of their range in Britain and wholly dependent on lowland heaths. While their stronghold is still in the New Forest and the south-west of the country, their numbers have gradually increased in recent years and their range has extended as far north as Norfolk – assisted by a concerted effort to restore and create more extensive tracts of heathland.

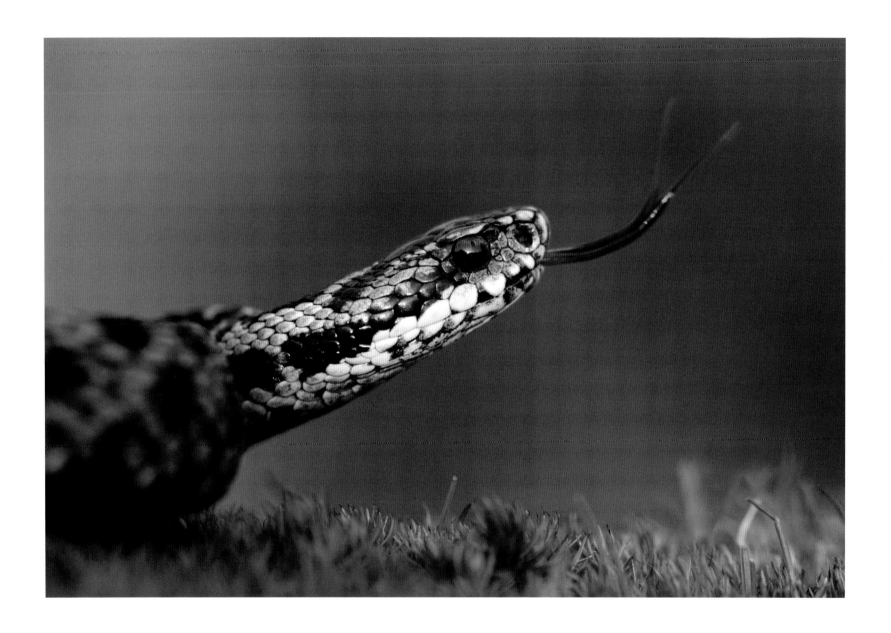

ADDER BASKING IN THE NEW FOREST

Hampshire, England

Lowland heaths act as effective suntraps, and open areas of sandy soil warm to the sun's rays much sooner than those of other habitats, making them attractive to cold-blooded creatures. We have only six native species of reptiles in the UK, and all of them occur on lowland heaths. In order to maintain the open patchwork of heath for species such as snakes and lizards, positive management is needed.

COMMON LIZARD IN EARLY SPRING

Hampshire, England

In north-east Hampshire, the Hampshire and Isle of Wight Wildlife Trust is working with the Ministry of Defence and local livestock owners on the Grazing for Wildlife project. Cattle and ponies are being used to selectively graze different areas to prevent the proliferation of scrub woodland and to maintain optimum conditions for species such as reptiles.

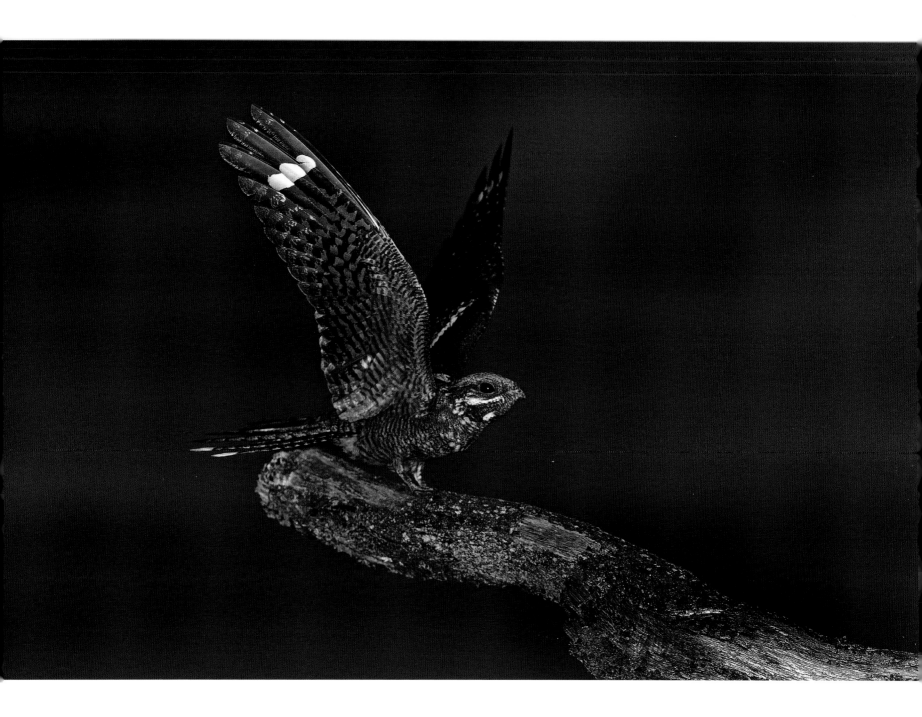

Heathland habitat is very important and very rare. It's home to specialised wildlife and it's also important for people.

Adam Burrows, Senior Reserve Manager, Suffolk Coast National Nature Reserve

248

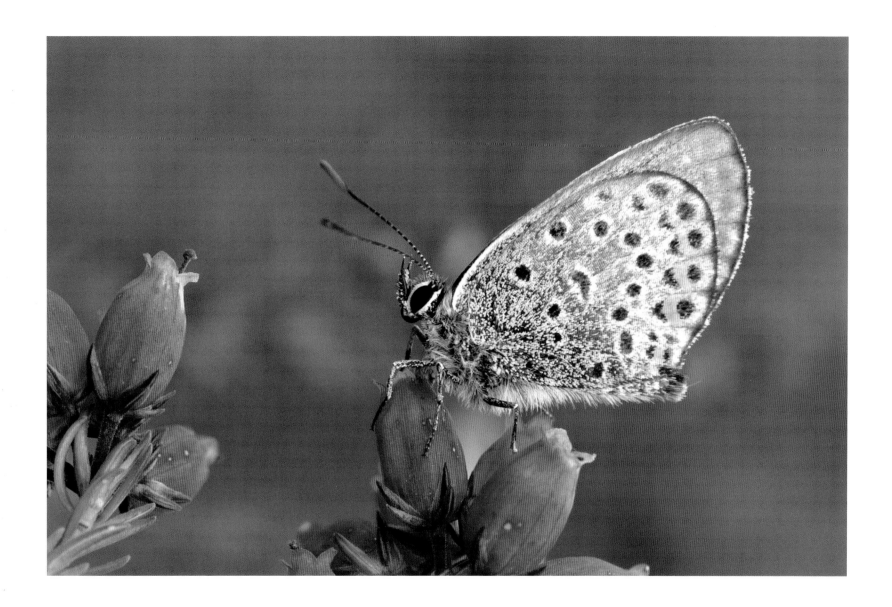

NIGHTJAR ALIGHTING ON ITS SONG PERCH

Suffolk, England

These strange, cryptic birds are almost impossible to find in daylight but after dark they come to life as they hunt for moths and go about their courtship behaviour. They are best located by the sound of their distinctive churring song and their peculiar wing-clapping display.

SILVER-STUDDED BLUE BUTTERFLY ON BELL HEATHER

Suffolk, England

This warmth-loving butterfly thrives on our southern heaths and is slow to recolonise new sites. In some places this process has been accelerated through managed translocations. Organisations like Butterfly Conservation and The Wildlife Trusts have been involved in several such initiatives, encouraging the spread of the species.

The Dorset lowland heaths are amazing biodiverse ecosystems, full of life, colour and sounds.

Jane Adams, amateur naturalist, Dorset

DEW ON A SPIDER'S WEB

Dorset, England

Ponds and areas of wet heath are vital for supporting healthy populations of insects and spiders, which in turn support species further up the food chain. For early morning walkers and joggers these feats of natural engineering decorate the heath with their intricate, lacy designs.

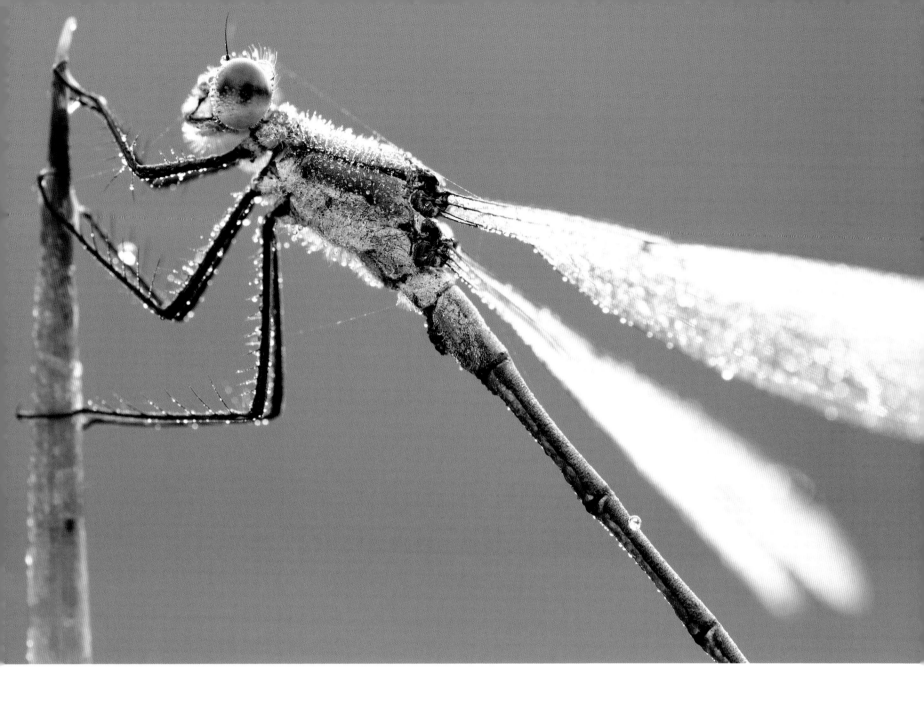

EMERALD DAMSELFLY AT DAWN

Dorset, England

There are as many as 22 types of dragonfly and damselfly to be found at the RSPB's Arne nature reserve. This dew-sodden emerald damselfly is one of the more common species, active from June to September, and often to be seen in the vicinity of the heathland pools – if not being whisked away in the talons of a hunting hobby!

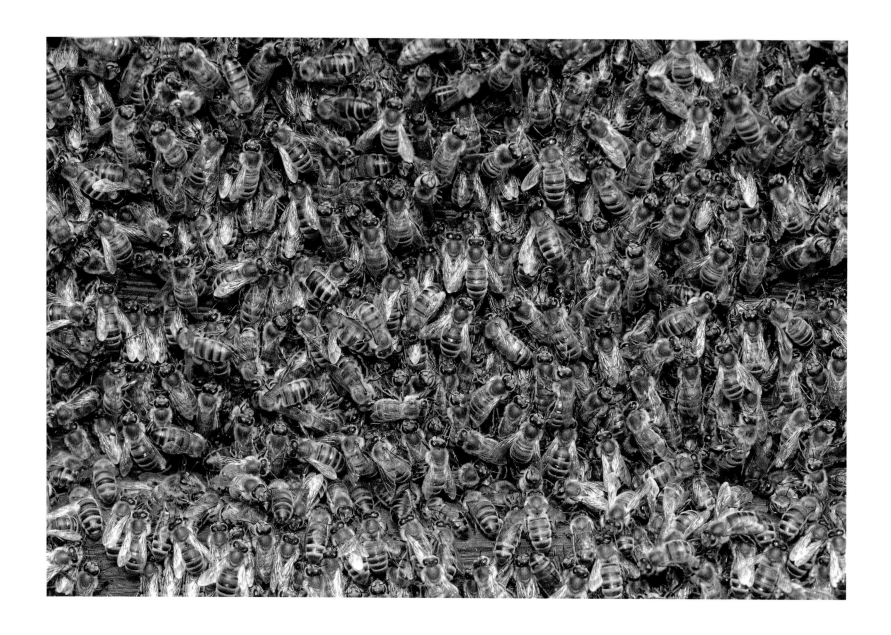

BEEKEEPING ON THE SUFFOLK SANDLINGS

Suffolk, England

Heather honey is a premium product with its own unique and fragrant taste, much valued by beekeepers and consumers alike (honey is the only food that contains all the substances required to sustain life). Since agricultural pesticides have been implicated as one possible cause of colony collapse disorder in honey bees, a phenomenon that is affecting bee populations across the country, our lowland heaths are more important than ever in providing a clean and healthy environment in which pollinating bees and other insects can flourish.

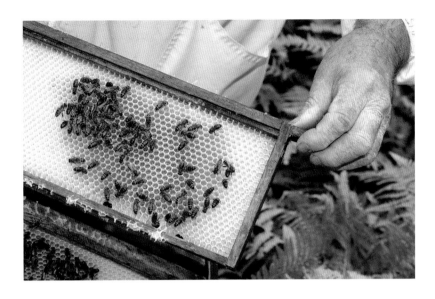

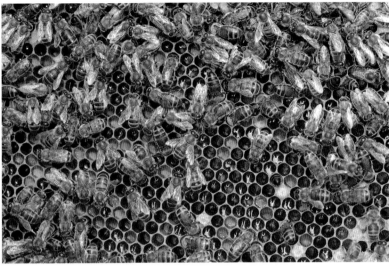

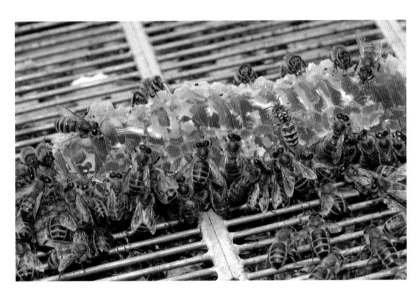

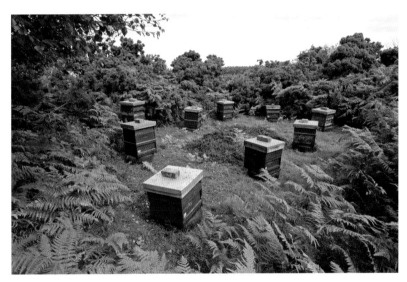

When on any heath I always feel a sense of human history. It's this, along with the specialist wildlife, which makes heaths so important, interesting and valuable to me. Elliott Fairs, conservationist

The Suffolk Coast and Heaths project is an exciting plan to revitalise the network of lowland heaths in this Area of Outstanding Natural Beauty. Comprising 42 fragmented pockets of heath, the project aims to recreate vibrant heathland from land previously lost to farming and forestry. Adders, Dartford warblers and nightjars will all benefit. And so will local people.

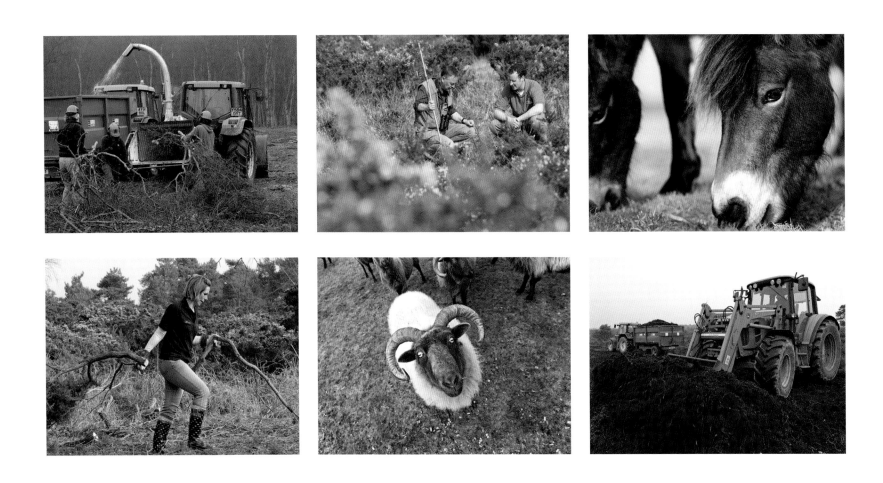

These heathlands are important to the local community. They are open areas where you get a sense of freedom.

Mel Kemp, Heathland Manager, RSPB Minsmere, Suffolk

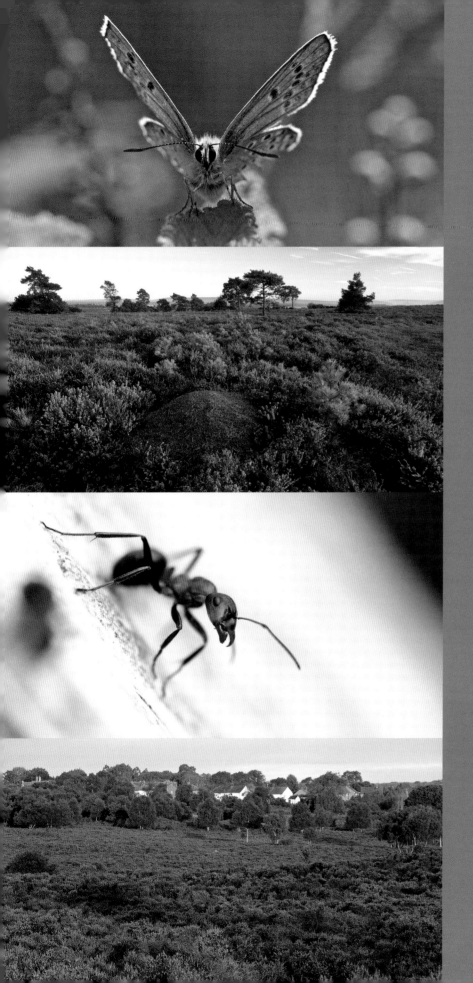

Heath in numbers

20%: The amount of the world's lowland heath found in the UK.

40: The number of species of insect that feed on heather alone.

58,000 hectares: The target expanse of lowland heath to be restored under the UK Biodiversity Action Plan.

75%: The amount of the UK population of Dartford warblers found on New Forest heathland.

5,000: The number of species of invertebrates occurring on heathland.

6: The number of native species of reptiles found in Britain, which are all supported by heathland.

£33,000: The amount contributed to Pembrokeshire's economy by the county's heathland beef.

£400 million: The annual tourism expenditure generated by visits to the New Forest.

90,000: The number of miles a hive of bees will fly to collect 1kg of honey.

4,000 hectares: The area undergoing heathland restoration as part of the Suffolk Sandlings Living Landscape project.

10 years: The length of time allocated to the North and East Hampshire Grazing for Biodiversity project.

Breathing space. Running track. Honey pot.

More than just a *heath*

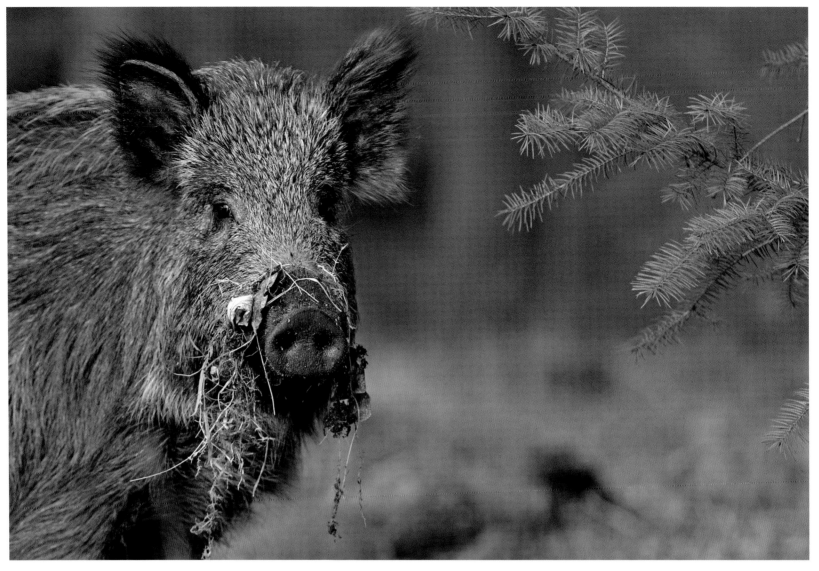

BEHIND THE SCENES

Photographing wildlife in the UK is far removed from conditions on an African safari – it takes time, effort, fieldcraft, ingenuity and, very often, good fortune. 2020VISION's photographers are all seasoned pros but that doesn't make the job easy. Here are just a few tales from behind the lens.

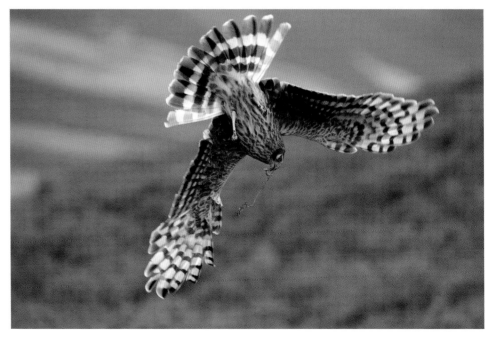

WILD BOAR

Andy Rouse

I was lying flat in the middle of the road trying to think like a worm, while taking only light, shallow breaths inside the netting surrounding my head. My whole body was shrouded in netting, an outfit known as a ghillie suit that made me look like a walking bush; it gave me the edge with the young lady some 9m in front of me. She was watching me intently with her snout in the air, trying to catch any telltale scent that would give away my true identity. I hoped that burying the suit for a week to give it natural smells and my policy of not washing for 24 hours before a stalking day would pay dividends. For 10 amazing minutes it worked. I was eye to eye with a female wild boar with the biggest smile on my face you could imagine.

She wasn't alone, either. It was her piglets that I'd seen first and who had caused me to crawl slowly and silently out onto the forest track. They stood right behind her, as confused as she was about the strange shape in front of them and even more desperate to come closer to investigate. Their mother was more suspicious than curious, and slowly she started to move around to the side of me to get a better view.

I froze but I knew that the end was fast approaching; soon she would catch my scent and my true identity would be revealed. I actually felt the gust of wind on my face that did the damage; a snort a second later was followed by the sound of several animals crashing through vegetation. I lay there for a further few minutes before slowly crawling away, the smile on my face wider than ever.

HEN HARRIERS

Mark Hamblin

As I squeezed myself into the cramped hide with my head pressed hard against the pool of rainwater that had gathered in the sagging roof above, I knew that I was in for an uncomfortable day. With water dripping down my collar, I craned my neck skywards, trying to catch a glimpse of one of the rarest birds of prey in the UK. Desperate not to miss her approach, my eye darted nervously between each of the tiny peepholes.

Suddenly a female hen harrier appeared directly in front of me, her sleek lines barely visible against the dark heather. I frantically tried to pick her up in the viewfinder – where was she? I switched my eye back to the peephole just in time to see her disappear into the heather. Damn it (or words to that effect!). I sunk back into my chair, disappointed.

About an hour later she rose almost vertically from the nest to acrobatically make a food pass with her mate high above, before landing around 150m away. I couldn't see her but kept my eyes fixed on the point where she had landed. After an age she took to the air, making a beeline in my direction.

This time I quickly trained the lens on her, my pulse quickening. Her bright yellow eyes were now clearly visible – but the next few seconds were a blur while I delivered a volley of shots as she banked and dived into the nest. I checked the back of the camera with my heart pumping hard. YEEESSS!! You beauty!

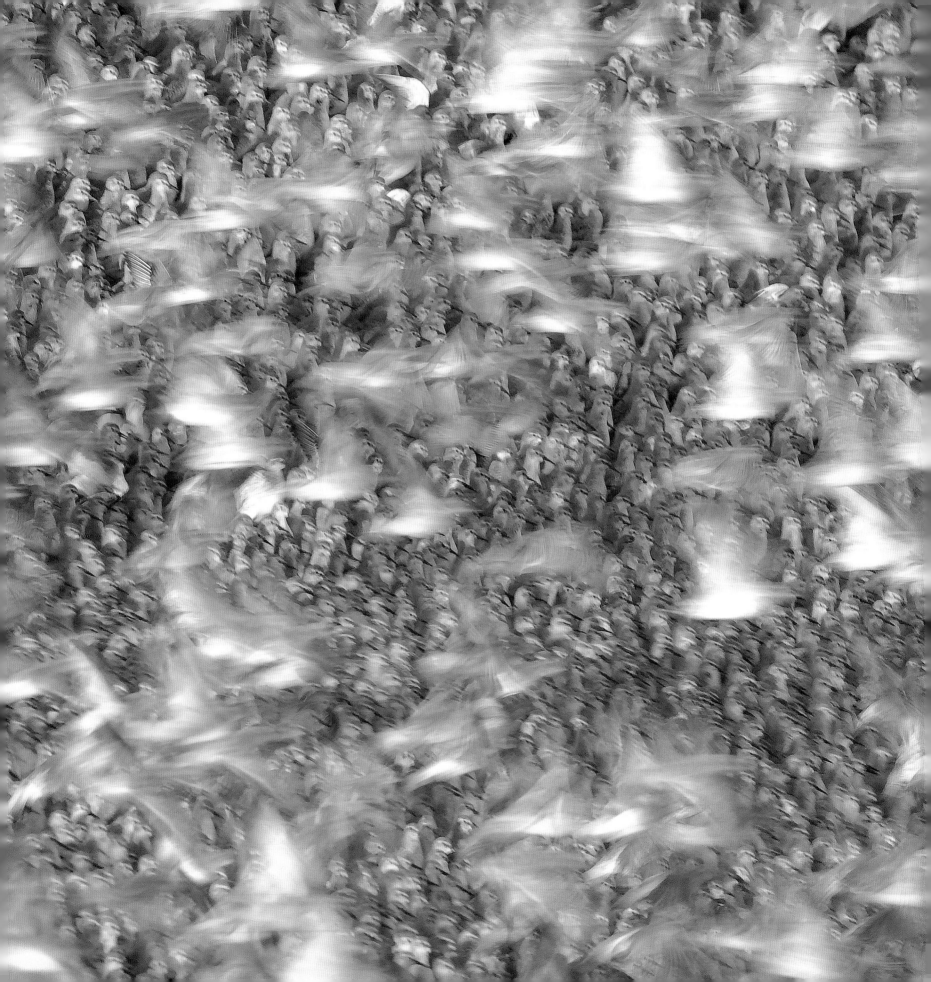

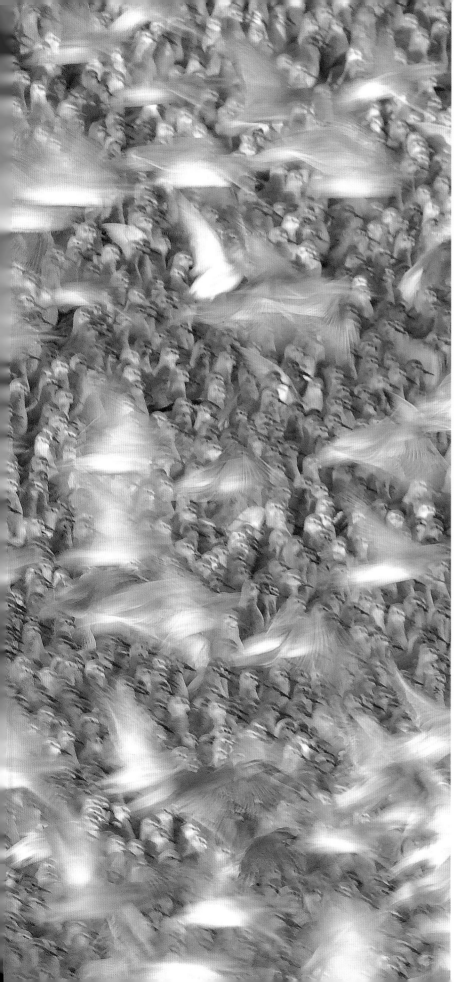

KNOT FLOCKS

Chris Gomersall

The gathering of knot at the RSPB's Snettisham reserve in Norfolk is one of the most enthralling spectacles in Britain's natural calendar – and it's had me hooked for over 25 years. The precise roosting location and the behaviour of the birds vary, affected by tides, wind speed and direction, disturbance, presence or absence of predators, and so on. One October morning it seemed the planets were in alignment and vibes were positive – I'd like to think it was my just reward for many previous fruitless visits. Payback time.

To be installed in the public hide in advance of high water and before the first glimpse of daylight, I had to start my journey before 4am. It's crucial to arrive early these days as word has spread about this remarkable free show, and visitors come from far and wide, tramping silently through the gloom with their burdens of knapsacks and tripods, like the ranks of the faithful on some religious pilgrimage.

The knot arrived on cue, as the tide covered the saltmarsh, and assembled on the shingle bank opposite the hide, just where I hoped they would. There must have been more than 30,000 birds in the roost flock, and the crowd scene more than filled the frame of my telephoto lens. Luckily there was a blanket of light cloud that softened shadows and allowed me to experiment with some slow shutter speeds. The final magic ingredient was a sudden interruption by an unseen predator, maybe a peregrine falcon, resulting in a blast-off of the panicked waders. Once the coast had cleared and the knot began to settle down again, each bird jostled for personal space, leading the flock to pulse and surge as one organism – a sort of avian version of the Mexican wave. And the sound was no less impressive than the sight, with the combined effect of their feeble calls rising to a dramatic crescendo as if the birds were applauding themselves. Encore!

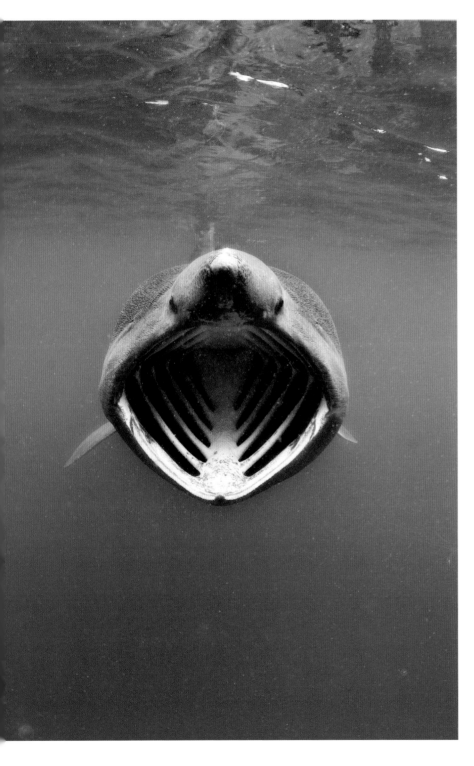

BASKING SHARKS

Alex Mustard

Some people find robins charismatic, with their friendly demeanour and red breasts. But the British wildlife that gets *me* really excited exists on a totally different scale. How about a shark that regularly exceeds 7m in length? Even more exciting is that our UK coasts are the best places in the world to see this amazing creature.

Basking sharks, or baskers, once you're on first-name terms, were a must-have for 2020VISION. And I didn't want to just get the shots; I wanted to get something special. Adopting a belt and braces approach, I arranged to shoot baskers in two locations in 2011: Cornwall and off Mull in Scotland.

Baskers aren't difficult to photograph, but they are often hard to find, their presence given away only when a dorsal fin tip happens to break the surface of the water. Searching for sewing implements in piles of drying grass can be much more fruitful. And so it proved. Penzance was a total no-show. So my first ever trip to Mull also became my last chance saloon.

In the Hebrides I teamed up with Sea Life Surveys, our destination the waters around Coll. No sooner did we arrive than I saw, out of the corner of my eye, a basking shark leap clean out of the water. Seeing 6 tonnes of British wildlife in mid-air left me dumbfounded. I didn't get close to getting a shot, but that one moment still replays in my mind in super slow-mo. The weather picked up and I didn't get out in the water for three days, but I got the shots in the end. So, while we went out into nature to bring back photos, it will actually be the memories of that unrecorded leap that I'll treasure most from my time on 2020VISION.

BOTTLENOSE DOLPHINS

John MacPherson

To my right, traffic races across Kessock Bridge. To my left, an impressive Swedish yacht negotiates the marina entrance. Across the firth, the North Kessock promenade is dotted with tourists and hopeful seagulls. I'm on the shoreline on the developing northern fringe of Inverness city, in front of a sprawl of builders' yards and industrial parks. Exotic? Hardly! This spot at the mouth of the River Ness is one of a couple of locations I've visited regularly to fulfil my assignment for 2020VISION – photographing the Moray Firth dolphins.

'Nature photography' conjures up images of an intrepid photographer rising pre-dawn, trudging miles through flesh-tearing thorns. Not in my case. I'd looked out of the window of my house, seen the firth was calm, and within 15 minutes I was there, lens on tripod, and ready to shoot!

Across the river mouth two lads with cans of lager and enjoying a large sweet-scented joint waved and replied that yes, there were some dolphins about, grabbing salmon running up the River Ness.

Over the next three hours, fins rise and disappear far out, then appear in the river as the water swells with a dolphin's powerful hunting rush. All hell breaks loose as fish frantically leap clear of the water, only to vanish again. Then there is calm, as the chase ends somewhere beneath the surface. A lone fin appears further upriver, 20m from a busy road, and a fish gets demolished in front of a bus full of locals.

This is repeated several times until it is time for me to depart, needing to collect my small boy from nursery in 20 minutes. Kit into van, and then a squeal from another photographer alerts me and I race back to see a chaotic scene of dolphins and salmon in a cloud of spray. Deep breath, hand holding the 500mm f4, brrrrrap of frames, deep breath, brrrrrap again, as a dolphin and salmon tussle metres from the shore: 30 seconds of briny bedlam and adrenalin. Then silence. Fins slice off into the shadows under the bridge. Gone.

Within three minutes I am in the traffic, in 15 minutes I am holding my son's hand at his nursery and answering his excited questions: 'Yes, William, I saw them again today, let's go and look at the photos. And tomorrow there's no nursery, so you can come and see the dolphins too!' A happy response: 'Hooray Daddy, dolphins tomorrow, dolphins tomorrow!'

This is the reality of dolphin photography in Inverness. Less than half a mile from the bustling city centre there's an (almost) daily display of breathtakingly dramatic life-and-death struggles, as massive predators try to capture enormous fish. How cool is that?!

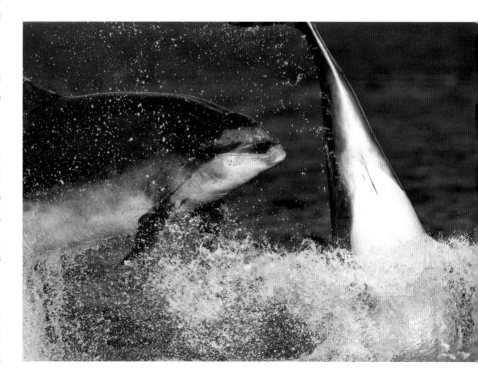

YOUNG CHAMPIONS

Throughout the 2020VISION project each of the professional photographers mentored a Young Champion, a keen and aspiring photographer aged between 16 and 24. This team was recruited from all over the country with help from the John Muir Trust in association with their conservation partners. The vision was to nurture engagement with the natural world and to tease out a few future stars who would go on to tell compelling stories with their cameras. Already several of the Young Champions have staged exhibitions and delivered personal presentations. We thought you might enjoy a small selection of Young Champion images.

Rob Burlace
Bryony Carter
Alasdair Cook
Oliver Creamer
Paul Floyd
Bertie Gregory

Tom Hughes
Katrina Martin
Luke Massey
Kristian Parton
Simon Phelps
Shaun Robertson

Bill Ryley
Shabana Shaffick-Richardson
Finlay Strivens
Rosie Watson
Jocelyn Williams

 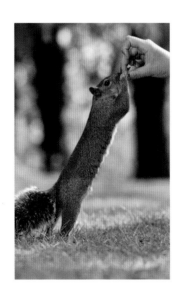 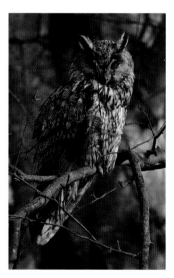

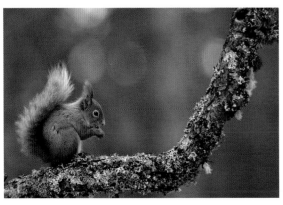

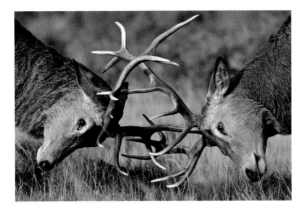
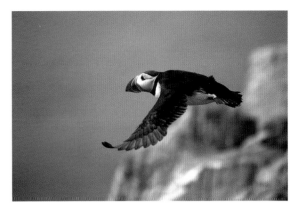

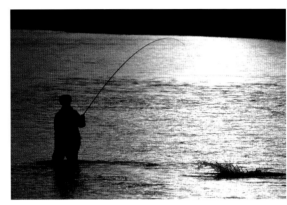
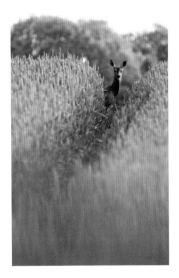

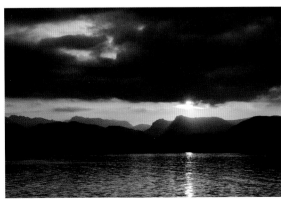
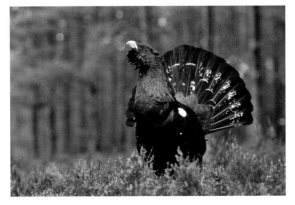
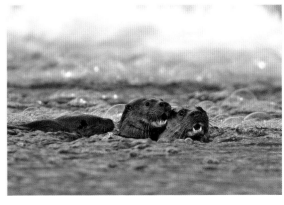

20 THINGS YOU CAN DO

Over to you! Here are 20 things – some pretty easy, others more ambitious – that you can do to help rebuild our natural home. The list is not definitive and we make no apology for the fact that some of these actions might seem a bit daunting, but, given the will, anything is possible. There's lots of information out there on how to go about helping nature, so go on – become an ecosystem hero!

1 DON'T BE A GARDEN NEATNESS OBSESSIVE

If you have a garden (and 15 million of us do), don't get too hung up about neatness – leave some areas wild and undisturbed. 'Weedy' areas are good for wildlife; nurture your nettles! Dead wood or log piles are also great for a surprising number of species. Avoid using peat products and don't use pesticides (especially slug pellets).

2 PLANT NATIVE TREES AND FLOWERS

If your garden is large enough, plant native trees or create a wildflower mini-meadow. If you have a small garden, consider native shrubs – even a window box will attract insects that are all part of the food chain and vital for pollination.

3 GROW YOUR OWN FOOD

Growing your own fruit and vegetables, and even rearing meat, in a garden, allotment or community farm is a great way to relax and can involve the whole family.

4 BE A SWITCHED-ON CONSUMER

Virtually everything we buy has a 'green' option, so learn what's good and avoid what's not so good. Fish that is harvested locally or under the Marine Stewardship Council's sustainability scheme is much better for safeguarding our oceans. Timber that carries the FSC mark means that it's been harvested from sustainable forests.

5 BUY 'WILD' PRESENTS

Instead of buying mass-produced presents at Christmas or birthdays, why not make a conservation pledge on behalf of your friend or relative? Plant a tree in their name or just make a donation. Better still, buy them an annual membership!

6 CONSIDER INVESTING IN WILDNESS

Why not consider leaving a legacy to a favourite conservation charity? Check out the RSPB's Futurescapes programme and The Wildlife Trusts' Living Landscape initiatives for some exciting landscape-scale restoration projects.

7 BECOME A PIONEER

Buy some wild land yourself or talk to your community or your employer about doing so. Just one or two individuals can start these initiatives. Take a look at the inspiring Carrifran Wildwood project in the Scottish Borders as an example.

8 BUILD A POND

It doesn't have to be that big to support lots of wildlife and it can really liven up a garden, school grounds or community area. Check out the Million Ponds Project if you need some inspiration.

9 WORK WITH YOUR NEIGHBOURS

Instead of putting up a fence between you and your neighbour, why not suggest planting a native hedge? Just imagine the difference we could make to wildlife – not to mention ourselves – if every garden in the UK were wildlife-friendly.

10 LET CHILDREN BE CHILDREN

Allowing children unsupervised creative play is an essential component in their development and wellbeing. Climbing trees, building dens and just sitting in the countryside teach children valuable life lessons. There's a growing body of evidence to suggest that children deprived of contact with nature are more prone to a range of physical and behavioural conditions. And the best bit? Playing in nature is free!

11 BECOME A VOLUNTEER

Volunteer for a conservation work party or holiday – you'll make new friends, feel healthier and be doing your bit to improve wildlife habitats. Local Wildlife Trusts run regular events and other organisations do everything from tree planting to gully blocking to willow bashing. It's a big green gym out there!

12 RESTORE WILDLIFE CORRIDORS

'Wildlife corridors' – hedges, belts of trees and uncultivated land – link isolated wildlife habitats, allowing species to move between them. Landowners and farmers working together can play a major role in this 'joined-up' conservation.

13 CREATE NEW HOMES FOR WILDLIFE

Put up nest boxes for birds, bats and even dormice in your garden, at your workplace or in school grounds. You may be rewarded with sightings of the new residents coming and going. Contact your local Wildlife Trust for information.

14 GET ON A MISSION WITH LITTER

Pick up litter when you're out and about, especially things like netting, wire and rope that can entangle wild animals. Arrange litter picks within your local community. Over the last 10 years the Morecambe Bay Partnership has arranged litter picks with nearly 5,000 people clearing 35 tonnes of waste from local beaches. It can be done!

15 REDUCE, RE-USE AND RECYCLE

Many items we've finished with might be useful to someone else, so use charity shops, car boot sales and websites like Freecycle to extend their life. Compost kitchen waste, use recycling services wherever possible, and send as little as you can to landfill. Avoid using disposable plastic carrier bags!

16 CAMPAIGN FOR GREEN BRIDGES

'Green bridges' allow animals to safely cross major roads and motorways that would otherwise present a physical barrier or often-fatal hazard and prevent them from moving between habitats or establishing new territories. Lobby your local council to implement such measures. It might be easier than you think, especially if you can get your request in at the planning stage.

17 BE A GREEN BUSINESS

It's not always easy to match profitability with environmentalism but the two aren't mutually exclusive. How about creating a company scheme that involves all employees? Regular tree-planting days? Such activities can be motivating for staff as well as beneficial to the public profile of your company.

18 BE AN ADVOCATE FOR NATURE

Start off by identifying one or two issues that are important to you and then do your homework. You could approach your local council to request that they sow wildflowers on roadside verges, or at least don't cut them so often; talk to teachers about encouraging outdoor learning; encourage local farmers to create skylark plots or beetle strips; write to your MP so they know how important the natural environment is to their constituents.

19 SHARE YOUR PASSION FOR NATURE

Enthusiasm is infectious. Talk to your kids, your friends and workmates. Show them pictures, send them links to interesting or inspiring websites and tell them about local wildlife.

20 AND FINALLY...

It's easy to convince ourselves that nature is for someone else to care for; and besides, we can never make much of a difference individually. Well, history tells us differently, so we'd like to leave you with this quote:

Never doubt that a small group of thoughtful committed citizens can change the world. Indeed, it is the only thing that ever has.

Margaret Mead (1901–78), American anthropologist

OUR PARTNERS

A project like 2020VISION relies on collaboration and commitment. We would like to thank all of our partners who have contributed in so many ways to make 2020VISION happen.

Brigadoon Boat Trips	South Downs National Park Authority
Royal Botanic Garden Edinburgh	Stealth Gear
Scottish Seabird Centre	The National Forest
Sea Life Surveys	Touching the Tide

2020VISION ENDORSING PARTNERS

Aigas Field Centre
Aikens, Tom
Avon Wildlife Trust
Bat Conservation Trust
Berkshire, Buckinghamshire and
 Oxfordshire Wildlife Trust
British Trust for Ornithology
British Society of
 Underwater Photographers
British Wildlife Centre
Broads Authority
Buglife
Bumblebee Conservation Trust
Cheshire Wildlife Trust
Cumbria Wildlife Trust
Cumbria Youth Alliance
Decade on Biodiversity
DiveLife
Dorset Wildlife Trust
Durham Wildlife Trust
Earth Restoration Service
Eco-Schools Scotland
Essex Wildlife Trust
Flora of the Fells Project
Friends of the Earth
Gloucestershire Wildlife Trust
Great Fen Project
Hampshire and Isle of Wight Wildlife Trust
Herts and Middlesex Wildlife Trust
IUCN UK
Lake District National Park Authority
Leicestershire and Rutland Wildlife Trust
Lincolnshire Wildlife Trust
Loch Lomond and the Trossachs
 National Park Authority
Marine Conservation Society

Montgomeryshire Wildlife Trust
Morecambe Bay Partnership
Mountaineering Council of Scotland
New Forest National Park Authority
New Networks for Nature
Norfolk Biodiversity Partnership
Norfolk Non-native Species Initiative
Norfolk Wildlife Trust
Northumberland Coast Area of Outstanding
 Natural Beauty
Northumberland National Park Authority
Northumberland Wildlife Trust
OneKind
Páramo Directional Clothing Systems
Peatlands Plus
People's Trust for Endangered Species
Rohan
Royal Zoological Society of Scotland
RSPB
Scotland's National Nature Reserves
Scottish Wild Land Group
Scottish Gamekeepers Association
SeaWeb
Shared Earth Trust
Shark Trust
Society of Biology
Staffordshire Wildlife Trust
Suffolk Biodiversity Partnership
Suffolk Wildlife Trust
Surrey Wildlife Trust
Sussex Wildlife Trust
Sustainable Uplands
Tayside Biodiversity Partnership
Tees Valley Wildlife Trust
The Blue Project
The Environment Bank
The National Trust
The Outward Bound Trust
The Wildlife Trust for Bedfordshire,

Cambridgeshire and Northamptonshire
The Wildlife Trust for Birmingham
 and the Black Country
The Wildlife Trust for Lancashire,
 Manchester and North Merseyside
Tonks, Mitch
Trees for Life
Ulster Wildlife Trust
University of the Highlands and Islands
Warwickshire Wildlife Trust
Wild Ennerdale
Wild Wonders of Europe
Wildfowl & Wetlands Trust
Wildland Research Institute
Worcestershire Wildlife Trust
WWF UK
Yorkshire Wildlife Trust

2020VISION MEDIA PARTNERS

BBC *Wildlife* magazine
BirdGuides webzine
Environment Films
ePHOTOzine website
Outdoor Photography magazine
Scotland Outdoors magazine
Wildlife Extra online magazine

INDEX

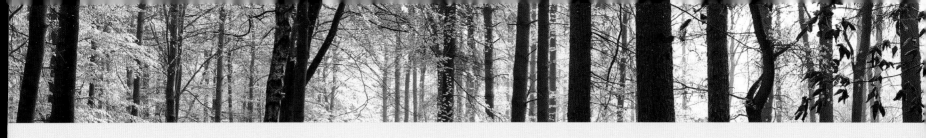

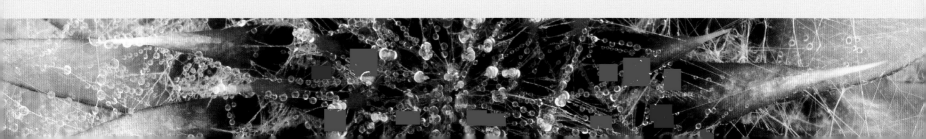

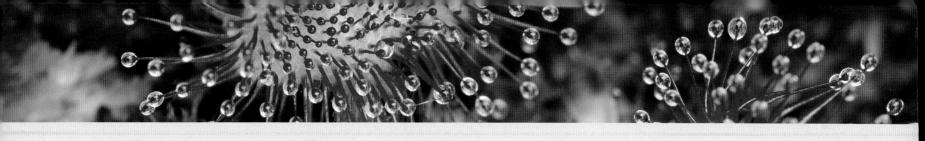

CREDITS

Abbreviations for the picture credits are as follows – (t) top, (b) bottom, (l) left, (r) right, (c) centre.

Introduction essays: Kenny Taylor

Image captions: Peter Cairns and Chris Gomersall

Species panels: Various (assembled by Niall Benvie)